# A HISTORY LOVER'S
## GUIDE TO

# RICHMOND

KRISTIN T. THROWER STOWE

D1253649

THE
History
PRESS

Published by The History Press
Charleston, SC
www.historypress.com

First published 2021

Manufactured in the United States

ISBN 9781467142175

Library of Congress Control Number: 2020948627

*Notice*: The information in this book is true and complete to the best of our knowledge. It is offered without guarantee on the part of the author or The History Press. The author and The History Press disclaim all liability in connection with the use of this book.

*To all who help preserve history and historical sites.*

# CONTENTS

# Contents

# PREFACE

Mary Wingfield Scott and Samuel Mordecai are central to the history of Richmond. Their names are mentioned quite often throughout this tour book, an acknowledgement of the extent of their work. In 1935, Mary Wingfield Scott founded the William Byrd Branch of the Association for the Preservation of Virginia Antiquities, which became Historic Richmond Foundation in 1956. Scott's dedication and love for historic buildings and neighborhoods saved numerous homes and inspired others to follow in her footsteps. The self-proclaimed unofficial Richmond historian, Samuel Mordecai's *Richmond in By-gone Days* (1856) was entertaining and informative. His observations and reflections are quite valuable to understanding the city and its citizens.

Richmond is a great city to tour. I fell in love with the city when researching for my first book, *Miller & Rhoads Legendary Santa Claus* (2001). Richmond's story is full of historical events dating back to Christopher Newport and John Smith's arrival in 1607. But the city's history goes back even further with the Algonquin Native Americans. By the time Newport and Smith had sailed up the James River, Powhatan's tribe had inhabited the area for years, and Belle Isle was their primary fishing grounds. A modern visitor to Richmond walks the same ground as Native Americans, John Smith, Benedict Arnold, Lila Meade Valentine, Maggie Walker, Edgar Allan Poe and many others. Political figures who roamed the Capitol Square include Thomas Jefferson, John Marshall, Abraham Lincoln and Douglas Wilder, the first elected African American governor. He served as governor of Virginia from 1990 to 1994.

# PREFACE

The city of Richmond is often hard for me to describe in one word or simple phrase, and as I learned more city history, the task became even more difficult. And then 2020 arrived. The social justice activism of the summer of 2020 spread across the nation, and it was bound to arrive in Richmond, the Confederate capital and the keeper of the Lost Cause. Richmond became national news as Confederate statues were removed, one by one, except for the statue of Robert E. Lee, which is still standing as of the printing of this book and its fate unknown. In October 2020, the *New York Times* declared the statue the most influential piece of protest art since World War II.

I have always believed and asserted that Richmond was and is so much more than the Civil War. Enjoy touring this place with a history that began before the discovery of Jamestown and continues to move toward the future. This work is organized into two parts: History and The Neighborhoods of Richmond in Mostly Chronological Order.

# ACKNOWLEDGEMENTS

As a child, I grew up traveling long distances from Virginia to visit relatives in Canada and Oklahoma, and each vacation began with at least a twelve-hour drive. I loved those long drives, my dad's tall tales and the mini adventures along the way. As a parent, I took my children on similar long vacation drives, had many mini adventures along the way, and told the same tall tales. As I am a lover of history, our family vacations included visits to historical sites and museums, and my daughter, at age ten, said, "Normal people don't travel to cities to visit museums." She now visits museums on her own and joins us for Richmond tours.

Writing is a group effort, and I would like to thank those who helped me complete this project.

A wonderful source, which I was lucky to access via the internet, is the Virginia Department of Historic Resources Nomination Forms. A huge thank-you to all of the people who worked to research, write and submit the forms. The National Park Service websites were also very useful.

The Valentine Museum is truly a treasure trove of all things Richmond. Thank you to Meg Hughes, director of collections/chief curator, and Kelly Kerney, research assistant, in the Valentine Research Library, for their help locating primary documents and photographs.

One of my favorite people I met writing this book is Stephenie L. Harrington. Harrington was my first interviewee for the book, and her passion for Oregon Hill is contagious. I hope she one day writes a book about Oregon Hill.

# Acknowledgements

My husband, Scott, and I enjoyed many excellent tours. We would like to thank Matthew Maggy at Richmond Tour Guys, Jeffry Burden at Shockoe Hill Cemetery, Amy Roberts at Beth Ahabah Museum and Archives, Steve Tarrant at the Railroad Museum for the Floodwall Tour, Curtis Anderson at the Virginia Museum and Benjamin C. Ross, church historian, Sixth Mount Zion Baptist Church. The Hollywood Segway Tour was a fun way to explore the large and hilly cemetery. Historic Richmond Foundation's mission to save historic architecture is greatly appreciated. We enjoyed touring Monumental Church, site of the 1811 theater tragedy. The Revolutionaries in Richmond Dinner at the Patrick Henry Pub was a fun and entertaining evening. In between courses, the Richmond Historic Haunts tour guides told tales of people and events that happened during the war.

Thank you to Stephanie Moore, my favorite AP Acorn. She introduced me to Kate Jenkins, my editor. Wow, what an awesome opportunity. Kate, thank you for asking me if I could write this book and then trusting me to do it. I am grateful, as writing this book has been a dream come true. Thank you to Abigail Fleming for her sharp eye and assistance with editing.

Shelley Murray and Vera Brown were nice enough to plow through early drafts, and with their suggestions, the book is better. Tammy Putnam and Thea Paul supported me throughout this whole process in more ways than I can mention, thank you. Dan Palese was able to capture the essence of Richmond in his photographs. Jennifer Bousquet patiently listened to Richmond stories for miles and miles as we trained for the Richmond Marathon. A special thank-you to my longest and dearest friend, Janie Hilton, thank you for the Sunday walks.

Those most important to thank are my family members. Each one of them played key roles in this process, and I can't thank them enough. My siblings, Kim W. and Scott Terbush, were very supportive. My mom, Judy Terbush, is my cheerleader, and she was always excited to hear how the book was coming along. My father, Tom Terbush, passed in 2007, yet it was he who encouraged my education and helped put me in the position to write. I miss you, Dad. I couldn't have done it without the support of my two children: Megan "Tig" helped edit, researched Union Hill and joined us on tours. Michael counted the steps (150) on Libby Hill on a very hot summer day and was a good sport, always willing to go on spontaneous sightseeing visits.

This book would have never been possible without my husband, Scott. He has been supportive from day one and has jumped in to help without being asked. I look forward to all of our future adventures.

# I.

---

# HISTORY

# THE JAMES RIVER

## JAMES RIVER PARK SYSTEM

*550+ Acres of Shoreline and Islands*
*Huguenot Flatwater to Ancarrow's Landing*

The James River stretches over 340 miles from the mountains to the bay, draining one-fourth of the water in Virginia. As settlement and trade routes headed upstream and westward, small towns emerged along the river. Today, the river provides drinking water to over two million people and six and a half million pounds of commercial seafood annually.

The James River Park System includes roughly thirty-five trails for hiking, running and biking near Richmond. To name a few, the North Bank, Buttermilk, Forest Hill and Belle Isle trails all connect to create an approximate six-mile loop around most of the Falls. Children growing up near the river are warned repeatedly of its dangers: the force of the rapids, the rocks and the yearly tragic drowning. But the river is a powerful draw for residents and visitors who seek exploration and quiet reflection.

The James River is temperamental and prone to flooding; its banks shift and change. The James River starts in the Appalachian Mountains, at the confluence of the Jackson and the Cowpasture Rivers, and carries the rainwater toward the Chesapeake Bay. The mountain rainfall sometimes adversely affects the river levels in Richmond. In 1771, a flash flood caused the

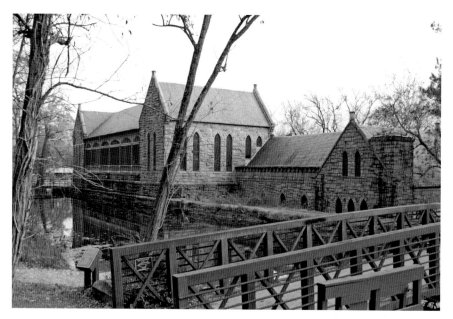

The Pump House. *Photograph by Dan Palese Photographs.*

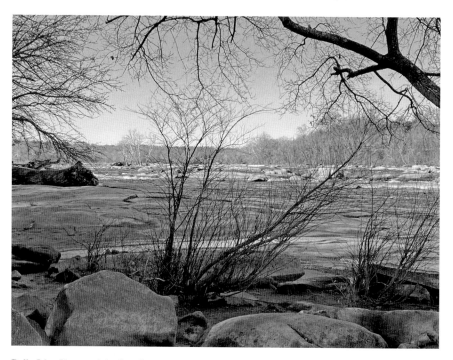

Belle Isle. *Photograph by Scott Stowe.*

deaths of more than one hundred people. Rain fell ten to twelve consecutive days in the mountains with no rainfall in Richmond. The city had no advance warning as the water rushed downstream like a wall, taking everything with it. Westham Warehouse was swept away; riverfront area businesses and tobacco warehouses were damaged. A monument on Turkey Island and a marker on Route 5, west of Willis Church Road, honor the dead.

The power of the James has caused death and destruction from the first settlers to modern times. The Mayo Bridge was rebuilt countless times, and horror stories circulate regarding flash floods and drowned fishermen.

## ROCKS @ FIRST BREAK HISTORICAL SIGN

*Hurricane Camille 1969*
*Northern Tip of Belle Isle*

Between 1816 and 2016, the James River near Richmond flooded 178 times. On August 19, 1969, Hurricane Camille entered the state of Virginia and dumped 27 inches of rain overnight in Nelson County, west of Richmond. The river crested at 28.6 feet and punched a hole in the dam adjacent to Belle Isle. The flooding left 113 dead and $116 million in damages. Three years later, Hurricane Agnes arrived in June 1972 and dumped almost 16 inches of rain in a 36-hour period. The river crested at 36.5 feet, nearly 17 feet above flood stage at the Westham gauge. The river waters reached the steps of Main Street Station, and 13 Virginians lost their lives, 4 of them from Richmond. The city sustained over $38 million in damage. In 1985, Tropical Storm Juan swelled the river, cresting at 30.76 feet. On August 30, 2004, Hurricane Gaston dumped 12 inches of rain on the city, and Shockoe Bottom's drainage was insufficient to handle flash flooding from the opposite direction headed toward the river.

On the south bank, space is provided atop the floodwall for walking, running and biking. The wall's elevated view provides a glimpse into the days of the numerous mills in Manchester, the south bank canal, the railroads and the majestic world of the James River. The wall was completed in 1995 to protect 750 acres on both sides of the river. The project cost over $140 million and produced a 4,300-foot concrete wall on the north side and 13,000 feet of combined earthen levee and concrete wall on the south. The floodwall was designed to protect approximately three miles on both sides of the James through the city. The Dock and Brander Street floodwall sections

were closed on November 13, 2020, as a precaution to the heavy rainfall; regular yearly maintenance is conducted to keep it prepared. The Mayo Bridge floodwall's maintenance takes place the first weekend in June, when one side is closed on Saturday and the other side on Sunday.

## THE WETLANDS OF THE JAMES RIVER PARK SYSTEM

*Street parking north end of Landria Drive, or Pony Pasture and walk the trail*

The river has three distinct gradients in Richmond: Western Section, Upper Section and Lower Section. The most western third starts at Huguenot Woods Flatwater (Huguenot Bridge) and continues to Pony Pasture. The river's gradient is four feet per mile, similar to the rest of the James River.

## PONY PASTURE

*7310 Riverside Drive*
*Free parking*

The Upper Section begins at Pony Pasture and travels four miles to Reedy Creek, including one mile of flat water and three miles of class I–II rapids. The final section, the Lower Section, includes the Hollywood Rapids, a set of class IV rapids. Belle Isle provides a scenic view of the rapids. The river drops seventy feet in two miles, which is thirty-five feet per mile. The average drop of the Grand Canyon section of the Colorado River is fifteen feet per mile. The Lower Section ends around the Mayo Bridge, which has the distinction of being where the river and tidal waters meet. The Great Shiplock Park, just a short distance from the Mayo Bridge, is a great place to see evidence of the tidal water.

## GREAT SHIPLOCK PARK AND CHAPEL ISLAND

*2803 Dock Street (Dock and Pear Streets)*

Free parking is available between the Capital Trail and the park. This was the lowest part of the James River and Kanawha Canal lock system. The

park has the old locks and an interpretive display regarding the lock system. Chapel Island is accessed by crossing the canal's footbridge. The island has nice trails and good fishing spots. Please see dgif.virginia.gov/fishing for details regarding fishing licenses. The James River offers fishermen quite the feast with numerous species of fish, including bass, catfish, sunfish, striper (rockfish), white perch and the herring/shad/menhaden/alewife family.

The James has numerous public and private islands scattered within the city limits. Belle Isle is a public sixty-five-acre island located across from Hollywood Cemetery. The island is connected to the shore by the pedestrian bridge located under the Lee Bridge on the north bank at Tredegar Street. A wooden pedestrian bridge near Twenty-Second Street, the Lee Bridge was a Public Works Administration project in the 1930s. Belle Isle is best known as a Confederate POW camp where enlisted Union prisoners suffered from the elements. The island was home to nail and iron manufacturing plants, the POW camp, a granite quarry and a hydroelectric plant before becoming a recreational spot for locals and visitors.

William Byrd II originally named the island Broad Rock because of the granite stone. The granite was part of a seven-mile band along the James River that started at Bosher's Dam, just north of the Edward E. Willey Memorial Bridge. The band of granite was also part of a north–south line of granite that ran from New Jersey to Georgia, parallel to I-95.

The Powhatan Indians used the island for seasonal fishing villages, and early settlers continued the fisheries on the island. In the 1800s, John Bell built a racetrack that attracted questionable businesses and unsavory characters; the island became an embarrassment to the Richmond ladies. When Bell finally left the area, the Richmond ladies renamed the island Belle Isle, meaning "pretty island" in French, to improve its reputation.

The island is one of Richmond's most popular areas, and residents flock there to sunbathe on the rocks, ride the rapids or explore old ruins.

## BROWN'S ISLAND

*Bottom of Twelfth Street*
*brownsisland.com*

Brown's Island, just downstream of Belle Isle, was created in 1789 by the excavation for Haxall Canal. In 1826, Elijah Brown was the first settler on the island, and it was afterward known as Brown's Island. Hydroelectrical

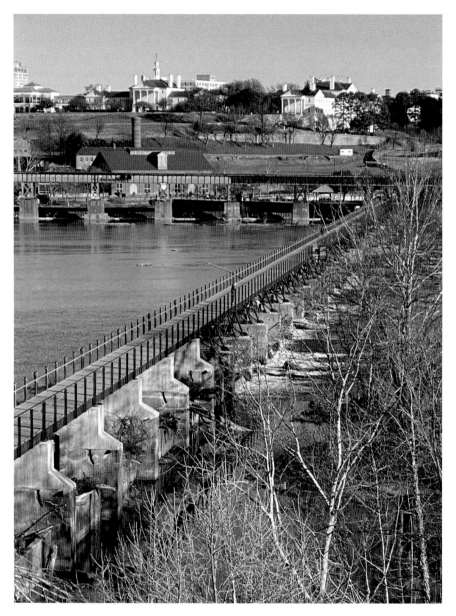

T. Tyler Potterfield Bridge looking north towards Tredegar Iron. *Photograph by Scott Stowe.*

and coal plants existed on the island at various times, but floods destroyed them. In 1987, the island became part of the James River Park System and hosts numerous events and includes paved walkways. Brown's Island is connected to Manchester by the new T. Tyler Potterfield Memorial Bridge.

## T. TYLER POTTERFIELD MEMORIAL BRIDGE

*Access: Brown's Island (north bank) and Semmes Avenue (south bank)*
*jamesriverpark.org*

The T. Tyler Potterfield Memorial Bridge, named in honor of the late City of Richmond planner, opened in 2016. The wheelchair-accessible 1,600-foot-long bridge was built on pilings of an old hydroelectric dam and reconnects Brown's Island to Manchester. William Byrd II's words come to mind when crossing the bridge, only 20 feet above the water: the river is "louder than a scolding wife's tongue." The Manchester Climbing Wall is located on the southern end of the bridge. Local climber Michael Greeby created a wonderful map of the climbing routes, jamesriverpark.org/project/manchester-climbing-wall.

# COLONIAL

The James River is central to Richmond and its history. A week after landing at Jamestown, Christopher Newport and John Smith explored the waters and looked for a passage to the Far East. They paddled upstream and thought the James River showed promise. Around one hundred miles upriver, they discovered they could no longer row upstream. Rocks and rapids forced their stop, the Fall Line of the James River, just below Richmond, Virginia.

On May 24, 1607, over the loud rumbling noise of the James River, Newport and Smith planted a wooden cross on an island among rocks. The cross was in the name of King James I, and a replica can be found at the intersection of Twelfth and East Byrd Streets. After realizing the westward exploration was temporarily halted, the Englishmen returned to Jamestown and didn't return to the area until the following year.

In 1608, the Englishmen attempted to establish a settlement at the Fall Line when John Smith sent a 120-man regiment with Captain Francis West to establish a fort on a north bank hill at the Falls. When Smith visited, he was surprised the fort was on the riverbank and not on higher ground. Smith had purchased the hill from Little Powhatan, but West refused to move his men and waged a skirmish against John Smith. Smith, frustrated, departed with his men to Jamestown. Barely down the river, Smith and his men heard fighting and returned to the fort to find the Native Americans had attacked the fort and killed some English settlers. John Smith assessed the situation and ended the fight. Smith repeated his order that West should move the fort to the top of Powhatan Hill. West again defied Smith and moved back to the

Edgar Allan Poe Museum, Main Street. *Photograph by Dan Palese Photographs.*

bank. Smith gave up and once again started a return trip to Jamestown. On the journey, John Smith's gunpowder bag, on the seat beside him, exploded, and he was severely burned. Smith returned to England for treatment, and West and his men moved back to Jamestown. Two years later, settlers attempted to settle on the north bank again. The local Native Americans attacked the settlement and killed all but one settler. In 1645, the English intended to build another fort on the north bank but instead decided to build Fort Charles on the south bank of the river.

People have lived in the Chesapeake region for over 1,500 years. Powhatan, Monacan, Mannohoacs and a few other tribes lived along the banks of the James. The tribe of Chief Powhatan occupied the area for over 300 years. At the time of Jamestown's establishment, Chief Powhatan oversaw a territory from the Chesapeake area westward to the Fall Line and from Maryland to North Carolina. The Powhatan population numbered approximately fourteen thousand.

Richmond and the Fall Line marked the boundary between the tribes of the Powhatan, Mannahoacs and Monacans. One of Chief Powhatan's sons was thought to live near Gambles Hill, the modern site of the Virginia War Memorial. Another Powhatan village was north of Rocketts Landing near the current Powhatan Park in Fulton Hill. In between the two hills was Shockoe Slip, the valley between the hills. The curious name is believed to be derived from the Powhatan word *Shacquohocan* for the large, flat stones at the mouth of Shockoe Creek. John Smith also recorded the word. "Slip" refers to the area's position on the canal basin. The Shockoe area developed into the economic heart of the city.

Powhatan kept the peace even after Smith's departure, and after the chief's death in April 1618, his brother Opechancanough succeeded him. Chief Opechancanough waged war against the settlers. In March 1622, the Natives attacked various settlements and killed 347 white men, women and children. Among the settlements attacked was the first ironworks in America, at Falling Creek six miles south of Richmond, and only a boy and a girl survived the attack.

Settlers fought back, and by March 1646, the Powhatan tribes had been defeated. Opechancanough was arrested and died. The next Powhatan leader, Chief Necotowance, signed a treaty with the English that restricted the movements of the Native Americans and drew a boundary between the white settlers and the Natives. The treaty provided the governor of Virginia the power to choose the chief of the Powhatan tribe. Through war, famine and disease, the Powhatan population fell, and they soon moved out of the area.

# BATTLE OF BLOODY RUN HISTORICAL MARKER

*North Thirty-Second Street and East Broad Street*

Ten years later, in 1656, an influx of six to seven hundred Native Americans, Rickohockans, suddenly appeared along the north bank. The new arrivals were not welcome. The colonial leaders placed Colonel Edward Hill of Shirley Plantation in command of white settlers and Pamunkey Native Americans. Hill's lack of leadership led to the deaths of numerous settlers and Natives, including Chief Totopotomo. The creek was renamed Bloody Creek because the water had turned red from numerous wounded and dead.

# BACON'S CASTLE

*465 Bacon's Castle Trail, Surry, Virginia*
*(757) 357-5976 | preservationvirginia.org | Admission fee*

Although Bacon's Castle is over an hour away from Richmond and Nathaniel Bacon did not own the house or the land, a few of Bacon's men stayed in the home during the rebellion. If the modern traveler's interest includes historic homes, this is the oldest brick dwelling in North America.

The final blow to the Natives along the Fall Line was Bacon's Rebellion. Nathaniel Bacon arrived in Virginia in 1674 and purchased land north of Richmond, Bacon's Quarter. That land is now within city limits. The Native Americans and settlers had small skirmishes, and the fighting spread south. In 1676, the Native Americans killed one of Bacon's men. Bacon and others waged an unauthorized war against any Native American, which included friendly tribes. The colonial government labeled Bacon's actions a rebellion, and he then waged a war against Governor Berkeley. The rebellion collapsed after Nathaniel Bacon's untimely death. He was buried in an unmarked grave to protect the body from abuse.

Bacon's Rebellion stripped the last of the power of the Powhatan Indians. A 1669 map included a Powhatan village on the north side of the river, and in 1701, that area was labeled Shockoe Creek and displayed individual "Powhite Indian cabins."

Shockoe Creek, located in Shockoe Valley and fed into the James River, had long been a trading post between settlers and Native Americans. Bacon's

friend William Byrd I had inherited the site from his uncle Thomas Stegg. The Stegg family had arrived in the colonies in the 1630s and established trade at Shockoe with the Native Americans. They increased land holdings with an additional 1,800 acres at the Falls of the James River, named Falls Plantation, and built a stone home. Thomas Stegg died in 1671 and left the vast majority of land to his sister's son William Byrd I. Byrd was eighteen, and he was ready to expand his uncle's land holdings. This was the beginning of the Byrd dynasty, which molded the city of Richmond. This dynasty lasted from 1671 to 1777.

William Byrd I and his wife, Mary, moved into the small Stone House on Falls Plantation. They had five children, one of whom died in infancy. Once the children were old enough, they were sent abroad for their education. William Byrd I successfully expanded the trading post and traded items such as cloth, kettles, hatchets, beads, rum, guns and ammunition in exchange for beaver skins, deerskins, furs, herbs and minerals. His market extended far beyond Virginia waters to include international trade with Africa for slaves and with England for hats, tables and shoes. Additionally, he owned a tobacco warehouse at the Falls, where tobacco farmers' crops were inspected and stored prior to shipment. In 1689, he pledged support to the French Huguenot refugees who settled in Manakintown on the southern banks of the river in what is now Powhatan County. Trade and tobacco provided the income to purchase indentured servants, which in turn provided Byrd with land under the headright system, which rewarded the financier of a trip to the New World with fifty acres of land for every passage paid for.

## WESTOVER PLANTATION

*7000 Westover Road, Charles City*
*(804) 829–2882 | westover-plantation.com/index.htm | Donation*

William's wife, Mary, disapproved of the remoteness and the dangers of living in the wilderness of the Stone House on the Falls Plantation. In 1688, William Byrd I purchased the Westover Plantation on the banks of the James River from Richard Bland. The plantation was adjacent to the Berkeley Plantation and provided opportunities to socialize. Westover Plantation began as a "hundred" settlement approximately thirty miles east of Richmond, now located off Route 5, less than an hour drive from Richmond.

Westover Plantation initally had a church in close proximity to the home. The distance between plantations and urban areas was often quite long, so Virginians adapted. Westover Church was constructed prior to Thomas Pawlett's purchase in 1637. Nearly one hundred years later, the church was moved to its current site on Herring Creek, approximately one and a half miles north of the plantation. Both sites are accessible via Route 5 or the Capital Trail.

Mary and William Byrd I lived on the property until their deaths. Mary died in 1699, and William Byrd I followed in 1704. When Byrd died, his son William II inherited roughly twenty-six thousand acres.

In 1674, William Byrd II was born in the old Stone House on the Falls Plantation, and at the age of seven, he was sent abroad for an education. He was eventually admitted to the bar. When he returned to Virginia, he was ready to enter the fine society of the landed elite. William Byrd II, as a well-educated man, learned the ways of England's upper class. He moved easily in the elite planter class of Virginia.

After his father's death, William Byrd II returned to the colonies in 1705 and claimed the twenty-six thousand acres. He married Lucy "Fidelia" Parke on May 4, 1706. They had four children, but their two sons died in infancy and Lucy herself died in 1716. Byrd married twenty-five-year-old Maria Taylor in May 1724, and they had four children, including his only surviving son, William Byrd III.

Around 1733, William Byrd II initiated the construction to replace the Westover wooden frame home with a brick home. The builder of the current (brick) Westover home was originally believed to be William Byrd II; it is now believed to have been built by William Byrd III. Regardless, the Westover Plantation epitomized the lifestyle of the planters' great wealth. William Byrd II's personal diaries told of countless guests, issues with slaves and the management of a huge estate. The 2,500-square-foot brick home's entrance faces the James River to greet guests who arrived by boat. The formal gardens, behind the home, contain the graves of William Byrd II and Evelyn.

His eldest daughter, Evelyn Byrd, was sent to England at the age of eighteen and fell in love with an unfavorable suitor. Her father demanded she return home, where she died of a broken heart. The current owners of Westover claim Evelyn haunts the home by showing herself to first-time guests. The ghost story is based on the friendship between Evelyn and Anne Harrison of Berkeley Plantation. Each promised to return from the grave and visit her friend. The visits are not intended to be mean-spirited.

# VIRGINIA CAPITAL TRAIL

*51.7-mile path from Richmond to Williamsburg*
*virginiacapitaltrail.org*

The main avenue of transportation was the river, although there was a rough trail from Williamsburg to Richmond, similar to the current Route 5. The Virginia Capital Trail is a paved two-lane path that follows Route 5 from Richmond to Williamsburg. The trail is open to runners, bicyclists, dog walkers and more. Vehicles and motorcycles are not permitted on the trail. Along the way, modern travelers can eat, sleep and explore historical sites.

William Byrd II understood land equaled wealth. He traveled and purchased land throughout the Virginia colony as far south as the North Carolina border. He is credited with naming the city. As he stood on Libby Hill and looked out over the river, Byrd proclaimed the view was similar to Richmond-on-the-Thames and named the area Richmond.

South and down from Libby Hill was the location of his father's trading post at the Falls. Shockoe Bottom, the floor of the valley, was filled with taverns, tobacco traders, stores and various rough crowds. Richmond's hills and purpose (trade) kept most of the population centered on the wharf. Byrd's tobacco inspection warehouse at Shockoe provided the background for a commercial center. The trading post docks bustled with merchants loading and unloading ships' cargo.

William Byrd II was opposed to permanent settlement at the trading post and fought the House of Burgesses' bill that supported "confiscating" his land for a town. While Byrd II fought legislation to prevent Shockoe from becoming a town and selling his Richmond lots, Richard Levens had already been granted a license for an ordinary, similar to a tavern. He served liquor from his home on the northeast corner of Cary and Twenty-Third Streets. Inspired, Abraham Cowley gained his own license for his home at Main and Twenty-Third Streets, and it was still operational after the Revolutionary War.

Since the settlement was already established, a bill vote was not held. Byrd decided to divide his land for sale. The construction costs of Westover and upkeep of his family—and his assumption of his father-in-law's debt—had strained his resources. His friend Mayor William Mayo offered to survey the land for free.

William Mayo and his brother Joseph, a pair of Englishmen, emigrated from Barbados in 1723. William Mayo surveyed the town, in 1737, and his map outlined the original boundaries: First Street east to Ninth Street (today

Capital Trail, Dock Street. *Photograph by Scott Stowe.*

that is Seventeenth Street, Shockoe Bottom east to Twenty-Fifth Street, Libby Hill) and the James River north to Broad Street. The cross streets were designated letters, starting at the river and moving north: D (Cary Street, the one nearest the river), E (Main Street, the business district), F (Franklin Street), G (Grace Street) and H (Broad Street). Mayo divided the area into thirty-two squares, and each square was divided into four lots. The sale of lots was conditional in that the lots must be built on within three years of purchase. The cost was around seven pounds per lot. William Byrd donated lots number 97 and 98 for a future church, St. John's Episcopal Church, and north bank shoreline for two annual fairs in May and November.

By 1742, Richmond's population had grown to 250, most of whom lived within the town's boundaries. New laws were enacted, such as the 1744 law that chimney construction must be all brick, and any wood chimneys must be torn down and replaced within three years. The wooden buildings, haphazardly built and in close proximity, contributed to the citizens' fear of a city fire.

The death of William Byrd II in 1744 started the slow demise of the Byrd dynasty. William Byrd III, his only son, inherited no debt and most of the estate's 179,000 acres, land on both sides of the river at the Falls.

Cary Street looking west. *Photograph by Scott Stowe.*

In 1755, William Byrd III began construction on his home, Belvidere, made of wood and set on a brick foundation. Belvidere differed from other plantations, since the entrance faced north, away from the river; his father's Westover Plantation and other plantations faced the James River. Belvidere was built west of Richmond, along a bluff now associated with the Oregon

Hill neighborhood. The original home was part of an estate that included seventeen acres and numerous outbuildings, bordered by Laurel Street (west), China Street (north), Holly (south) and Belvidere (east). The Oregon Hill Overlook's serpentine brick wall is rumored to have inspired Thomas Jefferson to incorporate a similar design on the University of Virginia campus.

The two-story frame home's length stretched over 130 feet and included separate office and kitchen buildings. The Byrd family suffered heartache at this home. Elizabeth Hill Carter, granddaughter of Robert "King" Carter, was Byrd's first wife. She gave birth to five children in seven years. She died at an early age; the Richmond rumor mill spread the story that Elizabeth pulled a large chest on herself. William Byrd III remarried six months later to Mary Willing.

William Byrd III was the antithesis of his father, as he gambled and drank away his fortune and resorted to selling off his inheritance in a lottery. William Byrd III tried to solve his financial difficulties by selling off his land in 1768 and sold ten thousand tickets at five pounds apiece. The ticket prizes included improved town lots, ten thousand acres laid off in one-hundred-acre lots and ten islands. He disposed of his hold on the town of Rocky Ridge, later known as Manchester. The sale included twenty-year leases on mills, fisheries, tobacco warehouses and Patrick Coutt's ferry.

Although most items sold, he was unable to reach financial stability and committed suicide on New Year's Day 1777 at Westover Plantation. Belvidere was sold, and subsequent owners included Light-Horse Harry Lee and Bushrod Washington, nephew of George Washington. The mansion's last use was as a boardinghouse. A terrible fire ravaged the wooden Belvidere in 1854, and the Oregon Hill residents salvaged the old bricks for their own dwellings. In Oregon Hill, stories circulate of homes built on old Belvidere basements that are still accessible.

Richmond's population grew slowly. In 1769, the population numbered about 600 and included white, free Black and enslaved residents. In 1790, when John and Eliza Marshall built their home on Capitol Square, she remarked that Richmond had few comforts when compared to Williamsburg.

Richmond's main industries were trade and tobacco. Byrd I combined the two; he established a tobacco inspection warehouse at his trading post. At the inspection warehouse, the tobacco was inspected and, based on the quality and quantity (pounds) of tobacco, a receipt was generated. The farmers exchanged the receipt for money and items in town.

By the time of the American Revolution, Richmond ranked sixth in the nation for shipping tobacco. Richmond exported fifty-five million pounds

of tobacco in 1755. Tobacco was a leading reason for land-hungry men like William Byrd I and his son to acquire more land. James River farmers, prior to the 1730s, often used the slash-and-burn method to clear the land to plant tobacco. As farmers quickly learned, they needed to continually add acreage to their holdings due to the destruction of the soil. The loss of nutrients forced farmers to allow fields to lie fallow or plant another crop. The farmers turned to raising animals and planting grains. The planting of grains combined with the power of the rapids provided the right combination for flour mills after the Revolutionary War.

# REVOLUTIONARY WAR

## ST. JOHN'S EPISCOPAL CHURCH

*2401 East Broad Street*
*(804) 648-5015 | historicstjohnschurch.org | Admission fee*

Main Street, running east–west, was the heart of the business district in the city. The street featured taverns, the Seventeenth Street Market and other businesses. In 1772, Mary and Ann Strachan opened a millinery shop trading in women's wear. The historic Old Stone House is located on Main. In 1742, the population was roughly 250 and in twenty-seven years would grow to 574. The population growth slowed between 1769 and 1776 and was only around 600. By the end of the Revolutionary War, the population had nearly doubled as a result of the capital being moved to Richmond. The 1782 census listed occupations, and the merchants and peddlers were larger than any other group. Other occupations included carpenters, cobblers and clothing workers, wheelwrights, tavern or board keepers, printers and seven people who worked for the state. According to the census, Richmond was the home to one chemist, one schoolteacher, one fireman, one attorney and four doctors.

The town's city limits had expanded to include the hills: Richmond (Libby), Shockoe, Capital and Church Hill. Richmond resembled a small town in regards to the close living spaces of the residents. The city's

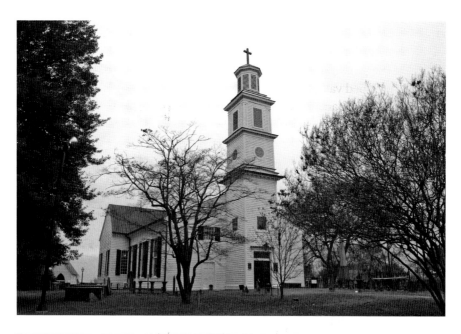

*Above*: St. John's Church. *Photograph by Dan Palese Photographs.*

*Left*: North Twenty-Third Street between East Grace and East Franklin. *Photograph by Scott Stowe.*

neighborhoods were mostly segregated more along the lines of economics and occupations than race. Additionally, the city was built on hills. The hills were not the rolling hills of the Midwest but cliffs that plunged deep into narrow creek bed valleys. The hills were so steep, the horse and carriage had to travel a switchback trail down one hill and up the other. One mile took approximately one full day. A modern-day traveler could experience this by walking up the cobblestone path from Main Street to Libby Hill or driving north on Cedar Street from Marshall Street, continuing on Cedar Street to Mosby Street and turning right and ending at Jefferson Park. Looking across from Jefferson Park to Capital Square (MCV), the modern visitor can see the height of the hills and Shockoe Valley in between where the small town of Richmond had expanded by the Revolutionary War.

Richmond was chosen to host two conventions prior to the Revolutionary War due to its proximity to the capital in Williamsburg. The men who attended the Virginia Convention were the leading men of the colony, such as George Washington, Thomas Jefferson, George Mason, Peyton Randolph, Patrick Henry and Richard Henry "Light-Horse" Lee.

## WILTON HOUSE MUSEUM

*215 South Wilton Road*
*(804) 282-5936 | wiltonhousemusem.org | Admission fee*

St. John's Church was the selected location for the meeting; it was the largest building in the city. The city didn't offer many overnight amenities for the visiting delegates. The men who traveled to Richmond from their plantations, such as George Washington, found lodging in various nearby plantations, such as Ampthill, at the original site south of the river; Mount Comfort owned by Samuel DuVal on upper Shockoe Creek, northeast of Richmond; and Wilton House in Richmond. Other men sought to rent a bed in the numerous taverns that lined Main Street in Shockoe Bottom. On the third day of the convention, March 23, 1775, the delegates debated various solutions (by peace or force) to the crisis with Great Britain. Patrick Henry, lawyer and member of the House of Burgesses, argued that the British were not interested in peace. He supported a petition to raise a militia and prepare to defend the colony from the British. It was this passionate speech that ended with the famous phrase "Give me liberty or give me death." While some delegates yelled "Treason," he stood by his words and

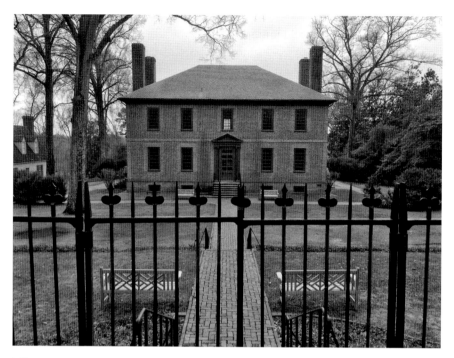

Wilton House. *Photograph by Scott Stowe.*

convinced enough delegates to pass a resolution to prepare the Virginia colony for armed readiness though independent (minute) companies. The following month, April 1775, the first shots were fired at Lexington and Concord was burned.

## HENRICO COUNTY COURTHOUSE

*(current building dates to 1898)*
*First public reading of the Declaration of Independence*
*Twenty-First and Main Streets*
*Private building*

The next convention that met in Richmond occurred from July to August 1775. This time, the delegates voted to commit the colony to war. In November, British governor Lord Dunmore issued a proclamation: Virginia Colony was in open rebellion, and it promised freedom to any slave who left his master and supported the British military. In Williamsburg, Virginia

regiments confronted Lord Dunmore's army and forced him offshore. Since Williamsburg was safe, the delegates held a convention there on June 29, 1776, and adopted a state constitution. Patrick Henry was elected the first governor of Virginia. Soon after, the Declaration of Independence was signed on July 4, 1776.

# WASHINGTON STATUE

*State capitol grounds*
*(804) 698-1500 | virginiacapitol.gov*

Not all Richmonders applauded the declaration or the upcoming war. Richmond had a few Loyalists, mostly Scottish merchants. The Loyalists who resided in the area suffered consequences for their loyalty. A young shoemaker, a loyal and loud supporter of King George, was dunked and dragged across the river and then tarred and feathered. The feathers were from his own mattress. The young man was warned to leave and to never

Richmond, circa 1900–15. *Library of Congress.*

return. Richmonders punished Tories through destruction and confiscation of property. Loyalist Scottish factorage firms lost their property. Other Loyalists were charged with treason and went to trial in the special court of Oyer and Terminer. The conviction rate was high, but no one was hanged for the crime. Jailed Loyalists suffered horrible treatment in the city's jail. Richmond Loyalist Richard Burnley was released from jail due to his health from maltreatment, and he died five days later.

The largest group to support the British were the free and enslaved people of Richmond and the surrounding area. Virginia had established slave laws as early as the 1640s. During wartime, Richmond had special regulations for people of color, slave and free. Slaves had a nightly curfew, unless they carried written permission from their owners. They were forbidden to hold meetings at night unless it was Christmas or another special occasion decided by the masters. Slaves were prohibited from activities that involved games and money, from cards to betting. The punishment was up to thirty lashes.

Urban slaves had more opportunities than plantation slaves. In Richmond, slaves and owners did not always live in the same residence. Free Black people and slaves were allowed to marry. Slaves sold their own provisions in the public market on Saturday afternoons and Sundays—all of this, of course, with the written consent of their owners. Richmond's population of skilled slave laborers worked in the mines, shops and even for the government. Westham Foundry employed slaves manufacturing cannons, cannonballs and grape canisters for the military, and for the civilians, hand irons, flatirons, anvils, wagon boxes, spades, shovels, sledgehammers, spikes and nails. The foundry was located in the small colonial village of Westham, near the current Huguenot Bridge on the North Shore.

## HUGUENOT FLATWATER–JAMES RIVER PARK SYSTEM

*South bank*
*8600 Riverside Drive just west of the Huguenot Bridge, parking for thirty-five cars*
*jamesriverpark.org/project/huguenot-flatwater*

Westham was established in 1752 as a trading post for the western farms. The items were removed from the boats and transported into town on the Westham Parkway. In 1776, John Ballendine moved to Westham, and a short while later, he and his partner John Reverly established the foundry. They convinced the General Assembly to fund the project, and by March

1779, the foundry was producing items for the war. William Armistead hired out his slave James Armistead Lafayette to work as a Continental spy. After the war, he gained his freedom and lived on a small farm near his former owner. Free Black Richmonders, such as Adam Armstrong and P. Humphrey Blaine, also supported the war effort.

Slavery became a sensitive subject as colonists fought for liberty. Some Virginians believed that slavery was wrong and passed the Manumission Act in 1782, under pressure from the Quakers and Germans in the colony. This was the first time since the early eighteenth century that owners were allowed to free their slaves. Robert Carter, son of "King" Carter, freed all of his five hundred slaves on his sixteen plantations in Virginia. He manumitted fifteen a year, until they were all freed. He leased farmland to them similar to sharecropping. Robert Pleasants of Henrico County freed seventy-eight slaves and deeded them land in Varina and Gravel Hill. He also became the president of the Virginia Abolition Society. The Quakers opened a free school for Black children in 1784.

## GALT'S TAVERN SITE

*Northwest corner of Nineteenth and Main Streets*

Not all Richmonders agreed with Carter and Pleasants, especially when forged freedom papers from Carter began to circulate. When Richmond became the capital of Virginia, the slave trade relocated from Manchester to the city. The few slave sales during the war tended to be in front of local taverns or on county court day. Galt Tavern, a popular spot for officers of all armies, conducted slave sales during 1777 and 1778.

## VALENTINE FIRST FREEDOM CENTER AND MONUMENT

*14 South Fourteenth Street and Cary Street*
*thevalentine.org/exhibition/first-freedom-center | Free*

In addition to liberty, other enlightenment ideas were taking hold. In 1777, Thomas Jefferson wrote the Virginia Statute for Religious Freedom in a building located at Fourteenth and Cary Streets, where the Virginia General Assembly met in secret. The Patriots confiscated the structure

Richmond, circa 1905. *Library of Congress.*

from Cuninghame and Company, a Scottish factorage firm, because of its Loyalist views. The Virginia capital moved from Williamsburg to Richmond in 1780 because the new state government reasoned it was safer and farther away from the British. The General Assembly met for the first time on May 1, 1780. The first order of business decided the site for the capitol, and the second order of business established a public market.

## VIRGINIA STATE CAPITOL

*1000 Bank Street*
*(804) 698-1788 | virginiacapitol.gov*

The General Assembly set aside six city squares to set up the new government: one lot each for the capitol, hall of justice and jail, executive board (future site), public market and two lots for use of the governor. The war prevented the start of the building.

Meanwhile, the population of Richmond grew from the influx of government workers and their families, free Black population, soldiers and recent immigrants. The population strained the local authorities, especially as they worked an increase of cases that dealt with horse stealing. Skilled labor industry benefited from the rise in the population of craftsmen, especially carpenters. Even before the war, there was a growing demand for skilled weavers, shoemakers, tailors and seamstresses due to the boycott of English goods. As the various trades, such as blacksmiths, leatherworkers and silversmiths, grew, price inflation and money devaluation made purchasing difficult. Still, Main Street stores and the city market continued to sell items.

## CITY OF RICHMOND BICENTENNIAL HISTORICAL MARKER

*East Main Street and South Twenty-Second Street*

The near doubling of the population in a short time caught the city unprepared. Richmond had long been established as a port town with limited lodgings located mostly inside taverns. The lodging was usually a large room above the tavern filled with beds. During the war years, visitors were shocked by the level of violence among the townspeople—no real skirmishes with the British, just frequent tavern bawls and street fights. Dr. William Foushee, Richmond's first mayor, started a hospital during the Revolutionary War and served as the surgeon general and director. He also was a proponent for the smallpox vaccination, and in the early 1800s, Henrico County authorized the doctor to give shots. He experienced firsthand the favored street fight method of gouging the opponent's eye when he almost lost an eye after being attacked for his friendship with British officers.

All wars have their heroes and villains, and the American Revolution was no different. The small trading town of Richmond encountered both the heroes: George Washington, Thomas Jefferson, Patrick Henry, Marquis de Lafayette and Peter Francisco, and the villains: Benedict Arnold and General Charles Cornwallis. Each one of these men left a mark on Richmond.

Peter Francisco, at the age of five, was left on Richmond's dock at City Point. His origins remain a mystery, and he was believed to be either Portuguese or Spanish. At the start of the Revolutionary War, Francisco enlisted at the age of fifteen and committed great acts of heroism. His heroism was linked to his great strength and height; he was six feet, six inches. Francisco rescued a 1,100-pound cannon from capture by carrying the cannon to

safely to the American lines. He was buried at Shockhoe Hill Cemetery. Virginia, Massachusetts and Rhode Island celebrate Peter Francisco Day each year on March 15 to commemorate the Battle of Guilford Courthouse in Greensboro, North Carolnia, when Francisco killed eleven British soldiers and survived after being wounded.

In 1775, Gabriel Galt opened Galt's Tavern, at Nineteenth and East Main Streets, a few short blocks from the Old Stone House. Here sat the true villains of the war, American traitor Benedict Arnold and British general Cornwallis. These men had calmly, and without force, more than once, marched into the city and took it with ease.

## BERKELEY PLANTATION

*12602 Harrison Landing Road*
*Charles City, VA 23030*
*(804) 829-6018 | berkeleyplantation.com | Admission fee*

Benedict Arnold is the most notorious and well-known traitor in American history. Brigadier General Arnold's role at the Battle of Saratoga was crucial to convince the French to support the colonies. After a disappointment, Arnold switched alliances and fought for the British. On January 4, 1781, he sailed upstream on the James River and stopped at Westover Plantation. There he rode his horse up and down the staircase, drew his sword and marked the staircase handrail. The scar is still visible today. At Berkeley Plantation, he plundered and left with approxiately forty slaves.

## TUCKAHOE PLANTATION

*Thomas Jefferson's childhood home*
*12601 River Road*
*(804) 774-1614 | tuckahoeplantation.com | Admission fee*

Arnold and his 1,600 troops marched west toward Richmond. Along the way, his men followed his example and exhibited similar behavior in other plantations. Governor Thomas Jefferson called out the Virginia Militia, but they offered no real threat to the advancing Arnold, Lieutenant Colonel Simcoe and British troops. Thomas Jefferson gathered important documents

Tuckahoe Plantation. *Photograph by Scott Stowe.*

and traveled west to Tuckahoe. Arnold arrived in town on January 5 and made himself quite comfortable at the Galt Tavern. Arnold appealed to Governor Jefferson and stated he would not burn down Richmond if the colonists allowed him to take the tobacco stored in the warehouses. Jefferson replied that Arnold may not have the tobacco. So, Arnold had his men set fire to the town. The wood-framed buildings fed the fire. Public buildings, homes, a warehouse and a printing press were destroyed by the fire.

## ARNOLD MONUMENT

*Western advancement of British troops*
*Mulberry and Grove Streets*

Meanwhile, just west of Richmond, Lieutenant Colonel John Simcoe and his regiment of the Queen's Rangers burned the foundry at Westham, dumped the gunpowder into the river and destroyed all of the weapons. When Arnold and Simcoe left Richmond, they took tobacco with them and additional stolen items, including a few runaway slaves.

# SCUFFLETOWN PARK

*418 Strawberry Street in the alley*
*Picnic table and nice hardscape, green grass*

Arnold encountered the colonial home guard at Scuffletown, just west of Richmond along the route to Westham. The very brief scuffle was enough to name the area. In 1791, a boardinghouse/tavern located in the same vicinity hung a sign that read "Help a Scuffler Through." Arnold returned to Richmond, but this time the presence of Lafayette protected the town.

Cornwallis arrived in Richmond from the South on June 16 and departed for Yorktown on June 20. While in Richmond, he enjoyed the Galt Tavern, and his troops set fire to homes and over two thousand hogsheads of tobacco. They destroyed stores, supplies, salt, harnesses, muskets and flour.

Cornwallis set up camp in Yorktown and eventually surrendered in October 1781. The official peace treaty, Peace of Paris, was signed on April 15, 1783. Richmond celebrated the end of the war on April 26, 1783, with a reading of the preliminary articles of peace, fireworks, banquets and a ball.

# POST REVOLUTION AND WAR OF 1812

Richmond emerged from the Revolutionary War as a state capital, an industrious economic hub. The population had doubled. In 1782, shortly after becoming incorporated, the new town government was composed of a panel of twelve men, called the Common Hall, and a mayor. Dr. Foushee was elected the city's first mayor. In order to vote, a man must reside in the area for a minimum of three months and have one hundred pounds worth of property. Mayor Foushee and the Common Hall dealt with the challenges of a growing city by enforcing new laws; they were trying to change the culture of the city. They passed Richmond's first speed limit laws, stating horses were prohibited from galloping within city limits (whether by a rider or pulling a wagon or cart) and were prohibited from free-range roaming in city limits.

Hogs were another nuisance animal. Owners were warned to keep their hogs on their property. If not, the constables had the right to seize any free-roaming pigs. The confiscated hog meat was given to the poor. The following year, the city's struggle continued with animals and people living together in an urban setting. The Common Hall passed a law stating that all dead animals had to be buried within twelve hours of death. If not, the city had the right to fine the owner.

Nine years later, the city leaders were still addressing the issues of transforming from a rural to an urban population with people living in close quarters. They issued an ordinance that detailed the specifics of the necessary houses. The ordinance required a distance of at least twenty feet

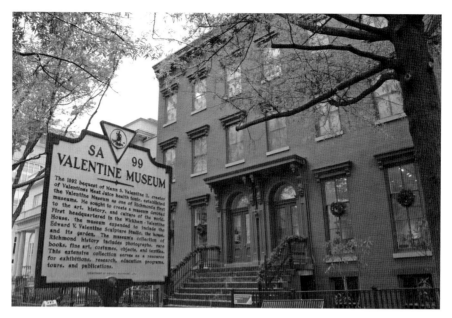

Valentine Museum, Court End. *Photograph by Dan Palese Photographs.*

from the building to the street. The city's leaders were forced to establish instructions on the topic of cleaning. The instructions discussed how often the necessary houses should be emptied and the time for performing that chore. During the hot and humid summer months, owners were obliged to clean the buildings every ten days and, during the other months, once every two months. The city preferred the cleaning to happen between 10:00 p.m. and sunrise.

Richmonders continued to live in constant fear of fire. The wood-frame homes were built in proximity, and fires spread quickly. In 1782, Mary Willing Byrd III gave the city her water engine, and by year's end, each city ward had one well. The city hired firemen, and each home received a water bucket—citizens were encouraged to assist.

As Richmonders adjusted to living in an urban setting, there were leftover issues from the days of the trading post. The streets remained unpaved and muddy with limited pedestrian sidewalks. The existing sidewalks were usually only in front of shops for women. Since walking was difficult given Richmond's hilly terrain, horses and carriages were the main mode of transportation. The wealthy lived just outside of the Main Street district, and they preferred to ride around town in carriages. Richmond was full of private carriages of various styles. The largest

carriage was the coach—preferably painted yellow. The coach carried four passengers, a driver and two footmen. The coach also had large lamps to light the way. The next size smaller were the chariots. The chariot carried two passengers and a driver; there were no footmen. This was the preferred manner of transportation for long journeys. The smaller carriage, the chair, was a two-wheeled chaise that held one person and was pulled by one horse. Mount Vernon has a wonderful vintage chair wagon on display.

The lodging choices had not changed much since before the Revolutionary War. There weren't too many places a person traveled to visit in the city of Richmond prior to the early nineteenth century. The city had no real hotels, at least not in the modern sense. Friends and neighbors played hosts to travelers. There was no real need for rooming houses until Richmond became the capital. The first available beds to rent for a night's lodging were located in the various taverns throughout Richmond, Manchester and surrounding small towns. The taverns' second story or second room held beds that were lined up and ready for overnight guests. Formicola's Tavern, located on the southern side of Main Street, between Fifteenth and Seventeenth Streets, was a two-story two-room building. The owner, a former maître d'hôtel to Lord Dunmore, fed the men downstairs and packed the upstairs with single beds. There were officially another fifteen people, including one female proprietor, who had permission to keep taverns during the war years. Taverns were an important element of a man's world. At the tavern, men ate and drank, talked about local news and debated politics and, of course, played a game or two of billiards and cards.

Richmond's many taverns lined Main Street, where the modern traveler might find similar themed places today. Some of the better-known historic ones included Bird in the Hand on the northwest corner of Main and Twenty-Fifth Streets, and Bowler's (later the Bell Tavern) at the northeast corner of Fifteenth and Main Streets and the Galt, mentioned earlier. When George Washington arrived in town in 1784, he and Lafayette celebrated at the Bell Tavern over an elegant dinner.

Taverns outside of the city center tended to have specific clientele. The Rocketts Landing Tavern catered to the crews of the trading ships. The taverns north of the city docks—The Swan, on the north side of Broad Street between Eighth and Ninth Streets, Baker's Tavern (later Goddin's) on Brooke Avenue and Richard's Tavern on the north side of Broad Street between Fifth and Sixth—catered to the wagon drivers who traveled from the Piedmont region or the Blue Ridge Mountains.

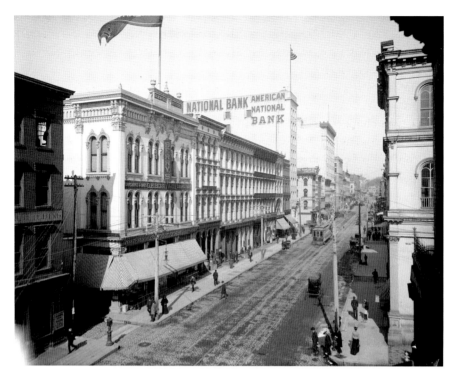

Main Street, Richmond, circa 1905. *Library of Congress.*

## WOODWARD HOUSE, 1780s

*Captain John Woodward*
*One of oldest frame homes in Richmond*
*3017 Williamsburg Avenue | Private residence*

These taverns were an integral part of the economy of the city. Richmond, throughout the Revolutionary War, continued to be a trading post with the lands north and west of the city. After the war, traders and commissioned merchants reached across the ocean to establish a trading market, similar to William Byrd II's early routes. In addition to the agricultural crops of tobacco and wheat, the western interior traders arrived with numerous items for trade, such as furs, lead, tallow, maple sugar, salt, wax, ginseng, butter, flour and the all-important dried rattlesnakes for making viper broth for consumptive patients. The traders arrived in wagons pulled by four to six horses. Most likely, they met with someone involved in the

tobacco trade to sell their wares. Tobacco's importance was undeniable. When cash was rare, tobacco was used for currency. Citizens paid their taxes in tobacco leaf.

The James River continued to play a crucial role in the development of Richmond. Yet the river was also an impediment to growth. The shorelines of the river changed and were prone to flooding and forever shifting riverbed silt. River crossings were few, and for most of the early history, Coutt's Ferry and the Mayo Toll Bridge were the only two ways to cross the river.

The Mayo brothers, William and Joseph, tried building bridges over the James near the Fall Line to connect Manchester to Richmond, but each time the river destroyed what they built.

The Mayos purchased an island in the middle of the river between Manchester and Richmond to anchor the sides of the bridges. In 1788, the first Mayo Bridge was constructed by large logs roped together, attached to the rocks and shorelines with spikes, and looked more like a raft than a bridge and was composed of two sections with Mayo Island in between. This was the first of the Mayo toll bridges built over and destroyed by the river. The profitable toll income made the Mayo family very wealthy. Two armed guards assisted in the pickup of the daily receipts. Two months later, ice floating down the James swept the bridge downriver.

In 1796, another bridge was constructed, and this time, the Mayos had the bridge built on wooden piers. Three years later, the bridge was again destroyed, and another bridge was built. Near the end of the Civil War, the Confederates burned the Mayo Bridge, and the replacement bridge was wiped out by a flood and had to be rebuilt again. And in the blizzard of 1899, ice destroyed the bridge.

## MAYO BRIDGE

*Fourteenth Street Bridge*

Finally, the city purchased the rights to the crossing and rebuilt the bridge in concrete. This version opened in 1913. The design of the bridge was influenced by the Pont Neuf on the River Seine. The great-granddaughter of John Mayo placed a plaque commemorating the occasion. The modern bridge is in the same location and is part of the Richmond Slave Trail. The Mayo Bridge still floods whenever the river level passes twenty-eight feet above flood stage.

During the smallpox epidemic of the early 1790s, the City of Manchester placed armed men on the Mayo Bridge to prevent infected Richmonders from crossing the river, and sentries were stationed along the riverbank to prevent anyone crossing by boat. A Richmond mob showed up at the bridge to wage war, and Governor Light-Horse Harry Lee arrived and calmed the crowd; an agreement was reached that allowed businesspeople and travelers to cross.

The city residents continued to live in Shockoe Bottom, in proximity to the docks, businesses, slave markets and taverns. This area, under the I-95 overpass and east to Union and Church Hills, was mostly destroyed during the Evacuation Fire of April 1865, when the Confederates left town. Very few buildings survived from the 1780s; most buildings were damaged. Two wonderful examples of mid-1780s architecture are the Adam Craig House (1784–87) and Mason Hall (1785–87). Both have a connection to Richmond's most famous writer, Edgar Allan Poe.

# THE ADAM CRAIG HOUSE

*1812 East Grace Street and North Nineteenth Street*
*Private residence*

The Adam Craig House, circa 1784, is the oldest frame house in Richmond. In 1782, Adam Craig left Williamsburg and arrived in Richmond, where he worked as a clerk for various local courts. He was well liked and respected. His daughter, Jane Stith Craig Stanard, is believed to be the inspiration for Edgar Allan Poe's tribute "To Helen." The tribute was written after she had married and lived at the Hay-Stanard house on Ninth. Jane was the mother of Robert, one of Edgar's childhood friends. Some believe she was supportive of his writing.

After Craig's death, the home had numerous owners and was bought by the Richmond Methodist Missionary Institute in 1912. By 1935, the home and outer buildings were in disrepair, and a small group of Richmonders decided to save the home. That was the start of the William Byrd Branch of the Association for the Preservation of Virginia Antiquities, now Preservation Virginia.

## MASON HALL

*1807 East Franklin Street*
*Contact masonshall1785.org for tour*

The Mason Hall, Richmond Randolph Lodge No. 19, was built in 1785 at 1807 East Franklin Street. Richmond citizens and Union soldiers saved the hall from the Evacuation Fire of April 1865. Project managers Edmund Randolph and John Marshall oversaw the design and construction of the hall. The early sympathetic Patriots met at the hall prior to the long trip to Philadelphia as representatives of Virginia. Those men helped write the 1787 U.S. Constitution.

The Mason Hall named the Marquis de Lafayette and his son honorary members as a thank-you for services during the American Revolutionary War. The hall donated its services and space for a hospital during the War of 1812. The Mason Hall also provided space for various religious groups and for entertainment. Eliza Poe, mother of Edgar Allan Poe, had her last performance at the Mason Hall.

A glance at the Masonic membership rolls shows quite a list of prestigious Richmonders. One name especially stands out—Chief Justice John Marshall. Marshall moved his family to the city when the capital of Virginia was moved to Richmond. Capitol Hill was surrounded by deep ravines, and next to the capitol building were long racks to tie up the horses. The Capitol Square's open commons was full of women drying laundry, children at play and pigs that roamed free. Richmond was still a rough, western trade town. Betsy Ambler, future-sister-in-law of John Marshall, remarked the town was full of the Scotch, small tenements and up-and-down hills; she was not impressed.

## CLAY STREET

*Named for Virginian Henry Clay, who worked in Richmond at the capitol
and read law under George Wythe.
He left Richmond in 1797 and headed toward Kentucky.*

Some of Richmond's citizens left and became quite prominent, such as Henry Clay. Clay was born in Hanover County, just north of the city, and studied law under George Wythe. After moving to Kentucky, Clay served in Congress and was secretary of state under President John Quincy Adams. Thomas

Jefferson and John Marchall studied law under George Wythe in Williamsburg. Marshall and Wythe attended the Virginia Convention of 1788. Wythe was a prominent politician before and after the Revolutionary War. In 1791, he moved to Richmond to be judge of Virginia's Court of Chancery.

## GEORGE WYTHE HISTORICAL MARKER

*Fifth and Grace Street*

Unfortunately, George Wythe died in 1806 from arsenic poisoning. His grandnephew, George Wythe Sweeney, was accused of having laced his uncle's morning coffee with the poison. Apparently, Sweeney was in financial difficulties and, as an heir to his uncle, saw a way out of debt. Unfortunately for Sweeney, Wythe realized what was happening and rewrote his will, leaving no money to his grandnephew. Wythe died from poisoning after a painful two weeks; a young male servant also died from arsenic. Sweeney was arrested for the death of his uncle but not convicted of the crime. The only witness to the act of poisoning was a Black female house servant, and the 1705 law prevented Black people, free or enslaved, from testifying. John Marshall mourned the death of his friend and colleague. Together they are honored by the Marshall-Wythe Law School at the College of William & Mary.

By the time the Marshall family moved to Richmond in 1785, he had served as a Continental army officer, was a judge advocate in 1777 and 1778 and had been admitted to the bar in 1780. President Adams nominated John Marshall to be chief justice of the United States, and he was confirmed in 1801. He served as chief justice for thirty-four years, and his court greatly influenced the fledgling United States and made the judicial branch a more powerful check and balance to the other two branches of federal government.

He was one of the great minds of the American courts, yet this man was best known locally as Richmond's worst-dressed citizen. A favorite John Marshall story begins at the Seventeenth Street Market with Marshall casually shopping. A stranger approached Marshall and assumed Marshall was a delivery man and asked him to carry home his purchase. Marshall accepted and carried the man's dead turkey to his home, and he never revealed his name. No one can recall if Marshall accepted a tip or not.

Marshall was fond of socializing with friends and colleagues and playing quoits, a game similar to horseshoes. Marshall was a member of a couple of quoits clubs. In addition to the game, the members enjoyed drinking mint

juleps and punch. Samuel Mordecai wrote Judge Marshall was rumored to throw a discus well and enjoyed playing at the Quoit Club at Buchanan's Spring, now the Carver neighborhood.

## RICHMOND PUBLIC LIBRARY MAIN BRANCH

*101 East Franklin Street*
*(804) 646-4867 | rvalibrary.org*

Richmond had other social clubs as well. The Amicable Society, started in 1788, helped people traveling through the area. The club was supported by the Female Humane Association and the Male Orphan Asylum and lasted over sixty years. The Library Society, run by librarian Thomas Nicolson, supplied books to the ladies of Richmond. They wanted access to the Minerva books published by William Lane in London. A majority of the books had female authors and were Gothic fiction and romance. Samuel Mordacci called the books "London Mint Trash."

## JOHN WICKHAM HOUSE

*1015 East Clay Street*
*(804) 649-0711 | thevalentine.org | Admission fee*

John Marshall presided over Aaron Burr's trial for treason. The trial brought many visitors to the city, including General Andrew Jackson and Washington Irving. The taverns overflowed with guests, and some people were forced to sleep in wagons and tents along the riverbank.

Aaron Burr was a well-known politician who served as vice president under Thomas Jefferson. During his term as vice president, Burr fought a duel with Alexander Hamilton, mortally wounding him. In 1807, Burr was charged with treason and sent to Richmond for trial. One of his lawyers was John Wickham (1763–1839). Wickham, a Loyalist, was a good friend of John Marshall and lived close to him. After the war, Wickham attended William & Mary and read law under George Wythe. Burr was acquitted of treason and left Richmond.

The nineteenth century opened with promise for Richmond, and many hoped for a change in the city's reputation of amusements and drinking

to a city of intellectual thought and economic success. Although in 1800 the city had a way to go, Richmond had one dentist—Peter Hawkins, a Black man best known to be a "tooth drawer"—three apothecaries and a few newspapers. Main Street still lacked sidewalks and paved areas.

In the early 1800s, the great excitement was the extension of the Kanawha Canal westward toward Lynchburg. George Washington had campaigned for a canal to connect Richmond with Ohio to open up western trade routes. The Kanawha Canal opened with seven completed miles that began at the Falls and headed west, dug with slave labor. By 1859, the canal tonnage exceeded 2,500 tons and carried more than the four railroads that came through Richmond.

One sign of economic growth was the opening of the first Bank of Virginia in 1804. The tobacco industry relied on the canal to bypass the Falls and transport the crop to the trading vessels waiting at the river docks. Richmond's tobacco industry grew from 655 employed in 1820 to the largest tobacco production market in the world by the 1840s. The industry included approximately fifty factories, two cigar factories and the various related industries such as box and label makers. Chewing tobacco had become quite the fad in 1810, and the product was a mix of tobacco and various cocktails that mellowed the flavor. Producers added spices, oils, sugars, rums and licorice. Rolled cigarettes appeared on the market after the Civil War.

The new Richmond Tobacco Exchange site opened at the corner of Virginia and Cary Streets on May 26, 1860. The exchange had been established two years prior. Tobacco served as a product and currency, and that led to the increase of tobacco production and products, which, in turn, created a greater need for workers. In the antebellum period, factory laborers processed tobacco by hand, and the tobacco industry remained a labor-intensive job. Tobacco was one of the top industries in Richmond.

The tobacco inspection warehouses were sharing more and more of the riverbank with the new flour mills and businesses. The growing population included a small number of immigrants from western Europe (Scotland, France, Spain, Germany, Holland). These newcomers brought with them the new technologies of the day and pushed (and received) new ways of transporting the factory and plant goods.

# COLUMBIA, 1817

*Philip Haxall Home*
*1142 West Grace Street*
*Private residence*

The success of the canal inspired entrepreneurs to look at hydropower, and by the time of the Civil War, Richmond was world-renowned for flour production. The flour mills lined the banks and canals of the James River. A Scotsman, David Ross, built the Columbia Mill in the early 1790s. Joseph Gallego (Spaniard) and his French brother-in-law Auguste Marie Cheavallie opened the Gallego Mill in 1796. Thomas Rutherfoord, Phillip Haxall, Edward Cunningham and William Byrd II all owned and operated mills along the river. The industry suffered setbacks as a result of Jefferson's Embargo Act of 1807 and the War of 1812 but grew during the antebellum period.

# MONUMENTAL EPISCOPAL CHURCH

*2224 East Broad Street*
*(804) 643-7407 | historicrichmond.com | Admission fee*

The Monumental Church was built as a memorial to the victims of the Richmond Theater Fire, which occurred on December 26, 1811. The fire consumed the theater and seventy-two people perished, fifty-four women and eighteen men, including a large number of the city's elite. The destruction stunned the city and the nation as the U.S. Senate and House of Representatives wore black crêpe to honor the victims.

The fire took place in the Richmond Theater, located at the site of 2224 East Broad Street, now the site of Monumental Church. Theater was popular with all classes of society, and patrons of all classes attended that night. The stage faced a semicircle of audience members sitting in the balcony boxes, including Acting Governor Smith and other ruling elites, while the lower levels and orchestra pit were filled with workers and slaves. The theater was built similar to other theaters of its time, with three exits: one backstage, one to the gallery and the main door that led to the parquet and boxes. The staircases that led up to the boxes were narrow single lanes.

Monumental Church, circa 1903. *Library of Congress.*

The Placide Stock Company performed, and as was customary at that time, the audience stayed after the show to enjoy the afterpiece. The afterpiece was either *Raymond and Agnes* or *The Bleeding Nun*. The fire broke out when a candle-lit chandelier caught one of the screens on fire. The fire spread quickly, and the audience rushed to vacate the quickly burning building. As box patrons realized their ability to descend the stairs was a feeble attempt at escape, they looked to the windows to jump. Most of the dead were located in the balcony boxes. The women's fashions created additional fire hazards and obstacles, as the garments prevented quick escapes. The trapped women represented the highest casualties.

Samuel Mordecai was outside witnessing the whole disaster since he had been unable to procure an evening ticket. He observed women jumping out of the second-story window, landing somewhat safely, only to be crushed by other women jumping out of the windows. Many inside and outside of the theater attempted to rescue people. Dr. James McCaw and Gilbert Hunt worked together to assist those jumping. Dr. McCaw coordinated the rescue from inside the theater, with Hunt on the outside. Dr. McCaw had been at the theater and was inside the burning building when Gilbert Hunt arrived to aid in the rescue. Hunt was a skilled slave, trained as a blacksmith, and he lived above his employer's residence. Hunt stood below the window and caught the women that Dr. McCaw dropped. Finally, Dr. McCaw jumped, but his clothes snagged on the metal and he dangled before falling. His injuries plagued him for the rest of his life.

Gilbert Hunt helped save numerous people but did not earn his freedom that night. He was able to purchase his freedom after his second heroic act, the penitentiary fire of 1832. Hunt worked with the fire captain to free the

iron windows by cutting out the brick. The captain used Hunt as a ladder to reach higher windows. After purchasing his freedom, shortly before the age of fifty, Hunt went to Liberia. Eventually, he returned to Richmond and resumed work as a blacksmith, living on the edge of poverty for the rest of his life.

The nation and the city mourned the deaths of theatergoers. Area shops closed, and the citizens were asked to wear black crêpe. Three days after the fire, the citizens held a mass funeral, and the dead were entombed on the site of the theater ruins. The city wanted to create a memorial to the fire victims, and victims' families had the option of burying their dead in one of the two mahogany boxes to be laid to rest in a single grave in the previous orchestra pit of the theater. The local Episcopal church proposed building a church on the grounds of the theater, and the city agreed. The victims of the fire were laid to rest in the crypt below the new Monumental Episcopal Church, built with funds raised by selling pews. John Marshall and Frances Valentine Allan (Edgar Allan Poe's adopted mother) each purchased one. Edgar Allan Poe attended church services on the very site where his mother's theater group, Placide Stock Company, had performed that fateful night. The church hired Robert Mills, the only architect student of Thomas Jefferson. Mills also designed the Washington Monument in D.C. and the Brockenbrough Home (White House of the Confederacy). Mills used theatrical themes and mosaics throughout the building. The cornerstone was laid on August 1, 1812, and the first Episcopal consecration occurred on May 4, 1814.

The simple marble urn monument, under the portico, has the victims' names inscribed on it. The list of names includes Benjamin Botts, age thirty-six, a member of the Aaron Burr defense legal team; Edwin Harvie of the Belvidere Estate; Abraham Venable, president of the bank; Governor Smith; five members of the Jacobs family; and numerous others. The names of the enslaved and free Black victims were also carved on the memorial.

Citizens reacted to the fire by blaming the lowering of morals in Richmond, and the fire was seen as an opportunity to correct society's ills. Richmond's theaters had a four-month prohibition on entertainment and were fined. Citizens were even asked to abstain from dancing for those four months.

The theater companies, the Placid and Green and Twaits, left the area and traveled to Norfolk. The theater companies boarded a boat, *Experiment*, which sank while sailing to Charleston. The theater troupe members survived. The Richmond theater scene slowly recovered, and by 1850, Richmond had become the entertainment capital of the Upper South. In 1850, at the Marshall Theater, Jenny Lind, a vocalist known as the "Swedish

Nightingale," performed. Her performance netted a profit of $12,000 (roughly $250,000 today).

Other types of entertainment existed in Richmond during the early 1800s, such as the Haymarket Gardens. The gardens were located between Sixth and Eighth Streets south of Arch and included the area between Byrd and Arch, Seventh and Eighth. The gardens' southern boundary was terraced land to the river. At Haymarket, patrons listened to musical entertainment, rode rides, played quoits or bowling and rode horses. The operator of the park was Major John Pryor. Major Pryor's wife, Annie Whiting, caused quite a scandal when she ran off with her French tutor, Jean Charles Frémon. Frémon was a French Revolution refugee hired by the major to give instructions to his wife. The tutor and the student fell in love and ran off. The couple had a son in Savannah, Georgia, on January 21, 1813, and they named him John Charles Frémont. He became a famous mapmaker and drew out the western lands. He ran for president in 1856 against James Buchanan. Today, the Haymarket Gardens would be located just east of Gamble's Hill Park.

Falling Gardens was another area of entertainment, located at Locust Alley to Fifteenth Street on both sides of Franklin. The special attraction was the bathhouse, which supplied both hot and cold running water for only two shillings and sixpence.

Men continued to flock to taverns for refreshment and conversation. City Tavern was well-known, and beer was the drink of choice. A popular conversation at the tavern was horse racing, a favorite sport for gentlemen. Richmond had spring and fall races, and race week was similar to a carnival with streets lined with pop-up shops. Taverns, boardinghouses and private residences filled with visiting race fans. The Race Ball was held in the Eagle's Ballroom, where the evening included old-fashioned English dancing and the Virginia reel. Today, Richmonder sports fans continue to flock twice a year to the Richmond Raceway for the NASCAR races.

Richmond's economy was affected by Thomas Jefferson's Embargo Act and the following Non-Intercourse Act. Much of the industry relied on trade with foreign nations, and the acts initially stopped and then limited shipping. Some items became scarce and costly during those few years; salt, sugar and coffee saw their prices per pound increase. Local residents turned to wearing homespun to support the boycott of British goods. City leaders floated the idea of raising money to make a cotton and wool factory, but that plan wasn't successful.

During the War of 1812, Richmond men served in various units, such as the Twentieth Regiment, and were sent to Albany to protect the frontier. All Richmond citizens were called into service in June 1813 when the Capitol Bell Tower rang out to alert the city residents of important wartime news. The British had attacked the Craney Island in Portsmouth and were thought to be heading to Richmond. The citizens prepared to defend the city, but the redcoats didn't arrive.

The immediate effect of the War of 1812 was the interference with trade, which resulted in an economic slowdown and the scarcity of items. Yet the long-term effect was positive growth of industry and transportation. Richmond was similar to the rest of the United States and saw flush times after the war.

# ANTEBELLUM

As the city's population grew and industries expanded, so did municipal services. A police station with a jail was erected at Broad and Sixth Streets. Shortly after, in 1817, the Union Hotel opened at the southwest corner of Nineteenth and Main Streets, the first true hotel in the city. The Union was followed by the Eagle on Main Street between Twelfth and Thirteenth and the American Hotel at Main and Twelfth.

The city's East Coast location made Richmond an ideal stop for visitors to tour the famous capital. In October 1824, Marquis de Lafayette visited Richmond, and citizens celebrated the return of the Revolutionary War hero with great cheer and excitement. A crowd met Lafayette's boat and followed him in an impromptu parade along Main Street to the Eagle Hotel. During the procession, Lafayette recognized a face in the crowd, his old military companion James Lafayette. At the start of the Revolutionary War, James was a slave from the New Kent Plantation. He asked his owner for permission to sign up, and the man agreed. James served Lafayette throughout the war. The two men grew close, and at the end of the war, Lafayette appealed to the General Assembly to grant James his freedom. The Assembly agreed, and James became a free man.

Marquis de Lafayette enjoyed a weeklong visit that included a proper parade, a public reception, a ball at the Eagle Hotel and an elegant dinner. At the dinner were the "Lafayette Girls," the most darling and beautiful young ladies in the area. Lafayette attended a service at Monumental Church

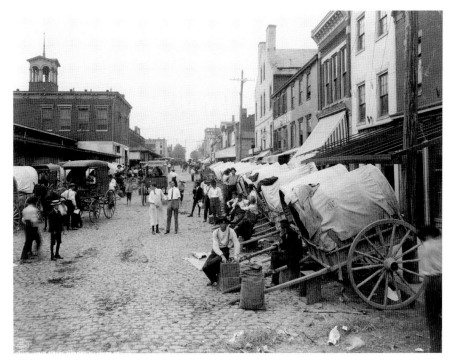

Sixth Street market, 1908. *Library of Congress.*

before he left Richmond. Although Lafayette enjoyed his stay in the capital city, he decided against sending a Richmond paper home to his wife because of the advertisements.

## OLD STONE HOUSE

*Edgar Allan Poe Museum*
*1914 East Main Street*
*(804) 648-5523 | poemuseum.org | Admission fee*

One of Richmond's most famous citizens, Edgar Allan Poe, was there to help celebrate Lafayette's visit. Poe was fifteen at the time, and he was second in command of the Morgan Legion and participated in events honoring Lafayette.

Edgar Allan Poe was born in Boston on January 19, 1809, and died in Baltimore in 1849. For part of his life, Richmond was his home. In 1811,

Stone house often identified as Washington's headquarters, circa 1900. This is the home of the present-day Poe Museum. *Library of Congress.*

his mother, Eliza Poe, was an actress with the Placide Company. While performing at the Masonic Lodge, she became ill and died. Edgar was less than three years old and was adopted by John and Frances Valentine Allan. Edgar explored the city and, as a teenager, performed quite a feat when he swam six miles up the James River, from Ludlow's Wharf to Warwick.

## ELMIRA SHELTON HOUSE, CIRCA 1844

*2407 East Grace Street*
*Private residence*

Richmond was also where Poe reportedly first found love; her name was Elmira Royster. Royster's father did not approve of Edgar, so the two of them met in Charles Ellis's garden. Ellis was John Allan's business partner. The garden occupied a city block and was across the street from Ellis's home on East Franklin Street. The lavish garden was full of linden trees and the perfect spot for the couple to meet.

## "TALAVERA," CIRCA 1838

*2315 West Grace Street*
*Private residence*

The young couple's relationship did not survive Poe's semester at the University of Virginia. Although he wrote Elmira, her father hid the letters.

By the time he returned from college, she was engaged to another man. Poe left Richmond and headed north. While he was away, he enlisted in the army and then quit with the help of his stepfather. After the army, he briefly attended West Point but dropped out due to financial difficulties. He moved to Baltimore and lived with his aunt and her daughter. When his cousin Virginia turned thirteen, they were married. He returned to Richmond in 1835 as an assistant editor with the *Southern Literary Messenger* but left two years later. Virginia died ten years later. After her death, Poe made a few trips back to Richmond, and on one of those trips, he and the widowed Elmira picked up their romance and made plans for a wedding. Poe tragically died ten days before the ceremony.

Another literary genius, Charles Dickens, and his wife visited Richmond in March 1842. They stayed at the Exchange Hotel. Similar to Lafayette, Dickens kept his true thoughts regarding Richmond to himself while in town. Once he was back on English soil, he professed he was not impressed with Richmond. Slavery, which Dickens didn't support, gave the city "an air of ruin and decay."

The nineteen-year-old Prince of Wales, later King Edward VII, visited on October 6, 1860. He enjoyed a banquet at the Exchange Hotel, spent the night at the Ballard House and attended services at St. Paul's Episcopal Church. Before leaving town, he toured St. John's Episcopal Church and Hollywood Cemetery.

Lafayette, Dickens, the Prince of Wales and other foreign travelers were probably aware of Richmond, Virginia, if not for the city then for the flour that was milled and shipped from the city. The canal and roads, such as Westham Plank Road, extended west and connected Richmond to the outlying farms. The improved transportation systems increased the amount of wheat brought to the city for processing.

## FLOUR INDUSTRY HISTORICAL SIGNS

*Richmond Riverfront Canal Walk*
*Twelfth Street*

The city's milling industry used the power of the river to mill the wheat into flour. The flour traveled all over the world; vast quantities of Richmond flour sailed around South America to the port of San Francisco. By the 1850s, almost all the flour in San Francisco came from Richmond. The flour mill

industry competed with that of larger cities. Even with fewer mills by more than half, Richmond's production levels were almost equal to Baltimore's in the late 1850s. The most successful mills were located between Hollywood Cemetery and the Mayo Bridge and took full advantage of the rapid pace of the water at the Fall Line. The mills exported almost 250,000 barrels of flour in 1831. At one time, Gallego Mills produced 900 barrels a day.

Gallego Mills was Richmond's largest mill and the largest physical plant in the world. Joseph Gallego (1758–1818) was born in Spain and arrived in Richmond in 1788. He started the mill around 1796. The mill changed location a few times due to either flooding or fire. Gallego Mill's manager Abram Warwick created new markets in Latin America and may have helped establish a coffee trade in Richmond as ships from Latin America returned with coffee after dropping off Richmond flour.

Haxall Mills filled around seven hundred barrels a day. Dunlop Mills took over the area where the original Byrd and Mayo Mills were located and built its own mills in 1852–53. The white workers employed by the mills tended to be recent Irish and German immigrants. The mill owned by John Bell, on Belle Isle, employed Oregon Hill residents as well as hired-out slaves.

## HEADMAN'S SQUARE

*Brown's Island*
*Statue dedicated to slave and free Black labor*

Richmond was able to expand into other areas of industry due to the support of the city council; the majority of members were businessmen. Manchester Cotton & Woolen Manufacturing Company was established in 1837 and was one of the first textile mills in the area. This factory also utilized water and its power from the Manchester Canal.

## TREDEGAR IRON WORKS

*500 Tredegar Street*
*(804) 649-1861 | acwm.org | Admission fee*

One of the most important industries in Richmond was Tredegar Iron Works. In 1837, Tredegar Iron Works opened, and in 1841, Joseph Reid

Tredegar Ironworks. *Photograph by Dan Palese Photographs*

Anderson was hired by Tredegar to run the company. By the 1850s, Richmond was the primary iron producer for the South, and Anderson had bought the company.

Tredgear began by manufacturing items for the railroad, such as spikes, car wheels and rail-connecting plates. The plant quickly grew as the iron industry grew and production soared. Talbot and Brothers Foundry built the first locomotive in Richmond in 1832. In 1850, a steam engine named *The Roanoke* was manufactured for the Richmond & Danville Railroad. Three years later, in 1853, Tredegar Iron Works had a contract for twenty locomotives. Railroads enhanced transportation from inland to the cities, and the industry thrived.

Anderson hired a mixture of freedmen, hired-out slaves and white laborers to work in the plant. Tredegar Iron Works also purchased and housed slaves, although at times the plant paid to house the slaves elsewhere. The white Tredegar workers lived in the wood-frame homes of Oregon Hill. By 1860, Tredegar claimed half of the $2.3 million total sales for the 1860 industry census.

# UNITED STATES POST OFFICE AND CUSTOMS HOUSE

*U.S. Fourth Court of Appeals*
*1000 East Main Street*
*The building is accessible only to those doing business in the federal courthouse.*

For a time, Richmond was the nation's largest manufacturer of tobacco and second largest in flour production. The tobacco inspection and trade industry grew to over fifty tobacco factories that employed white labor, freedmen and hired-out slaves. The commission merchants, the men who organized the storage, inspection, shipping and selling of tobacco, were mostly from Virginia and established business relationships with northern businesses. In 1858, plans were drawn by Ammi B. Young for a federal customhouse in Richmond. The building was constructed of local Petersburg granite quarried along the James River. During the Civil War, Jefferson Davis's office was in the customhouse. It was one of the few buildings that didn't burn down during the Evacuation Fire.

# VIRGINIA TELEPHONE MUSEUM

*713 East Grace Street*
*(804) 691-3498 | wcast.info | Contact for tour*

The industries relied heavily on the new railroad system that connected the interior lands to the docks along the James River. The city laid the first miles of track for the Richmond, Fredericksburg & Potomac Railroad in 1836 and had at least five railroad companies traveling through Richmond. Virginia had built 1,771 miles of track by 1860. Samuel Morse's telegraph lines followed the route of the Richmond, Fredericksburg & Potomac Railroad.

The industry and transportation improvements provided Richmond with opportunity to grow, economically and physically. By 1851, the streets had been renamed and were lit by gas fixtures. Public buildings and spaces existed from Church Hill to a couple of blocks west of Capitol Hill. Shockoe Bottom remained a rough area and still not a comfortable place for respectable women.

The rapid urban growth of cities throughout the nation left little room for trees and grass. Along with larger cities, Richmond also began to examine the creation of green spaces. In 1849, on the western side of Richmond, on a

Hollywood Cemetery. Davis plot in background. *Cook Collection, The Valentine.*

hilly overlook, the private Hollywood Cemetery opened. The cemetery was more of a park than a graveyard. The cemetery struggled to sell plots due to its proximity of the James River; people believed the bodies had potential to contaminate the water, and others believed the Falls were too loud and would disrupt the dead.

Richmond was like most other nineteenth-century urban cities but had its own unique stories and anecdotes. Punishment and entertainment came in many forms throughout the nineteenth century, and in one instance, Richmond combined them both into one event. In 1827, three Spanish men were charged with piracy and found guilty in Chief Justice Marshall's court. The sentence for piracy was death by hanging. Spectators lined the streets to watch as the convicted men rode to the gallows on their coffins in the back of a wagon. The men accepted their sentences, and the rope was looped around their necks. When the trap door dropped, two ropes broke and the two men fell to the ground. The seven-thousand-plus spectators gasped, as the men were still alive. The citizens had just witnessed a horrific botched hanging of two Spanish pirates. Only one pirate had been successfully

hanged. The two others were escorted back up to the gallows and stood next to their hanging fellow pirate. This time, the punishment worked, and the men were left to hang for an hour to make sure. After a proper burial, the bodies were dug up and shocked with electricity. Some people were curious if the popular new theory of shocking dead people actually brought them back to life. It did not work.

Dueling, to protect one's honor and character, continued in Richmond until the late 1880s. In 1847, Thomas Ritchie Jr., editor of the *Richmond Enquirer* newspaper, called the editor of the *Richmond Whig*, John Hampden Pleasants, a coward. The pair, their seconds and their doctors appeared in Manchester at the chosen site of the Mayo Mill for their duel. After both men fired and the smoke cleared, Pleasants was mortally wounded. Ritchie was charged with his death yet acquitted of the crime. One of the last deadly duels was fought over a fair maiden, "Mary." Apparently, Mary paid more attention to one suitor, John B. Mordecai, than would-be suitor Page McCarty. McCarty was jealous and wrote and published an unflattering poem with Mary as the topic. Mordecai came to her defense. Neither man's first shot hit the mark, but McCarty was successful on the second shot. Mordecai passed away five days later, and McCarty was charged with manslaughter. He was convicted and sent to prison, then pardoned due to ill health.

In 1854, Richmonders also experienced a thrill when a 23.75-carat diamond was found at Ninth and Perry Streets. The area was being leveled, and a workman, Benjamin Moore, found the gem. He sold it to Captain Dewey, who then sold it to the famous boxer John Morrissey. Morrissey paid $6,000 for the diamond.

# SLAVERY RECONCILIATION STATUE

*Fifteenth and East Main Streets*

Richmond's free Black and slave population lived and worked in the city. By 1860, the slave population had risen to 11,000, while the free population hovered around 2,500. Slave occupations and residences aligned with traditional male and female gender roles. The men typically worked in the industrial factories, including tobacco warehouses and flour mills and skilled trades, such as blacksmiths, carpenters, coopers, masons, wheelwrights and others. Male slaves were sent from the rural countryside

to the urban center by their owners to earn wages for the slaveholder. The factory and shop owners either acquired their slaves through the hire-out system or owned the slaves outright. A majority of factory owners were reluctant to house the slaves, so they paid for them to live elsewhere in rooms or attics.

Most men lived away from their slaveholders, while most female slaves lived in proximity to the people who enslaved or hired them. A majority of Black women were domestic slaves, and since domestic work centered on the home, most women lived in the house or in an outbuilding in the courtyard. Domestic slaves were also hired out. Slaves employed in the hire-out system earned wages, although most of the wages were sent to the master, and there was a little leftover to purchase few personal items and clothing. Some free Black residents were able to own their own businesses, such as barbershops, grocery stores, confectioneries, fruit shops and livery stables.

## EXECUTION OF GABRIEL HISTORICAL MARKER

*East Broad Street (on the I-95 overpass)*

In 1800, Gabriel Prosser, enslaved by Thomas Prosser, planned a rebellion for Richmond. Gabriel's master hired him out to various people in the city, and as a skilled worker, he had many job opportunities. This quasi-freedom brought him into more contact with people, possibly Haitian transplants who arrived with white slaveholders when they left the island and arrived in Tidewater. Gabriel and his accomplices may have heard about the successful Haiti rebellions.

## SPRING PARK

*2000 Park Street*
*Henrico County*

Prosser's plan was simple: steal weapons or tools to kill white citizens and burn down vital parts of the city. His plan included freeing and arming slaves and poor white men joining the rebellion. He rallied people close to the current Spring Park. Reports vary on the actual number of slaves, free

men and others who were involved, but unfortunately for Gabriel Prosser, the weather turned sour and rain flooded the roads into Richmond. The plan was pushed back until the following Sunday. While the men waited for the new date, two slaves revealed the plot to their master, who in turn informed the governor. Once the weather cleared, the slaves were rounded up and tried in the court of oyer and terminer. If the five justices of the peace determined guilt then the punishment was hanging. Gabriel Prosser eluded capture until September. When he was put on trial in October, he was likely the twenty-fifth person who had been tried for the rebellion. Prosser was found guilty and hanged at the site of the African American graveyard. He was one of at least twenty-seven people to hang. The event didn't end with Gabriel's death—the city leaders hung the bodies around town as a reminder of the punishment. The Richmond militia responded to a few more instances of slave rebellions in 1808 and 1809, but like most, the uprisings were unsuccessful.

Most slave uprisings never moved past the planning stages. In August 1831, in Southampton County, Virginia, seventy-five miles east of Richmond, a slave uprising moved beyond planning stages and was executed. Nat Turner and other slaves killed fifty-five white men, women and children before the rebellion was stopped and the rebelling slaves were captured. The state courts and local mobs killed over two hundred people they believed were involved in the rebellion. When Nat Turner was finally captured, he was hanged and then skinned.

The slave-owning communities grew more frightened of possible rebellions; therefore, additional laws and regulations were placed on the enslaved and free Black populations. By the outbreak of the Civil War, restrictions were placed on most aspects of their lives. All free and enslaved people had to carry identification papers, and slaves lost the permission to acquire work on their own through the hire-out system, although slaveholders continued to negotiate with businesses to hire out labor. They were not able to buy alcohol or own guns. An Ordinance Concerning Negroes, 1859, specified that slaves were not allowed to travel in carriages or walk across the capitol grounds without a white person present. The list of restrictions grew as needed to control the possibility of a slave uprising.

# HENRY BOX BROWN

*Metal reproduction of the box*
*Box Brown Plaza*
*1498 Dock Street*

One man had enough and decided to escape the horrors of slavery. Henry "Box" Brown was born about 1815 in Louisa County, Virginia. Henry was hired out in Richmond to work in a tobacco factory. Henry married Nancy around 1836, and they had three children. When she was pregnant with their fourth child, Nancy and the children were sold. Henry had just enough time to say goodbye to his family as they rode the wagons out of town. On March 23, 1849, with some assistance, he squeezed into a shipping box and was shipped to William Johnson in Philadelphia. For part of the ride, he rode resting on his head, but he arrived safe. In May, he spoke to the New England Anti-Slavery convention in Boston, and by September, his story had been published in a book. After the passing of the Compromise of 1850 with a stricter Fugitive Slave Law, Henry decided to leave and settled in England. He returned to the States in 1875 and died in Toronto on June 15, 1897.

Reproduction of the box in which Henry "Box" Brown escaped to Philadelphia. *Photograph by Scott Stowe.*

Nancy Brown was one of the 300,000 to 400,000 slaves sold in Virginia from 1800 to 1861. The city of Richmond was second to New Orleans in the nation for the largest slave market. The selling of slaves was a sizable portion of the Richmond economy, and in 1857, it was valued at $3.5 to $4 million. Most of the business of the auctioneers, speculators and proprietors took place between Fourteenth and Seventeenth Streets, from the James River to Broad Street. This area is currently under the I-95 overpass. In this vicinity, there were at least twenty traders, and five of them had offices at the Exchange Hotel on Auction Row on East Franklin between Fourteenth and Fifteenth and Lumpkin's Jail.

The enslaved arrived and departed at what is now the Ancarrow's Boat Landing at the Manchester Docks. They were walked along a three-mile route that followed the river to the Mayo Bridge. Once across, they walked up Fifteenth Street past the auction homes to a jail to be housed until the sale. The slaves were moved at night in order to not offend the citizens of Richmond.

## LUMPKIN'S JAIL

*East Franklin Street east of North Fifteenth Street*

The most infamous and well-known slave trader, Robert Lumpkin, set up a place in Shockoe Bottom. He had purchased the property from Lewis A. Collier, also a slave trader. After Lumpkin took over, the property became known as the Devil's Half Acre. The property included the main buildings, guest quarters, a kitchen, a tavern, an office and smaller jails, and the whole property was surrounded by a tall fence. The jail was used to house slaves prior to auction. Buyers were allowed to stay on the property.

Anthony Burns was a runaway slave who was captured and kept at the jail for many months. He had run away to Boston but was captured and returned to Virginia. While he was waiting to be sold, he lived in a six-by-eight-foot room with a bench and a coarse blanket. For most of the time he was there, he was shackled and fed once a day. His water supply was changed, at most, twice a week. Burns was sold to a farmer in North Carolina who accepted money from an antislavery society and set free. He worked with the society in New England and wrote his autobiography. He attended Oberlin University but then decided it was safer to leave the United States. He died in Canada in 1862.

# VIRGINIA UNION UNIVERSITY

<em>The Belgian Building</em>
<em>1500 North Lombardy Street</em>
<em>vuu.edu/about-vuu/history</em>
<em>The University's Fine Arts Center is open to the public.</em>

After the war, Lumpkin lived barely a year and left his property to his wife, a woman he had previously enslaved. She in turn allowed Dr. Nathaniel Colver to use the jail as a school for freed slaves. That same school eventually became Virginia Union University. Virginia Union's origins were in Lumpkin's Jail and evolved into the Richmond Theological Seminary. The seminary moved into the Union Hotel before settling at its current location. In 1899, Richmond Theological School of Richmond merged with Wayland College for women and became the private Virginia Union University.

Samuel Mordecai concluded, "It is to be hoped that this beautiful, patriarchal system will in spite of the mischievous and wicked interference of abolitionists, extend instead of being further contracted." That was not to be the case. Richmond was once again going to be thrust into the national spotlight as the nation went to war.

There are times of history in which relatively successful cities emerge as giants, much larger than others and even themselves. This happened twice to Richmond, first when Virginia's capital moved to Richmond during the American Revolution and then when Richmond became the capital of the Confederate States of America. The small tradepost had grown into an established worldwide trade network by the time of the Civil War.

# CIVIL WAR

## THE AMERICAN CIVIL WAR MUSEUM

*500 Tredegar Street*
*(804) 649-1861 | acwm.org | Admission fee*

Richmond, as the capital of Virginia, the midpoint on the East Coast, with the railroads and the industry of Tredegar, was of value to both the Union and the Confederacy. The city's value to the Confederacy was partly due to its world trade network and industry. The city had four banks and ranked thirteenth in manufacturing in the nation, included fifty-two tobacco factories, world-renowned flour mills, Tredegar Iron Works, brick kilns, lumberyards, textile mills and box and nail factories.

Initially, the majority of Richmonders were against secession, and at the Virginia Convention, the vote was 88–45 opposed. Even after Fort Sumter fell, leading Virginians held discussions with President Lincoln and were reluctant to join the Confederacy. The discussions ended when Lincoln decided to send in troops, and Virginians voted to leave the Union on April 19, 1861.

Richmond was unprepared for war and its role as the capital of the Confederacy. With the relocation of the Confederate capital, the city struggled to accommodate all three levels of government—federal, state and local—and the subsequent population growth.

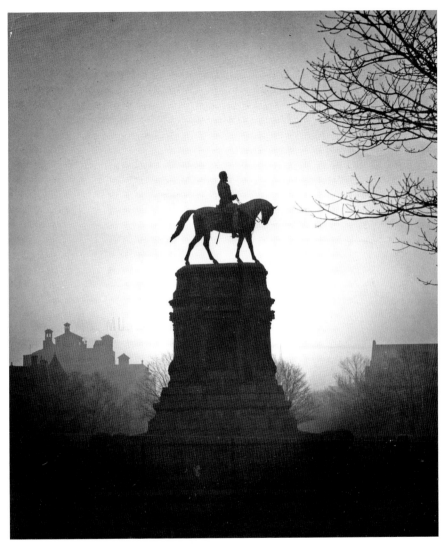

Robert E. Lee monument, 1948. *The Valentine.*

Richmond became the Confederate capital in May 1861, and the town grew in population and size almost overnight. The migrants represented many diverse groups: Confederate government officials and their families, Native Americans, war merchants, soldiers, wounded, refugees and thieves and pickpockets. The government officials and families inhabited the areas close to the capitol or on Church Hill. The refugees and laborers lived in overcrowded shanties along Shockoe Creek or the banks of the river.

# CONFEDERATE WHITE HOUSE

*1201 East Clay Street*
*(804) 649-1861 | acwm.org | Admission fee*

The former home of the president of the Confederacy is hidden among the many Medical College of Virginia (MCV) buildings. Remember to take your parking deck ticket to the museum for validation.

Jefferson Davis was inaugurated first in Montgomery, Alabama, and then again in Richmond. On that rainy day, February 22, 1862, George Washington's birthday, Davis was inaugurated at the base of a statue of Washington and surrounded by crowds braving the weather to witness the historical event. When Davis first arrived in Richmond, he was a guest at the Spotswood Hotel, at the southeast corner of Eighth and Main Streets. The home of John Brockenbrough, president of the Bank of Virginia, became the White House of the Confederacy. This Federal-style home housed the Davis family throughout the war. In this home, the Davises experienced the birth of a daughter and the death of a son, though Varina

White House of the Confederacy. *Photograph by Scott Stowe.*

Davis had no time to mourn her loss, as she filled her obligations by entertaining guests most nights.

Jefferson Davis's office was in the customhouse, located on Main Street and close to the War Department, which was located in Mechanic's Hall at Ninth and East Franklin. The original customhouse structure is now the five center bays of the U.S. Court of Appeals.

## STEWART-LEE HOUSE, CIRCA 1844–49

*707 East Franklin House*
*Private business*

Another new Richmond resident was General Robert E. Lee. On April 22, 1861, Lee arrived in Richmond and accepted the position of major general commanding the Virginia forces. His offices were located in the Mechanics Hall. Lee's first residence was also the Spotswood Hotel until 1864, when his wife and daughters moved to Richmond after Arlington was confiscated. The family moved into the home their sons had rented at 707 East Franklin Street. The house was built in 1844–49 by Norman Stewart, a tobacco merchant, and the Lee family resided in the home until shortly after the war. Mathew Brady's famous photographs of Robert E. Lee were taken at this building. Union soldiers protected the home from the Evacuation Fire and guarded the house until the Lees left for Lexington. The Home Builders Association currently occupies the building.

By March 1862, President Davis had declared martial law for Richmond and the surrounding ten miles. The law prevented the distillation, selling or giving away of liquor, and soon distilleries and saloons were closed. In three years, the population soared from 38,000 in 1860 to 100,000 by 1863. The city had immediate housing shortages, and when the wounded started to arrive, the city was short on beds. The city was stripped of trees and fences, and outbuildings all disappeared to fuel the camps and hospitals. The residents lived with the war daily for the duration.

Although no combat or full-blown attack occurred in Richmond, the land was altered and used for soldiers' camps, hospitals and fortifications surrounding the city. Camp Lee, named after Major General Henry "Light-Horse Harry" Lee III, was located on the site of the old Hermitage Fairgrounds on Broad Street, currently the Washington Football Team Training Camp. Monroe Square was also used for assemblies and drills,

and later the barracks were converted to a hospital to house five hundred patients. Richmond College was used as artillery soldiers' barracks.

Richmond, as the capital of the Confederacy and given its proximity to Washington, D.C., was heavily fortified. Battery No. 10 was built by slaves who were paid in soldiers' rations and medicine. The slaveholders were paid sixteen dollars a month per slave. Slaves performed most of the noncombatant tasks, building earthworks and laboring in the commissary, on railroads, in military hospitals and manufacturing. The Confederate outer fortifications were near Atlee Station, near the site of J.E.B. Stuart's mortal wounding, and circled southeast toward Cold Harbor. The fortifications turned southwest toward Fort Harrison and Petersburg. The Union troops attempted to attack Richmond and, in one instance, under the command of Colonel Ulric Dahlgren, made it to the western intersection of Three Chopt and River Roads. The Richmond Home Guard, made up of men over the age of forty, teens sixteen to eighteen and city workers, stopped Dahlgren from advancing. He was later ambushed near King and Queen Courthouse and killed—on him were papers that provided instruction to kill Davis and his cabinet. The papers vanished, and the sides disagreed whether the papers existed. Elizabeth Van Lew and her underground co-conspirators moved Dahlgren's body from the original grave to prevent the Confederates from desecrating the body.

# BELL TOWER

*Southwest corner of Capitol Square*
*Private*

The fear of Union invasion was commonplace and the bell tower on the capitol grounds provided warning of any possible attacks. Richmonders' war experience was similar to a city under siege as they struggled with the effects of war on society and daily life. The surrounding battles prevented trade in and out of the city, which led to shortages in food and supplies. Chimborazo and Winder Hospitals and Tredegar Iron Works planted their own gardens to supplement the rations. The dire food situation roused approximately five thousand citizens, mostly women, to participate in a Bread Riot on April 2, 1863. The initial meeting took place in Oregon Hill at the Belvidere Baptist Church. Mary Jackson, the unofficial leader, led the march to the Capitol Square, and women looted along the way. Mayor

Joseph Mayo and Governor Letcher attempted to calm the crowd with very little success. Historians differ on which man, Jefferson Davis or Governor Letcher, threatened to shoot into the crowd if they didn't disperse. The crowd slowly broke up and went away.

The women of Richmond fought a different type of war than the men who served. A few women dressed as men and fought on both sides of the war, but most women took on the role as protector of the family. Women throughout the South managed plantations, businesses and family in war-torn areas. Women and children migrated to cities in large numbers looking for safety, shelter and work. The women of Richmond had to contend with high inflation, scarcity of goods, wounded lying in the street, murder and robberies.

In Richmond, some women supported the war effort by their work in the local factories. Josiah Gorgas, Confederate chief of ordnance, employed women in various laboratories and arsenals. The Confederate States Laboratory on Brown's Island produced war goods such as ammunition, friction primers, percussion caps and other ordnance. Women manufactured over one thousand cartridges a day. In 1863, a horrible accident occurred at the Brown Island factory. Teenager Mary Ryan's job was to fill friction primers that were used to ignite gunpowder. One day she made a crucial mistake as she attempted to unstick a primer by hitting it on a table. The primer exploded, igniting additional gunpowder and munitions, resulting in the deaths of over thirty women and men.

As the war casualties increased, women's employment expanded beyond the factories and into government work and nursing. Women signed Confederate Treasury notes, sorted postal letters and performed other civil servant jobs in order to free up able-bodied men for the battlefield.

Confederate sympathizers Hetty and Jennie Cary lived in Baltimore and smuggled items into the South at the beginning of the war; they were referred to as the "Cary Invincibles." Hetty Cary moved to Richmond once people in Baltimore believed she was a Confederate sympathizer and married John Pegram, a brigadier general in Lee's army. He died three weeks later at Hatcher's Run. Another Cary, cousin Constance "Connie" Cary Harrison and wife of Burton Harrison, Jefferson Davis's private secretary, wrote her observations of life in town for the *Southern Illustrated News of Richmond*.

# BELLEVUE SCHOOL

*2301 East Grace Street*
*Public school*

Not all southern belles supported the Confederacy. Present-day Bellevue School was built on the site of Elizabeth Van Lew's home, which the city demolished in 1911. The home was originally owned by Dr. John Adams, son of the famous Church Hill speculator Richard Adams. In the 1830s, John Van Lew, Elizabeth's father and a northern hardware merchant, purchased the home and moved in with his family and fifteen slaves. The Van Lews were members of Richmond's high society and entertained their friends with performances from Edgar Allan Poe reading *The Raven* and concerts with singer Jenny Lind. After the death of John Van Lew in 1843, the home became known for harboring antislavery sentiment, and his daughter Elizabeth Van Lew became a Union spy.

Elizabeth Van Lew was born on October 15, 1818, to John and Eliza Baker, both northerners. Elizabeth was educated at a Quaker school in Philadelphia, and shortly after her return to Richmond, her father passed away. After his death, Elizabeth and her mother started to free their slaves. They also sold small land parcels to freed women at reduced prices. By 1860, their household had only two elderly slave women; the Van Lew women didn't free them in order to shield them from having to leave Virginia per the Manumission Laws. Elizabeth Draper, one of their freed slaves, gave birth to Maggie Lena (Mitchell) Walker in the home on July 15, 1864.

Van Lew was part of a Union spy ring that collected information from Union soldiers held in Richmond prisons. She was very resourceful; she carried messages in secret compartments, moved dead comrades and even hid a horse in her attic while Confederate soldiers searched her home. Her former slave Mary Elizabeth Bowser reportedly worked in the Confederate White House and reported to Van Lew.

After the war, President Grant awarded Van Lew's service by naming her postmistress of Richmond, where she served for eight years. She died in 1900 and was buried in Shockoe Hill Cemetery. Eleven years after her death, city planners tore down her home and built the Bellevue School.

Richmond's proximity to the surrounding battlefields was a factor in the location of the Union POW prisons and also factored in the numerous hospitals spread throughout the city. The city had as many as fifty hospitals ranging in size from private homes to the largest military hospital in the world. Most women, white, free and slave, worked in the hospitals.

# CONFEDERATE HOSPITALS' HISTORICAL MARKERS

*General Hospital No. 11, Nineteenth between Main and East Franklin Streets*
*General Hospital No. 12, East Franklin between Nineteenth and Twentieth Streets*
*Second Alabama Hospital, Twenty-Fifth, East Franklin and Main Streets*

The Confederate government ordered the construction of five general hospitals in Richmond. Wounded arrived by train after the First Battle of Manassas and continued to arrive in the city throughout the war. Camp Winder and Chimborazo Hospitals were built and were quickly over capacity. The city was dotted with hospitals located in tent cities in parks, private homes, universities, churches and empty buildings, and at times, the wounded covered the streets waiting for help. The medical facilities were strained after the Battle of Seven Pines when approximately 4,700 wounded arrived in the city.

The Confederacy's shortage of men to work as nurses provided an opportunity for women of all classes and races to find work in hospitals. Nursing became a chief occupation for women, although it was not the profession it is today. Some women, like Sally L. Tompkin, and her friends opened hospitals to help with the overcrowding. Tompkin's hospital, at Main and Third Streets, was in the home of her friend Judge John Robertson.

Camp Winder Hospital. *The Valentine.*

Tompkin was commissioned as a captain in the Confederacy, which provided her with the necessary supplies; however, she refused any income for her services. Her dedication to cleanliness resulted in the loss of only 73 men out of more than 1,300 treated in her hospital.

Women, free and enslaved, were a valuable resource at the hospital. White women worked as nurses and as domestics, and slave and free Black women worked the more menial jobs. The hospital employed freedmen and slaves as well. The men's jobs tended to be lifting, washing and carrying the patients.

The Confederate Winder Hospital was opened in April 1862 and quickly surpassed capacity with 4,800 wounded soldiers. Sibley tents, which housed ten men per tent, were added to house additional men. The ninety-eight buildings were located on 125 acres of farmland, just east of Byrd Park today. The hospital buildings included a dairy, bakery, icehouse, kitchen and barracks for employees.

## CHIMBORAZO HOSPITAL NATIONAL PARK

*3215 East Broad Street*
*nps.gov/rich/learn/historyculture/chimborazo.htm*

The famous Chimborazo Civil War hospital was built on the Chimborazo Hill, just east of Church Hill and on a bluff overlooking the bend of the James River. The name derives from the Ecuadorian volcano Mount Chimborazo. The hospital opened in 1861 under the direction of Dr. James McCaw, whose previous employment was chief surgeon at the Medical College of Virginia. The hospital treated over seventy-five thousand patients and had a mortality rate slightly over 9 percent, a figure unmatched until World War II. Dr. McCaw divided the hospital complex into five separate sections, each with a surgeon in chief, its own laundry, kitchen and bathhouse. The hospital had a central bakery and an icehouse. The *Chimborazo* canalboat sailed from Richmond to Lexington to gather supplies for the hospital. Dr. McCaw made sure the hospital had a garden and a field for goats and cows in order to have fresh milk.

Chimborazo Medical Museum. *Photograph by Scott Stowe.*

## GENERAL J.E.B. STUART'S DEATH HISTORICAL MARKER

*200 block of West Grace Street*

The Confederate medical staff worked hard to save as many lives as possible, but the lack of supplies and conditions interfered with those efforts. The death march song was said to have played all day long. The wounded General J.E.B. Stuart was brought to Richmond and died at his brother-in-law's house at 206 West Grace Street. The city was also hit with a smallpox outbreak and vaccinated all citizens, including the poor.

Richmond was a city barricaded by its own design and encampments, yet the citizens found ways to entertain themselves among all the death and decay. At the start of the war, the South was no longer a destination for theater companies since the uncertainty of war kept the theaters closed. When Richmond became the capital of the Confederacy, the theater companies reappeared. The theater was quite popular, and shows played most every night; even President Davis enjoyed attending the

performances. At the Marshall Theater, a lesser-known actor, John Wilkes Booth, performed. Booth, while not a member of the Richmond Grays, assisted in their mission to prevent men from freeing John Brown and he also witnessed Brown's hanging.

At first, General Lee was not thrilled by the dancing, but then he encouraged the dances as a stress reliever for his men. The citizens struggled to find some positives in a city destroyed by war, people had starvation parties where no food was offered and party clothes were made out of homespun. People had to contend with inflation as the Confederate dollar continued to lose value and inflation increased the prices of goods.

Richmond provided valuable resources to the Confederacy. One of the most important factories was Tredegar Iron Works, located along the north bank of the James River. During the war, Anderson's businesses grew to include coal mines, tannery, shoe-making shops, a sawmill, a fire brick factory, farms and herds, nine canalboats and one blockade runner. He was quite prepared for the business of war, even stockpiling cotton to sell after the conflict's end. Tredegar supplied the Confederacy with much-needed ammunition, such as naval mines, rifled cannons and armor plating for the CSS *Virginia*. Of Tredegar's labor force of 2,500 men, 750 were slaves or freedmen and they produced over 1,100 cannons and 90 percent of Confederate cannonballs and shot. Tredegar supplied iron to Rocketts and Graves Navy Yard to build ships for the Confederacy. Together they produced over eleven vessels, including the first of the ironclads, the *CSS Richmond*, at Rocketts Navy Yard in July 1862, and the CSS *Virginia II*, built at the Graves Navy Yard in 1864.

When the fall of Richmond began, Anderson staged his workers around the plant to protect it from vandals and from the Evacuation Fire. The factory survived, and when his stored cotton sold for $160,000, Tredegar was able to continue after the war. Anderson had shipped cotton overseas for storage prior to the war, similar to Lewis Ginter and a few others. This ensured the men would have money after the war, regardless of the outcome.

Tredegar and other local industries benefited from the five railroad lines that carried goods in and out of the city. By 1865, the only railroad left was the Richmond & Danville running to the southwest. The numerous train tracks had provided a simple solution for where to house the Union prisoners of war (POWs). Richmond's proximity to Washington, D.C., made the Confederate capital city an ideal place to hold the POWs until they were traded for Confederate soldiers. Once General Ulysses S. Grant stopped the prisoner exchange, the prison population grew and jail conditions worsened. The

Confederacy placed the POWs into prisons according to their rank; officers were sent to Libby Prison, and the enlisted were sent to Belle Isle. Neither prison provided enough basic necessities for the number of men housed.

Confederate prisons were located near the river. The infamous Libby Prison was located across the street from the current Virginia Holocaust Museum. The prison was taken down and became a museum in Chicago in 1889. The museum was a popular attraction during the World's Columbian Exhibition in 1893, although the building was not associated with the fair. Eventually, the building was torn down and the bricks distributed. In 1861, the warehouse was confiscated, and soon, the first prisoners arrived in March 1862. The prison's name came from Luther Libby's warehouse sign; the sign was not removed, and the name stuck. The prison's three separate buildings were connected by inner doors. The prisoners were kept on the top two floors, and the bottom floor contained the hospital, kitchen and offices and also housed slaves. The officers fared slightly better than the enlisted men since they were housed in a building with some protection from the elements, although the windows had no glass. The rations were paltry, and the food sent from the North for rations was not always given to the POWs. The prisoners complained of the summer heat, winter cold and the uncomfortable surroundings. The prison did not have bunks, so the men crowded on the floors in rooms filled beyond capacity. The men suffered from lice, hunger and diseases, such as dysentery and typhoid pneumonia.

In February 1864, over one hundred prisoners tunneled their way out of the prison. The men had dug for weeks to reach beyond the Confederate sentries, and almost half the escapees made it to the North. Toward the end of the war, the Libby prisoners were transferred to a new prison in Macon, Georgia.

## BELLE ISLE, JAMES RIVER

*The main access to Belle Isle is by pedestrian footbridge from Tredegar Street on the north shore and walking under the Lee Bridge.*

The trains delivered the prisoners directly to Libby Prison for processing, and the men were then assigned their locations. The enlisted men were sent to Belle Isle Prison, a four-acre open site. When exploring the island, a modern-day traveler might see the many past uses of the island: a granite quarry pit, a power plant, an iron milling factory and an iron foundry.

James River looking west. In the background is the pedestrian footbridge from Tredegar Street to Belle Isle. *Photograph by Dan Palese Photographs.*

The POW camp was open to the elements so the Confederacy purchased nearly three hundred Sibley tents to house the men. Unfortunately, the tents were unable to accommodate all the prisoners, who ranged in number from eight to ten thousand daily. The prison did not have walls to prevent escape, but an eight-foot trench and dirt berm surrounded the area. If a prisoner jumped the trench and touched the berm, he was shot. While some say this was the origin of the word *deadline*, the term was more associated with the Andersonville Prison. The lack of shelter and rations caused many men to become ill and susceptible to diseases and eventually killed some. The actual number of men who died was disputed between the North and the South; some prisoners noted upward of fourteen to twenty men dying per night during the winter months.

Richmond had two other prisons, Castle Thunder and Castle Lightning, which housed Southern prisoners. Castle Thunder was three separate buildings and held over 1,400 political prisoners and deserters. The prisoners were housed by gender, race and criminal offense. Across the street was Castle Lightning, which held Confederate soldiers and civilians. The prison closed in 1863.

As the war continued, the Confederacy showed deep strains when the government floated the idea of enlisting slaves to fight in the army. General Lee believed the slaves could earn their freedom in exchange for fighting in the war; the Confederate Congress thought differently.

By March 1865, food was scarce, although hard currency bought some commodities. The Spotswood Hotel changed from the early days of the war when Lee lived there. By the end of the war, the hotel had cut up the carpet for blankets and served meals on cracked dishes. The prison population increased as thieves stole food and martial law was enforced. The new Black recruits began drill exercises; one-third were free men, the others had slaveholders' permission to volunteer. Even Dr. McCaw at Chimborazo organized five companies of fifty-nine men each to protect the city.

# ST. PAUL'S EPISCOPAL CHURCH

*815 East Grace Street*
*(804) 643-3589 | stpaulsrva.org | Admission fee*

President Jefferson Davis sat in St. Paul's Episcopal Church on April 2, 1865, and waited for his turn for communion. As he sat there, a war department

messenger delivered a message from General Lee. Lee was abandoning the city of Petersburg, and it was time to evacuate Richmond. General Ewell was in charge of the evacuation and had orders to burn the bridges, cotton and tobacco warehouses, in addition to moving troops and weapons after the moon went down.

As the information spread, citizens packed belongings and headed out of the city. President Davis and others caught the last train out of the city and headed toward Danville in the hope the Confederacy continued the fight. Robert Lumpkin attempted to take his last fifty slaves to the Deep South to sell but was unable to leave town and returned to the jail with them. The city council had met and decided it was too risky to leave the stockpiled whiskey, so the decision was made to destroy it. Shortly after midnight, the morning of April 3, the whiskey was dumped and flowed down the streets.

Ewell ordered the fire at the warehouses, and shortly after, the wind intensified and fanned the flames and the fire spread. Flying embers landed on roofs and sailed through open windows. Citizens rushed to the open capitol grounds for fresh air and safety. The fire quickly grew out of control; from the Main Street business district to the river, between Eighth and Fifteenth Streets, was ruined, approximately twenty blocks. An estimated eight hundred to one thousand buildings were destroyed. The Confederates also destroyed arsenals and blew up ships to create obstacles in the river. The fire destroyed the toll and railroad bridges; the remains of old railroad bridge trestles are still visible in the James River.

The Union forces entered the town that morning, and by 7:30 a.m. the American flag was flying above the capitol. The Union troops immediately set out to help put out fires. Around 10 percent of the city was burned along with 90 percent of the business district. The slaves rejoiced and celebrated the Union troops, and the Black community continued to celebrate the day for a few years. The Union Army of Engineers built a bridge of pontoon boats to connect the city to Manchester.

Mayor Joseph Mayo and others surrendered the city at the junction of Osborne Turnpike and New Market Road; they had to sew coattails together to make a white cloth. Chimborazo was the only recorded meeting between Richmond Confederate and Union officers when the hospital was turned over to the Union.

# LINCOLN AND TAD STATUE

*490 Tredegar Street*

On April 4, President Lincoln and his son Tad arrived at Rocketts Landing. After disembarking the ship, they walked to the Confederate White House and Lincoln sat in Jefferson Davis's office chair. Lincoln gave a brief speech and then toured the burned areas. When Abraham Lincoln was assassinated, Richmond was draped with black cloth by the Union troops.

# RECONSTRUCTION THROUGH WORLD WAR I

## 1877–1918

The Evacuation Fires were still smoldering when Richmond faced the realization that the war was over. The business and financial districts of Shockoe Bottom and Shockoe Slip were destroyed by fire. Tredegar's one mill was the lone survivor of the destruction. Richmond's mill industry never fully recovered to the earlier prosperity.

Meanwhile, the city's residents faced the new reality of the end of the Confederacy. The evidence was everywhere: the burned buildings, wounded Confederates and the freedom of slaves. The Black urban population increased as freed slaves left the country farms and arrived in the city hoping for a better life. Many sought the assistance of the Freedmen's Bureau, located near Tenth and Broad Streets. The fifty-six bureau agents stationed in Richmond supported numerous schools for African Americans, including a high school. Richmond's first school for African Americans opened in April 1865, within days of Lee's surrender at Appomattox. Most of the schools started in church basements before acquiring or building a schoolhouse.

The success of the Freedmen's Bureau was partly due to the Virginia General District court refusing to ratify the Fourteenth Amendment. The Federal government turned the state of Virginia into a military district run by Union officers. The Republican-leaning Union officers supported and protected the African Americans' new freedoms, such as the right to vote. At least twenty-five African Americans served on the city council during the years 1865 to 1895.

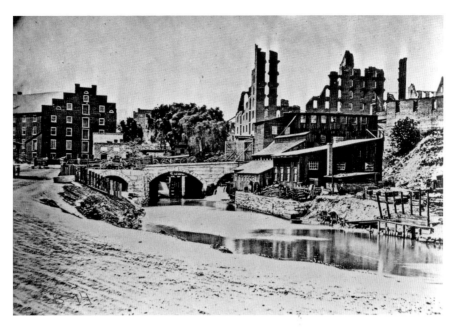

Haxall-Crenshaw Mills, Byrd and Twelfth Streets. *The Valentine.*

The unfamiliar territory of the Thirteenth Amendment, abolishment of slavery, led to some adjustments in social norms. The horse-drawn streetcars were back in service, and the previous restrictions concerning slaves were no longer relevant. The African American community fought for permission to ride the streetcars and then fought against segregation. After protests, marches and arrests, the city council determined the first four streetcars were for white women and children, the next two cars were for African Americans and white men were allowed on any streetcar.

By 1870, the population of Richmond had reached roughly fifty-one thousand. Reconstruction was coming to an end, and the city leaders were anxious to remove the power from the Republicans. So anxious, they elected their own mayor, while the Republican leadership had elected their own mayor. The case of two mayors was sent to the Virginia Supreme Court of Appeals for a ruling. On April 27, 1870, the day of the decision, a crowd overflowed the balcony, and the weight of the observers caused the top floor of the capitol to collapse. The floor continued through the next floor and stopped on the level of the Hall of the House of Delegates. The accident injured over two hundred people and claimed the lives of sixty-two, including Patrick Henry Aylett, Patrick Henry's grandson.

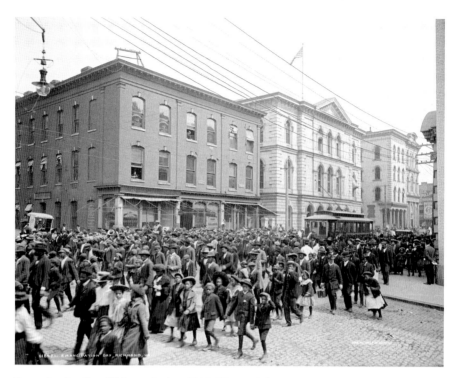

Emancipation Day, Richmond, circa 1905. *Library of Congress.*

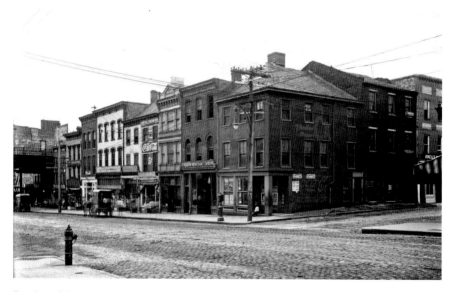

Southern Literary Messenger building at Fifteenth and Main Streets. 1913. *Cook Collection, The Valentine.*

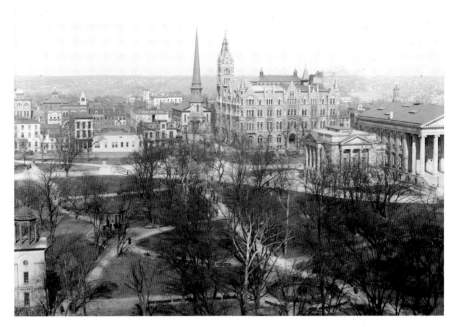

Richmond, circa 1900–15. *Library of Congress.*

Historians mark the year 1877 as the conclusion of the Reconstruction era, and by this date, all Southern states had rejoined the Union. The Thirteenth, Fourteenth and Fifteenth Reconstruction Amendments were ratified and added to the U.S. Constitution. The end of the Reconstruction era marked the beginning of the Industrial Revolution and urban growth, while also marking the lost advances of the African American population acquired under Republican rule.

Although the city was able to rebuild quicker than other wartorn cities, Richmond experienced a time of slow residential growth from the 1880s until World War I, and very little appeared to change.

## OLD CITY HALL

*1001 East Broad Street*
*(804) 646-7000 | richmondgov.com | Free*

In 1874, Richmonders demolished its city hall for fear the building would collapse like the capitol building. Construction began in 1886 and was

finished in 1894, $1 million over budget. The Peterburg granite used in the construction was from local quarries.

The population of Richmond in 1870 was close to 52,000; by 1920, the population had almost tripled to 171,000. The city's informal organization and post–Evacuation Fire rebuild resembled the pre–Civil War era. Church Hill and the areas just west of Capitol Square were popular with the city's elites. The valley near Main and Seventeenth Streets was considered the "vice district," and saloons dotted the area.

The downtown saloons encouraged male patrons by offering "men-only" free or at-cost lunch; women were discouraged from visiting a saloon. Women had to pay for their lunch. Broad Street downtown encouraged female customers to come shop at the new department stores. Downtown quickly became the women's shopping district as the men continued to head toward the financial district located along Main Street.

## MILLER & RHOADS DEPARTMENT STORE

*Legendary Santa Claus*
*2626 West Broad Street*
*(804) 474-7062 | childrensmuseumofrichmond.org | Free to visit Santa*

In 1885, Webster S. Rhoads, Linton O. Miller and Simon W. Gerhart opened a one-room dry goods store on Broad Street on the Sixth Street block. The Miller, Rhoads & Gerhart Dry Goods Store was initially outside of the main shopping district of the city—that designation was Main Street—but the street's "climate" was not welcoming to female shoppers. The three men were initially headed south from Pennsylvania to open a store, and along the way, the train stopped in Richmond. The men took the opportunity to stretch their legs. After seeing the city, the three men decided to stay and open the store in Richmond. Shortly after, Simon W. Gerhart sold his business shares to the other two partners and left the area. The remaining partners renamed the store Miller & Rhoads (M&R).

M&R Department Store became the premier shopping store for the carriage-trade shoppers, the modern-day equivalent to the "ladies who lunch." Its rival, Thalhimers, was located on the adjacent block. Both department stores have closed, although the Miller & Rhoads legendary Santa Claus lives on at the Children's Museum of Richmond (downtown location). From the day after Thanksgiving to Christmas Eve, at the start

of every day, bells jingle to signal the approach of Santa, who arrives by coming down the chimney, a special delight for all to witness. This Santa is legendary because he can call children by name. Santa Claus goes up the chimney only once, and that is on Christmas Eve, when, "And laying finger aside of his nose, and giving a nod, up the chimney he rose." For the story of the department store and Santa Claus, see the author's 2001 book, *Miller & Rhoads Legendary Santa Claus*. There are other M&R books, but this one was the original and reveals no secrets.

## PUMPHOUSE PARK

*1627 Pump House Drive*
*jamesriverpark.org/project/pumphouse-park*

The modern-day traveler can explore the park on trails that lead to historic canals and an eighteenth-century canal archway that honors George Washington.

The city's infrastructure needed improvement, so in the 1880s the city constructed a new pumphouse, which drew water from the river and the canal

Byrd Park. *Photograph by Dan Palese Photographs.*

and pumped it to the Byrd Park reservoir. Wilfred Emory Cutshaw supervised the design and construction of the nineteenth-century Gothic Revival–style building, and he also worked on the Old City Hall project. Both municipal buildings used local granite. Cutshaw valued efficiency and created a dual-purpose building, including a dance hall in the pumphouse building. The dance hall was built on the floor above the pump machinery and was quite the place to go. After 1924, the pumphouse closed, and by midcentury, the machinery scrap metal was sold during World War II. There are current whispers about town that the pumphouse may reopen, possibly as a visitor center or the James River Park System offices and an educational center.

# FIRST TROLLEY CAR SYSTEM HISTORICAL MARKER

*Fifth Street 0.2 miles south of Leigh Street*

The city leaders sought to improve transportation between the city core and the new western neighborhoods. The early streetcar system, owned by the Richmond City Railway Company, covered only the downtown district. Horses and mules pulled the railcars over a four-and-a-half-mile track system.

At the request of the city leaders, Frank Julian Sprague arrived in Richmond in 1877. They tasked Sprague with developing an electric railcar system. If he was successful, Richmond would have the first electric streetcar system in the nation. Sprague had no prototype model and ended up behind schedule and over budget as he tried to find a system that worked. He donated some of his own money to keep the project alive. On May 8, 1888, the first electric trolley carried the first customers, with twenty-three cars on twelve miles of track. As the city continued to spread out from the core, the electric trolley system laid more track. The total track included slightly more than eighty miles.

The early electric trolley (streetcar) took five men to operate, and the car generated no less than seven horsepower. In 1902, the streetcar workers went on strike for higher wages and won. The following year, when the streetcar workers went on strike again, the transit officials resisted, and both sides prepared for a fight. In one incident, shots were exchanged on Lombardy Street, and a riot in Fulton left two dead. The mayor called in the state militia to break the strike.

The new electric trolley changed the city dynamics as the tracks expanded the city's boundaries with ease and a five-cent fare. The five-cent fare was

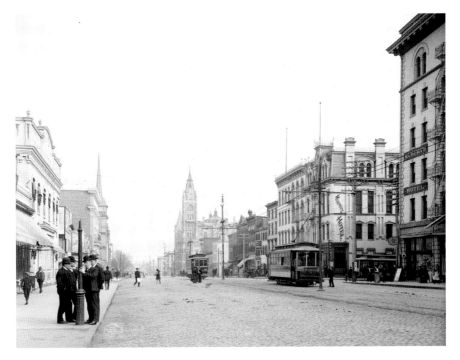

Broad Street, Richmond, circa 1905. *Library of Congress.*

too pricey for all Richmonders to commute from the city core to the new western and northern suburbs. The growth of middle-class salaries provided the needed income to live a greater distance from the job and to pay the fare. The new neighborhoods were filled with bank cashiers, insurance agents, teachers, middle managers and other white-collar professionals.

## CHURCH HILL TUNNEL COLLAPSE HISTORICAL MARKER

*North Eighteenth Street (U.S. 360) and East Marshall Street*

The Chesapeake and Ohio Railroad decided to build a 4,000-foot-long tunnel to connect Seventeenth Street to Rocketts Landing Docks. The construction began in 1872 and was completed in late 1873; it was the longest tunnel in the United States at that time. In 1925, the C&O Railroad attempted to repair the tunnel under Jefferson Park. The Church Hill Tunnel was dug to 190 feet when the tunnel collapsed. On October 2, 1925, Locomotive no. 231 was caught when the tunnel caved in. The cave-in killed four men; Tim

Mason's body was found at the throttle, and a fireman, Benjamin F. Mosby, died in a hospital from his injuries. The other two bodies were not recovered and left with the train when the tunnel was filled with sand and sealed.

The Industrial Revolution spawned an era of reform movements to correct societal ills that resulted from the industrialization. Richmond citizens also participated in reform movements, expecially the wives of clerks, skilled workers and proprietors.

Church women sponsored the first local meeting of the Richmond Woman's Christian Temperance Union. The meeting was held in the YMCA parlor in September 1882. The women's concerns were infant mortality, factory conditions, prisons and temperance. The temperance issue was hotly debated in the city. The skilled workers, mostly Protestant, supported pro-temperance reform, while German and Irish workers opposed the laws. The various temperance groups were successful, and in 1914, the state passed a referendum on the adoption of prohibition. The law went into effect in 1916.

## COLE DIGGES HOME, CIRCA 1809

*Preservation Virginia*
*204 West Franklin*
*(804) 643-7407 | historicrichmond.com*

Women were also a major force in the preservation of historic buildings. The Association for the Preservation of Virginia Antiquities (APVA) was founded by Cynthia Beverley Tucker Washington Coleman of Williamsburg and Mary Jeffrey Galt of Norfolk in 1889. The organization is currently known as APVA/Preservation Virginia and dedicated to preserving material culture, historic buildings and sites.

## THE EQUAL SUFFRAGE LEAGUE OF VIRGINIA
## HISTORICAL MARKER

*Crenshaw Home*
*919 West Franklin Street*

Richmond was fortunate to have Lila Meade Valentine (1865–1921); she is the only woman honored in the Virginia Capitol. Lila married Benjamin

B. Valentine in 1886 and fully embraced the role of reformer and worked tirelessly to help others. She started the Richmond Education Association (REA) in her home to raise money for a new high school. She also assisted in the founding of the Instructive Visiting Nurse Association of Richmond (IVNA), which helped lower-income residents. She co-founded the Equal Suffrage League of Virginia and worked tirelessly for the right to vote. She registered to vote from her sickbed and passed away on July 14, 1921, before she could cast her vote.

## GRACE ARENTS HISTORICAL MARKER

*Idlewood Avenue and South Cherry Street*

Grace Arents (1848–1926), Lewis Ginter's niece, was another reformer who left her stamp on the city and improved the education and health of many, especially in the Oregon Hill neighborhood. She established Arents Free School (the city's first free kindergarten) and Clark Springs Playground and donated funds to St. Andrew's Episcopal Church. Arents and Mary Garland Smith lived at Bloemendaal, a seventy-two-acre farm in Henrico. Arents lived there until her death, when the property was then donated to the City of Richmond. A provision in the will allowed Mary Garland Smith to live there on the farm until her death in 1968.

The city was slow to act on Grace's request to make a memorial garden honoring her uncle Lewis Ginter. The work on the Lewis Ginter Botanical Garden finally started in 1982. Lewis Ginter was well known and liked in Richmond, even though he was a Yankee. He financed and built the Jefferson Hotel and Ginter Park and donated to local charities and organizations.

Lewis Ginter (1824–1997) was born in New York City, and at the age of eighteen, he moved to Richmond. His earliest business venture was a toy shop. The success of that shop provided the funds to start another business. This time, Ginter and new partner John F. Alvey sold linens. The company was quite successful, and on the eve of the Civil War, Ginter's estimated fortune was over $1 million. When the war broke out, Ginter donated his wealth to the Confederacy and also volunteered for service.

The Evacuation Fire had left Richmond and his business destroyed. Luckily, prior to the outbreak of war, Ginter, like Joseph Anderson of Tredegar, bought tobacco and cotton and stored it to sell after the hostilities ceased. With those funds, he moved back to New York. In New York,

Ginter worked in the world of finance, and by 1873, he was a partner of his own firm.

After the Panic of 1873, Ginter returned to Richmond and moved into the field of tobacco manufacturing with partner John F. Allen. The two men initially sold foreign tobacco products but then converted to selling Virginia tobacco. The cigarettes were available in many different brands: Napoleon, Virginia Pets and others. Ginter designed the cigarette packages, and the designs included national flags, kings and rulers and actors and actresses. The cigarettes were popular, and the factory of skilled women and young girls produced two million cigarettes a day.

After Ginter's company merged with W. Duke Son & Company and became American Tobacco Company, he joined the philanthropist class of the late nineteenth and early twentieth centuries. He preferred to donate to his Richmond community and was quite generous. By the time of his death in 1897, he had given away most of his fortune.

Tobacco manufacturing continued to be the city's prime industry and survived the destructive years of the Civil War. White women of Richmond were hired to operate the cigarette rolling machines in the largest cigarette and cigar factory in the world.

Unfortunately, Richmond's flour mill industry was not so lucky. The industry was unable to rebound, and by 1900, the milling production in the area was inconsequential. Haxall Mills had failed by the mid-1890s and the Gallego Mill was purchased by another company and eventually closed in 1924.

# CHARLES S. MORGAN FOUNTAIN

*Shockoe Plaza*
*South of Thirteenth and Cary Streets*

Shockoe Bottom continued to be an important trade center, and horses hauled the inland freight. Charles S. Morgan donated a fountain for the draft animals' refreshment. Bowers Brothers exported fine flour and Virginia tobacco and imported coffee, tea and spices. The James River's shifting banks and sand prevented the city from resuming its role as a world shipping trade center. Instead, Richmond looked to the wholesale and distribution (jobbing) industry. By the 1880s, jobbing had become a major business and employed approximately twenty-eight thousand. The numerous railroads that convened in Richmond made this a worthy opportunity and profession.

Richmond grew into an important regional transportation center between Baltimore and Atlanta with six railroads running through the city. In the late 1890s, the Chesapeake and Ohio Railroad began construction on a viaduct from Lee Bridge to Fulton Railroad Yard. The viaduct followed the river and at Byrd Street formed the top layer of the Triple Railroad Crossing, the middle viaduct was managed by the Seaboard Airline Railroad and the Southern Railway was ground level. For a time, the American Locomotive Works had a Richmond branch that built locomotives and employed around three thousand workers. The plant was on Arthur Ashe Boulevard, just north of Broad Street. The Bow Tie Cinema incorporated part of the historic building into its theater.

## FULL CAST IRON FRONTS

*Stearns Block, 1869*
*Designed by George Johnson*
*1007–13 East Main and 1207–11 East Main*

Iron and tobacco industries dominated the economy, but other production, such as the paper box factory and Valentine's meat juice, contributed. The Valentine Museum is a treasure trove of Richmond history and memorabilia. The museum offers visitors many educational opportunities, various tours throughout the city, including the Wickham Home tour, and rotating

Ironwork, Court End. *Photograph by Dan Palese Photographs.*

exhibits in the galleries. For the researcher, the Valentine research library is truly a blessing; the knowledgeable and helpful staff work diligently to assist researchers. The museum has fulfilled the expectations of Mann Valentine Sr. when he donated the Wickham Home for a museum. Mann Sr. became a collector after his success as a businessman.

## THE VALENTINE MUSEUM

*1015 East Clay Street*
*(804) 649-0711 | thevalentine.org | Admission fee*

Valentine's wife, Ann, fell ill and was slowly starving to death. He was desperate to find a solution to fix her ailments and experimented with various formulas to find a cure. The solution was his formula of meat juices and egg whites. The tonic provided Ann with much-needed protein, and she soon regained her strength. Valentine patented the juice and sold the product worldwide. He trained all seven of his sons to go into the family business. When Mann Valentine Sr. died in 1893, he bequeathed his home and the Wickham house as museums.

As the industries grew, the workplace dynamic shifted under the Jim Crow discrimination, and occupations became more dominated by certain groups of people. African Americans, mainly male, dominated certain aspects of the tobacco industry. A small minority, less than 10 percent of the available jobs, were semiskilled positions in the tobacco industry and shoe manufacturing. Most Black men worked as laborers, teamsters, deliverymen, waiters and servants and were the lowest paid.

The Jim Crow South limited opportunities for Black citizens to engage in the city's economy or political system, and the white economy shut out the community. African Americans responded and created a separate economy centered on the Jackson Ward neighborhood, which thrived with Black–owned banks, businesses and real estate. Jackson Ward, in its isolation, was able to support the new growing Black middle class. This group of teachers, lawyers and others created their own societies and masonic lodges.

The city had become divided along racial lines. This was a change from Richmond's earlier neighborhoods and workplaces, which had a mixture of enslaved, free Black and white residents; residential areas were mostly divided along economic lines, not racial. After the Civil War and the Jim Crow laws, residential areas became divided according to race. Even Broad

Street was seen as a symbolic dividing racial line, Jackson Ward to the north and Lost Cause statues to the south.

Jim Crow segregation laws allowed white businesses to legally exclude or restrict African American access to retail shops and employment. The African American community created their own business to serve the needs of the people, and by 1907 there were over 453 Black-owned businesses. By 1920, that number had risen to 797. The businesses included hair salons, food and clothing stores, financial services and real estate, including stores to furnish homes. Most businesses tended to be small and showed little profit. Yet some businesses like the George O. Brown studios, Old Dominion Gallery, were quite popular. Brown's studio documented the lives of Black Richmonders for over seventy years. The Smithsonian and Chicago's DuSable Museum of African American History exhibited his photographs of daily life in the African American community. Brown's family continued the photography business for another sixty years after his death.

The African American businesses received assistance from fraternal orders and African American–owned banks. The African American–owned banks evolved from various fraternal orders, and these banks were limited to low-yield government bonds and real estate speculation. Fraternal orders supported the community by providing sick and death benefits to their members.

The fraternal order True Reformers chartered the first African American bank in Richmond. In 1882, William Washington Browne, founder of Grand Fountain of the United Order of True Reformers, was invited by the local Richmond True Reformers to come to the city to help organize a paid sick-and-death benefit. Browne was a firm believer in Booker T. Washington's ideas that the power of Black institutions led to greater equality.

The True Reformers were not able to deposit money in the local bank, so they asked a white shopkeeper for assistance. The shopkeeper agreed to store the membership dues in the store's safe. He grew alarmed when he saw the amount of money being collected by the True Reformers. The shopkeeper informed the group that this was too much money for African Americans. So, Browne and other True Reformer officers removed the money from the safe. They returned the membership dues, disbanded the fraternal order and opened a bank. With the guidance of Giles Jackson, an African American attorney, a charter was drawn up and the bank opened on April 3, 1889. The first day's deposits surpassed $1,200.

The bank survived until 1910, and during its existence, the bank owned numerous properties, including the fifty-room Hotel Reformer, located

on Sixth and Baker Streets. The Reformers managed the Reformers Mercantile and Industrial Association wholesale grocery store, but they did not own the business.

## JOHN MITCHELL JR. "FIGHTING EDITOR" HISTORICAL MARKER

*North Third and East Marshall Streets*
*Planet offices were formerly located on this block.*

John Mitchell Jr., editor of the *Richmond Planet* newspaper, founded the Mechanics Saving Bank in 1902, and it lasted twenty-two years. The bank dealt mostly with real estate loans and property ownership.

## ST. LUKE'S PENNY SAVINGS BANK

*900 St. James Street*
*Private building*

The most popular and successful African American bank was St. Luke's Penny Savings Bank, which was opened in 1903 by Maggie Lena Walker. In 1910, the bank separated from the order and was renamed St. Luke's Bank and Trust Company, which is part of Premier Bank today. As bank president, Maggie Walker continued to loan money for home purchases and stayed away from real estate speculation. The numerous African American banks helped homeownership increase from 368 residencies in 1865 to over 2,000 in 1920.

Jim Crow laws influenced the newly written 1902 Virginia State Constitution. Article II, the new poll tax and literacy test, was implemented to disenfranchise the African American voters. One year after the new state constitution was adopted, the number of registered African Americans in Richmond dropped significantly. Additional tactics included ballot tampering, with fake candidate names spelled similarly to the legitimate candidates in hopes of confusing people and splitting the vote. The disenfranchisement delayed city services to the neighborhoods of African Americans and the poor working-class whites.

In 1898, a few Richmonders served in the Spanish-American War. Two battalions of African American militias volunteered; the soldiers' supplies were provided by private citizens, as the state bore no financial responsibility.

The soldiers soon returned to Virginia, dissatisfied that they were to be managed by a white officer, and were sent to Macon, Georgia, to serve as support staff. Virginia's white regiments, the Richmond Blues and Grays, Companies H and M, were also ready to defend the nation. Similar to the African American troops, the white troops didn't see any battles, although a few died from "embalmed beef" and typhoid fever. Unfortunately not in time for the Spanish-American War, the Trigg Shipbuilding Company built the South's first torpedo boat in 1899, but the company closed by 1902.

# UNIVERSITY OF RICHMOND MUSEUM

*Joel and Lila Harnett Museum of Art and Print Study Center*
*Modlin Center, Free*

*The Lora Robins Gallery of Design from Nature*
*Boatwright Library, Ground Floor, Free*

In 1903, Westhampton Amusement Park closed, and the land was sold. A few short years later, University of Richmond's President Boatwright convinced the board to move the school to the area. A trolley brought the students from downtown to the campus.

Automobiles first appeared in Richmond in 1900, and by 1913, almost two hundred Richmonders owned automobiles. Automobile racing in Richmond began almost the moment the car was brought into the city limits, enthusiasts included men and women. To qualify for a race, one simply had to own a car. In 1910, a three-city endurance contest began and ended in Richmond. The participants raced to Washington. On the second day, they raced from Washington to Charlottesville, and the final leg was back to Richmond. The drivers and riders had a tough adventure, traveling on unpaved roads with well-worn wagon wheel ruts. In another endurance race, this one to North Carolina and back, one driver settled the car wheels in the worn-in ruts from the wagons and fell asleep. His travel companions were not aware the driver had drifted off until he stopped steering and the car left the ruts and crashed. Everyone was okay, but lessons were learned.

The Model T first appeared in Richmond in 1907 and cost approximately $850. The city's business leaders reached out to James Allen Kline and invited him to Richmond to start a car plant. In Pennsylvania, Kline and partners started a car company, and by 1905, they had designed and built

Westhampton Lake, University of Richmond. *Photograph by Scott Stowe.*

a model. The city offered him an area in Scott's Addition, just north of Broad Street along Arthur Ashe Boulevard. This fifteen-acre site, where the Greyhound Bus Station is now located, was the perfect spot to build his factory. The Kline Kar corporation produced approximately 2,500 vehicles. Only two Kline Kars exist today; one is exhibited at the Virginia Museum of History and Culture Center. The police had their first motor patrol wagon in 1907 and motorcycles in 1912.

When World War I began, Richmonders, both citizens and local industries, were eager to participate. The city's population grew as soldiers flooded the streets, either on their way, enjoying or returning from leave. Roughly 100,000 Virginians fought in the war, and nearly 4,000 died. Just south of Petersburg, the U.S. government purchased land for a new military camp, Fort Lee. The camp was quickly established and accommodated over 45,000 soldiers trained for war.

Local businesses and individuals also contributed to the war effort. The Kline Motor Kar Company converted to war industry production. The Richmond branch of the American Locomotive Company installed new machinery, and Tredegar produced shells and munitions. Local Red Cross volunteers made bandages, and Dr. Stuart McGuire left Richmond for France, where he was the head of Base Hospital 45. Some Richmond citizens exhibited the national sentiment of nativism and promoted anti-German bias by targeting persons with German ties. August Dietz, the proprietor of the successful print shop, Dietz Press, was socially snubbed due to his German birth. The Guardian Life Insurance Company was the new name of the previous Germania Life.

# SCIENCE MUSEUM

*2500 West Broad Street*
*(804) 864-1400 | smv.org | Admission fee*

The war slowed construction of the new Union Railroad Station on Broad Street, located on the grounds of the old state fairgrounds. New York architect John Russell Pope designed the neoclassical train station; his other Richmond project was the Branch House on Monument Avenue. Broad Street Station opened on January 6, 1919, and the last train left the station on November 15, 1975. Today, the station is home to the Science Museum of Virginia.

Science Museum of Virginia. *Photograph by Scott Stowe.*

Shortly before Richmonders celebrated the end of World War I, they battled the Spanish flu. The flu first arrived at Fort Lee in August 1918, and it quickly spread throughout the camp and up the road to Richmond. In September, the city leaders published pamphlets and posters that warned about the disease and provided some helpful ways to prevent it from spreading. By early October, the city was in full epidemic mode and had over two thousand cases of the flu. The decision was made to close schools and public places, such as churches and theaters, which reopened the following month. John Marshall High School became a temporary hospital, and Baker School was used as a hospital for African Americans. From September to the end of the year, some twenty thousand cases of flu had been reported, and close to one thousand people died of either influenza or pneumonia.

## CARILLON WORLD WAR I MEMORIAL

*Byrd Park*
*1300 Blanton Avenue*

Richmond celebrated Armistice Day with impromptu parades followed by a more official parade later in the day. In 1932, the Carillon World War I Memorial was built by the city to honor Virginia's 3,700 men and

Virginia War Memorial Carillon. *Photograph by Dan Palese Photographs.*

women who died in the war. The Carillon's opening day celebration had a parade with bands and the cadets from Virginia Military Institute and Virginia Polytechnic Institute and State University (Virginia Tech). The parade marched from the state capitol to the Carillon, where more than 15,000 people, including veterans, had gathered to celebrate the day. A short distance away, near the Byrd Park tennis courts, is a flagpole with a plaque that lists the 275 Richmonders who perished in the war. Byrd Park also contains a one-mile exercise trail, three small lakes and in-season pedal boats on Boat Lake.

# 1920-1930s

Richmond entered the 1920s optimistic about the future. The population had grown to 182,000 by 1924, and the city expanded in all directions, including up. Tall buildings were erected in downtown. In 1927, the city opened a municipal airport, named Richard Evelyn Byrd Field, named in honor of Admiral Byrd. He had recently flown over the North Pole. The opening celebration included Charles A. Lindbergh, flying the *Spirit of St. Louis*, circling the new field and landing to the cheers and applause of the large crowd.

Manufacturing and tobacco industries continued to dominate the local economy. Production facilities employed approximately thirty-five thousand people. Tobacco and connected industries accounted for over 20 percent of manufacturing output. In 1925, American Tobacco Company built an additional cigarette factory, and eventually, the company produced 100 million cigarettes a day.

New industries continued to arrive in Richmond. Albemarle Paper Company, one of the South's largest paper manufacturers, built Riverside Mills in Richmond. Pepsi Cola Corporation of Richmond bought the name, trademark and formulas for the sweet drink. The company manufactured the cola syrups, which supplied seventy bottling companies.

Some industries were not able to rebound after the First World War. The Kline Kar converted back to automobiles after World War I, but the skilled handwork needed for each vehicle quickly became too costly and the plant closed in 1923. The automobile market converted to the Henry

Vintage signs, Valentine Museum. *Photograph by Dan Palese Photographs.*

Ford–inspired assembly-line automobiles, and inexpensive cars flooded the consumer market. The same year the Kline Kar closed, two new transportation companies emerged in the city. The Yellow Cab Company purchased twelve new taxies, and Richmond Rapid Transit ran the first lines to connect the Fan with downtown. In 1926, the city put a traffic light system in place. Cities like Richmond slowly paved their streets, and by 1927, the city had one-third of all streets paved.

Americans' love for the automobile created a whole new world of travel and exploring. Tourists were invited to vacation and explore Richmond's many historical sites. In 1926, the National Editorial Association Convention in Los Angeles offered a Richmond Treasure Chest as second prize in a contest. The chest, made by Richmond Cedar Works, was filled with locally made products, including a handkerchief, hair dressing, chewing gum and, of course, cigarettes.

Richmond promoted itself as a tourist destination, especially for the Confederate veterans. At the intersection of Arthur Ashe Boulevard and Monument, a Stonewall Jackson statue was placed in 1919. In 1929, Matthew Fontaine Maury's was the last Confederate statue placed on Monument Avenue. Along Arthur Ashe Boulevard, the Confederate Memorial Institute, known as Battle Abbey, was completed in 1921. The following year, more

than six thousand Confederate veterans and others attended the United Confederate Veterans reunion. The last reunion was held in 1932.

As some Richmonders embraced and celebrated the past, others turned to the new world of movie palaces and luxurious department stores. The Roaring Twenties was a popular time for movies. The city buzzed with the newly built movie houses; they were glamorous and opulent in architectural details.

The nation had fallen in love with the movies, and a flood of new theaters were constructed throughout the 1920s—almost four thousand picture palaces sprang up in the United States. The decade started with the silent film era and ended with the advent of talkies. The live performance and vaudeville theaters struggled to compete against this new type of entertainment, although some tried.

## ALTRIA THEATER

*6 North Laurel Street*
*(804) 592-3368 | altriatheater.com*

In 1926, a new live performance theater was built on the west side of Monroe Park. The Shriners hired Marcellus Wright Sr. and Charles M. Robinson, Richmond architects, to design a structure to house numerous activities for the fraternal order. The corner lot at Laurel and Main Streets, just across from the southwest corner of Monroe Park, was chosen for the 176,000-square-foot structure. Construction for the Acca Temple Shrine, known as the Mosque, began in 1926. The building would include a 4,000-seat theater, a Wurlitzer organ with seventeen ranks of pipes, a bowling alley, a ballroom that held up to 3,500 and, in the basement, a swimming pool. The Mosque's theater presented plays, musicals and award ceremonies. On July 2, 1939, First Lady Eleanor Roosevelt attended the NAACP awards at the theater, where she presented the twenty-fourth Spingarn Medal to Marian Anderson. The people who attended the event filled the theater seats and spilled out into Monroe Park, where an estimated 4,000 people listened to the event through a loudspeaker. The following year, the Shriners' sold the building to the city. The theater's size was an obstacle for leasing out the space. It went through several restorations and is now part of the Richmond CenterStage Complex and called the Altria Theater.

Theater Row on Broad Street evolved from the early vaudeville venues of the 1920s. Jake Wells started by having the Old Theater demolished and

Altria Theater and Monroe Park. *Photograph by Dan Palese Photographs.*

built the Colonial Theater in its place. The movie theater held 1,900 tiered seats that faced an orchestra pit for fourteen musicians and an organ that cost approximately $21,000.

## THE NATIONAL THEATER

*708 East Broad Street*
*thenationalva.com*

A short distance away, in Theater Row, at 708 East Broad Street, the National Theater was built in 1923. C.W. Howell, designer, spared no expense when designing the interior in an Italian Renaissance style. Richmonder artist Ferruccio Legnaioli was hired for the marble and plaster work. The National's interior originally included an opulent marble staircase and seated 1,300 patrons. Howell's design probably didn't include plans for a haunted theater, yet rumors mention a ghost residing at the National. In 1928, a National vaudeville performer took his own life by hanging from the rafters. His ghost is believed to haunt the theater. His hijinks here included unscrewing the backstage light bulbs as quickly as they were put in. The theater still operates today with musical performances and comedians.

## CARPENTER CENTER

*Sixth and Grace Streets*
*dominionenergycenter.com*

Richmond was lucky to have a Loew's Movie Cinema. The cinema broke ground in 1927 and opened on April 9, 1928. The strategic placement of the theater between Miller & Rhoads and Thalihmers department store offset the physical location of being off Theater Row and located on Grace Street. The elite department store clientele gave the Loew's theater a higher status than other similar movie palaces. The theater's atmospheric style resembled a Spanish garden at night, including small lights in the ceiling for stars. John Eberson, architect, designed the two-thousand-seat theater at a cost of roughly $1.25 million.

Movie palaces and theaters were also built outside the city limits, although all of them today are now within the city limits. The Capitol Theater was located one mile away from Theater Row at 2525 West Broad Street and opened in November 1926. The following year, the Capitol showed *When a Man Loves*, starring John Barrymore. Warner Brothers labeled the movie "the first sound film for the studio," which was a little stretch since the company sent a pre-sound recording along with the film strip. The need for the orchestra or organ/piano man quickly became unnecessary. In 1928, the Capitol showed *The Jazz Singer*, the first "talkie." The theater was demolished in 1984.

## BYRD THEATER

*2908 West Cary Street*
*(804) 358-3056 | byrdtheatre.org*

For the connoisseur of 1920s movie palaces, the Byrd Theater is sure to please. The Byrd Theater opened in 1928 on Cary Street (then Westhampton Avenue) in a mixed neighborhood of retail and residential homes. Architect Fred Bishop designed an atmospheric-style French palace of the Empire period that included a gilded ceiling and a two-ton, five-thousand-crystal Czechoslovakian chandelier. The lobby included a Rococo eight-by-twenty-foot fish pool and fountain. The Byrd had only 900 downstairs seats and 596 (then 480) seats in the balcony, but the theater was a popular spot.

The owners have maintained the beauty of the theater, including many of the original objects and traditions. One favorite tradition is the Saturday night singalong accompanied by the mighty Wurlitzer organ. At the start of the evening show, now and then, the organ and organist rise from the orchestra pit to lead the singalong. Eddie Weaver, Byrd organist from 1961 to 1981, was a local celebrity; he also played live lunchtime music in the regal Miller & Rhoads Tea Room. The current Byrd organist, Bob Gulledge, was Weaver's student. The theater continues to raise funds for renovation.

## ROBINSON THEATER COMMUNITY ARTS CENTER

*2903 Q Street*
*robinsontheater.org*

Neighborhoods outside of the city built theaters during the 1920s, including the Brookland (1925) on the north side and Venus (1926) on Hull Street (south of the James River). A little while later, the Robinson opened in 1937 and was located in Church Hill. This venue, named after Bill "Bojangles" Robinson, was a theater for the African American community.

As the streetcar reached neighborhoods farther west, Grace Street, from First to Ninth Streets, became the Fifth Avenue of the Southeast by 1924. The smoothly paved sidewalks lined the fronts of the preferred shopping district of the carriage-trade shoppers. Antebellum homes were demolished to make room for businesses moving from Main Street to Grace Street. Richmond's department stores evolved into retail palaces, similar to Macy's in New York City and Marshall Field's in Chicago.

Miller & Rhoads Department Store had grown in popularity, and by 1924, it was ready for a new addition. The new addition occupied the entire Grace Street frontage from Fifth to Sixth Streets. The Christmas window displays were equal to Macy's in New York, and the seven shopping floors rivaled any New York or Chicago department store. Thalihmers, an M&R rival, was located directly across the street, and together, the two stores dominated Richmond shopping until the late twentieth century.

## MAIN BRANCH RICHMOND PUBLIC LIBRARY

*101 East Franklin Street*
*(804) 646-7223 | rvalibrary.org/about/locations/main-library*

A public library opened in Lewis Ginter's mansion at Shafer and Main Streets in 1924. Sallie Dooley, of Maymont, left $500,000 to the city for a library, which was built at First and Franklin. In 1925, the Phillis Wheatley YWCA opened a small library for the African American community.

WRVA, the first radio station in the nation, was in Richmond. The station was called the Edgeworth Tobacco Station and was owned by Larus and Brothers. The radio's power of 7,500 watts at peak made it the most powerful station. In 1966, WRVA was still ranked among the most powerful stations in the nation.

## *LOVING V. VIRGINIA* HISTORICAL MARKER

*Eleventh and Broad Streets*

Jim Crow laws, disenfranchisement and politics limited and restricted the growth of the African American population. Virginia passed the Racial Integrity Act of 1924, which outlawed interracial marriage. The act defined "white" as someone without any Black blood at all. In 1967, *Loving v. Virginia* overturned the act. White Richmonders created zoning ordinances that separated the races into different neighborhoods; the law prevented persons of different races from buying on the same street. That law was overturned in 1948 by the U.S. Supreme Court case *Shelley v. Kraemer*.

The city leaders' concern for white unity and tradition came at a cost to modernizing public services and structures. Jackson Ward suffered from neglect as the conservative city government followed Virginia senator Harry Byrd and his political friends' beliefs that centered on a low-tax, low-service economy. His success was partly due to the fact many Virginians were locked out of voting due to voting restrictions. The Harry Byrd political machine controlled the state for fifty years, beginning in the 1920s. In 1920, the African American community attempted to grab some political power when John Mitchell ran for governor, and Maggie Walker ran for superintendent of public instruction. They ran together on the Lily Black ticket. This was a symbolic gesture in an effort to bring awareness to the lack of voting rights for African American. Neither won the race.

Senator Harry Byrd's fiscal policy and the conservative nature of the Richmond city leaders slowed the effort to bring 1930s Roosevelt New Deal alphabet agencies to the state. In response to the slow action of the city government, Abe Tomkin, a member of the Socialist Party, arrived in town and motivated the African American community to march on city hall in protest. The 1933 march was met with fifty police officers, although no violence occurred. Tomkin was arrested and, upon release, left the area.

The conservatives' hold on Richmond slowed down federal aid when the Great Depression ripped through the United States. Virginia's economic state policy required the state to have a balanced budget, and Virginia leaders were not eager to take out construction loans to take advantage of the Public Works Administration. Luckily, the diversified economy of Richmond was in a better position than other areas, and the city elites' wealth was not all tied to the stock market, so business owners were able to expand during the 1930s. Even the local department store, Miller & Rhoads, saw very little difference in shoppers throughout the Great Depression and actually turned a profit and celebrated its Golden Jubilee in 1935.

Tobacco manufacturing supported the economy of Richmond and provided for thousands of jobs, not just limited to cigarette production but also in many related industries. Philip Morris & Company opened a cigarette factory in Richmond in 1929, and in the years from 1933 to 2939, it sold nine billion cigarettes. By 1940, the Richmond metropolitan area manufactured one-third of all cigarettes made in the United States. Manufacturing employment increased from 14,319 in 1933 to 18,326 by 1939, while the industrial production increased by 59 percent as the nation's overall production decreased by 16.7 percent. The DuPont rayon factory expanded as the demand for the material increased. Reynolds Metals Company moved from New Jersey to Richmond in 1938.

## EVERGREEN CEMETERY

*50 Evergreen Road*
*(804) 234-3905 ext. 105 | evergreen@enrichmond.org*
*Maggie Walker and John Mitchell Jr. are buried here.*

Even with the diverse economy and the increased market for cigarettes, unemployment in business reached 9 percent by 1932, partly as a result of the closing of sawmills and coal mines, and some local factories had to cut

shifts. The African American community felt the Great Depression before their white neighbors. Unemployment increased, and they were limited to unskilled jobs. In 1930, white residents held all city garbage collector and street-sweeper jobs. The 1930 Richmond Census recorded 115,000 white residents and 53,000 African American residents.

## BRYAN PARK

*Shelter No. 1 built by the Works Progress Administration*
*Azalea Garden is open to driving visitors from April 1 to May 15.*
*4308 Hermitage Road*
*friendsofbryanpark.org*

The state and city eventually worked with the federal government and some of the agencies. The Public Works Administration projects included the Lee Bridge, the Virginia State Library, Maggie J. Walker High School, an eighteen-story Medical College of Virginia building and the completion of the Virginia Fine Arts Museum.

The Civilian Works Administration hired 1,500 to 2,000 men to work in the city parks, playgrounds and cemeteries. In Chesterfield County, just south of Richmond, the Civilian Conservation Corps hired young men from the city and created a recreational area along Swift Creek. The area is now Pocahontas State Park. The surrounding Civil War battlefields were preserved with various federal workers and, when completed, were donated to the state. The state had no funds to continue the upkeep and turned over the battlefields to the National Park Service.

The city worked with the Federal Emergency Relief Agency to manage the Citizen's Service Exchange, which ran from 1932 to 1945, when it became the Richmond branch of Goodwill Industries. The program operated as a work-exchange program, where participants were paid with scrip that they could use to buy or sell work. A variety of services and products were used in the program such as shoe repairs, sewing rooms, firewood and medical and dental services. Not all was gloom and doom in Richmond. The Civil Works Service created an eighty-five-member concert orchestra and a sixty-piece band.

Prohibition had been the state law since 1914, but some Richmonders were keen on having their drink. Bootleggers' phone numbers were well known, although there were no known speakeasies in Richmond. The

Housing, Richmond, Virginia, twelve dollars a month for three rooms, circa 1938. *Library of Congress.*

speakeasy area was south of the river in Westover Hills. During a span of twelve months, in Richmond, over 2,000 people were arrested and police seized over 3,400 gallons of alcohol. Over the same period, July 1, 1929 to June 30, 1930, over 150 vehicles were confiscated.

Bootleggers were stationed throughout the city and even past the Prohibition era. In his history of Richmond, Virginius Dabney mentioned bootleg whiskey in the sarcophagus of John Marshall's grave. Even Governor Harry Byrd was forced to break the law when Winston Churchill came to visit in 1929. Governor Byrd was a "dry" and followed the Virginia Prohibition Act; however, he contacted his friends to find brandy for Churchill.

The city resorted to hiring a ten-man detachment, called the "Purity Squad," to find and destroy alcohol. The city received numerous complaints on the tactics of the squad but continued to employ them. National Prohibition ended in 1933 with the passing of the Twenty-First Amendment. Richmond's main bootlegger was named an inspector for the new state Alcoholic Beverage Control Board (ABC), the state's exclusive seller of alcoholic spirits. In 1935, Richmond was the first city that marketed canned beer. Bootleggers didn't completely disappear—Pine and China Streets, the "Corner," as it was called in Oregon Hill, was a well-known secret as the bootlegging hangout corner.

Richmonders could now pour their spirits, wine and beer and enjoy reading literature from local literary award–winning authors. Helena Lefroy Caperton (1878–1962) won the O. Henry Award in 1930, and Ellen Glasgow, Douglas Southall Freeman and Virginius Dabney were all awarded a Pulitzer Prize. Richmond had numerous other authors, such as Henry Sydnor Harrison (1880–1930), feature writer and chief editorial writer of *Richmond Times Dispatch* until 1910 and author of *Queed* (1911), *V.V.'s Eyes* (1913), *Angela's Business* (1915) and *Good Hope* (released posthumously 1931). Mary Dallas Street wrote *Summers End* (1936) and *Christopher Holt* (1946).

The last Confederate reunion was held in Richmond in 1932, and in 1941, the last Confederate veteran in the soldiers' home passed away. The worst of the Depression in Richmond was over by 1936, and the city once again picked up the pieces. After Franklin D. Roosevelt's National Bank Holiday, the Consolidated Bank and Trust Company was the first bank to reopen—the very bank started by Maggie Walker. Richmond only had one bank remain closed, the American Bank and Trust.

# WORLD WAR II

## VIRGINIA HOLOCAUST MUSEUM

*2000 East Cary Street*
*(804) 257-5400 | vaholocaust.org | Free*

When the Japanese attacked Pearl Harbor, Richmonders flocked to the movie houses to watch newsreels. The city and its citizens were once again ready to support a war effort. Richmond's various manufacturers supported the war effort by converting from consumer goods to a wide variety of wartime goods. Friedman-Marks Clothing Company made army and navy trousers, Reynolds-Metals produced items made of aluminum, Du Pont converted from rayon thread production to parachutes and gunpowder bags and Tredegar produced munitions. Du Pont and Reynolds-Metals plants were the two largest employers and ran their plants around the clock. Tobacco remained the number-one industry in the city, as American Tobacco's plants sold 87 million cigarettes in 1940 and 173 million in 1944. One-third of the nation's cigarettes were produced in Richmond.

As most production plants, businesses and universities supported the war effort, ordinary citizens and children participated as well. The Richmond Office of Civilian Defense assigned air raid wardens throughout the city and even allowed women to serve as wardens during daytime hours. The city held regular air raid and blackout drills. Richmond needed to have at least 2,300 active air wardens per the population. Even teens as young

Virginia Holocaust Museum. *Photograph by Scott Stowe.*

as sixteen were accepted to serve as warden messengers—of course, with written consent from their parents. The Civilian Defense helped and managed promotion of war bonds, air raid and block wardens and other support activities.

Citizens created various organizations and funds to support the citizens of warring nations. Local organizations—the British War Relief, Queen Wilhelmina Fund (Holland), America Relief for France and the Russian War Relief, to name a few—raised money and purchased items such as toys, food and clothing to be shipped overseas. The groups also sent money.

The women enlisted in the military (WASPS and WAVES), volunteered locally and worked in traditionally male occupations. Women worked as welders in the Richmond Engineering Company and produced bomb heads. The women's volunteer activities included organizing dances, nursing, nutrition and social work. Other women, as well as businesses, such as Miller & Rhoads, planted victory gardens to offset the hardships caused by rationing.

The city was teeming with young sailors—the *Richmond News Leader* estimated over thirty-four thousand servicemen visited Richmond each

weekend in 1943–44. Even the tony Jefferson Hotel housed soldiers, although the management removed and covered the stained-glass dome with mattresses to protect it from the rowdy young men. Most of the men arrived from Fort Lee, just south of Petersburg; others were from nearby the University of Richmond, where they received training as pilots in the navy V-12 program.

Popular wartime attractions were the USO dances and movies, and Richmond provided both. The *Richmond Times Dispatch* boldly stated that "Richmond had one of the best USO Clubs" in the country. The USO dances were held in two different venues: the white soldiers danced at the Mosque, and the African American soldiers attended dances and stayed at the Howitzers Armory on North Eighth Street. In 1943, the USO Club at 201 East Grace Street had an estimated attendance of forty-seven thousand per month. This club provided washrooms stocked with soap, towels, shaving equipment and showers. The young patrons were also supplied with stamps, writing materials, telephones, typewriters, games and a library. On Saturday mornings, over one thousand servicemen visited the USO coffee bar.

The movies were entertainment for all ages, and the youngsters preferred Saturday mornings to flock to the theaters to watch the weekly serials and westerns. During the war, movie theaters allowed children to donate tin cans for their price of admission. The adults also enjoyed the escape the movies offered, especially Friday and Saturday nights. The lines for the movie houses snaked around the block, and ushers spent time keeping lines separated by theater. A weekend show might start with a comedian or a dance routine, live music from the orchestra pit and then a singalong followed by the newsreel, all before the movie started.

In April 1945, Richmonders gathered in local churches to mourn the death of President Roosevelt. The businesses and entertainment venues closed down the afternoon of his funeral. At 4:00 p.m., a moment of silence was held across the city, streetcars and buses stopped and radios and telephones were quiet.

The following month, the city celebrated V-E Day, May 8, 1945. The downtown stores decorated their windows in a liberation theme. Richmonders celebrated the end of the war in Europe by attending church or impromptu parades. A few soulful veterans laid wreaths at the Virginia World Memorial Carillon.

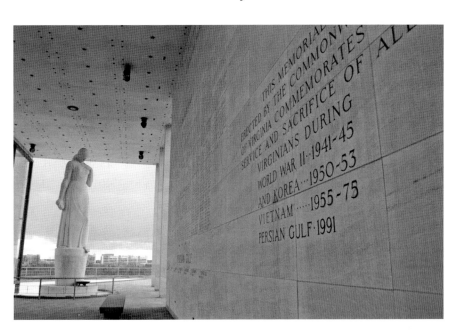

Virginia War Memorial. *Photograph by Dan Palese Photographs.*

## VIRGINIA WAR MEMORIAL

*621 South Belvidere Street*
*vawarmemorial.org | Free*

The Second World War finally ended in September 1945, and the state of Virginia had suffered over six thousand casualties. The Virginia War Memorial was built five years after the war as a way to honor the Virginians who died in service. The memorial has added names from additional wars, totaling more than twelve thousand service women and men. Standing guard over the names is *Memory*, a female figure in grief with an eternal flame at her feet.

# POST WORLD WAR II

The postwar Richmond city experienced new levels of modernity and social change. The South's first television station, WTVA, owned by Wilbur M. Havens, first broadcast on April 22, 1948. This was the first television station south of Washington, D.C., to broadcast and covered a large area of central Virginia, from Fredericksburg to North Carolina. The city's landscape was altered by a postwar modern world dominated by the automobile. The last electric streetcar ran in 1949 and was replaced by a bus system that easily transferred city residents downtown. The automobile provided the family the luxury of living even farther in the outlying areas and commuting to work. In 1973, Richmond's workforce composition included 44 percent commuters—this placed the city in the top percentage of commuters—beating New York City and Washington, D.C.

As residents moved to the suburbs, shopping districts moved from the city's downtown. Willow Lawn Shopping Center, Richmond's first suburban mall, opened in 1956 and shifted shopping from the Grace Street district. The mall's location was west of downtown and surrounded by residential housing. The mall provided entertainment for the whole family, and in addition to convenience, the newly built suburban malls and restaurants provided guests an air-conditioned environment.

The postwar city continued to struggle with racial divisions exacerbated by the Jim Crow era. In Richmond, African Americans gained rights slowly. For example, in 1943, African American teachers' pay was equal to white

Community Public Safety Memorial. *Photograph by Scott Stowe.*

teachers. The first African American policeman was hired by the city in 1946, and three years later, a female African American police officer was hired. In 1948, Oliver Hill won a seat on the Richmond City Council, which was the first time an African American had a seat on the council since 1898.

Born in Richmond in 1907, he attended Howard Law School and graduated second after Thurgood Marshall. Hill served as the head of the NAACP of Virginia's legal defense team. He partnered with Spottswood W. Robinson III to represent the plaintiff in *Davis v. County School Board of Prince Edward County, VA* (1951). Barbara Johns led a student walkout protesting the conditions of the school for African Americans in Prince Edward County, Virginia. The students filed suit arguing the Virginia law for separate schools was unconstitutional, and the Virginia Supreme Court disagreed. Hill and Robinson III appealed the ruling, and the case reached the U.S. Supreme Court. The court case was combined with other segregation cases and labeled by the first alphabetical one, *Brown v. Board of Education of Topeka, Kansas.*

# VIRGINIA CIVIL RIGHTS MEMORIAL

*Virginia state capitol grounds*
*Near the entrance to the Executive Mansion*

The integration of the South following the *Brown* decision was hampered by Senator Harry Byrd's Massive Resistance plan, which was in total opposition to public school desegregation and promised to withhold state money from integrated schools. Hill's firm filed lawsuits that opposed the legislatures efforts to continue segregation. Yet the General Assembly enacted the Pupil Placement Board, which created an application process to attend city schools. Parents filled out paperwork and noted the school choice, and the board decided on the school. This provided the white community the means to manage the schools' student population. Hill argued and won a court order to temporarily stop the practice in Richmond. In the 1958–59 school year, Richmond closed a few schools rather than allow integration. This practice was stopped by a federal judicial panel ruling against closing schools. The Virginia State Supreme Court ended Byrd's Massive Resistance.

In 1970, Judge Robert R. Merhige Jr. ruled for forced integration by busing students to schools outside of their district. This ruling made him the

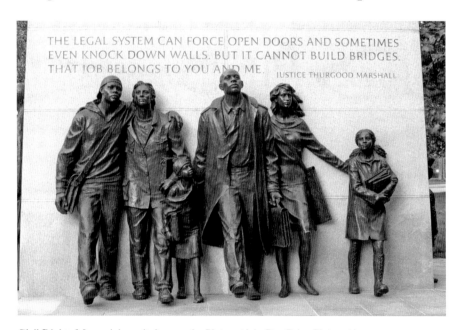

Civil Rights Memorial, capitol grounds. *Photograph by Dan Palese Photographs.*

most hated man in Richmond. The animosity extended to his dog, which was murdered. In the same year, Governor Linwood Holton showed his support for integration and walked his daughter to John F. Kennedy High School, a predominantly African American school in Richmond.

Although busing was tried and discontinued, the white student population continued to plummet, and by the fall of 2003, only 1,880 white students were enrolled in Richmond public schools, which accounted for only 7 percent of the total enrollment.

## RICHMOND 34 HISTORICAL MARKER

*Honoring the thirty-four students arrested at Thalhimers*
*Broad Street between Sixth and Seventh Streets*

The protest and fight to send students to better-equipped schools motivated and inspired other groups to push for their rights too. The NAACP relied on the assistance of the local community leaders and college students to organize and conduct protests. In February 1960, Virginia Union University's students protested the Jim Crow boundaries by staging sit-ins at lunch counters in Broad Street stores Thalhimers, Murphy and Peoples Service Drug. The students arrived well dressed and sat peacefully at the all-white lunch counters. The students continued the sit-ins, and the movement grew to include boycotting and picketing the stores. Ruth Tinsley, the wife of NAACP president Jesse Tinsley, was arrested while waiting for a friend outside of the Thalhimers Department Store. A policeman believed she was picketing and asked her to leave. When Tinsley refused to move since she was not picketing, she was arrested. The stores finally relented, and in August 1960, the lunch counters were desegregated.

## EBENEZER BAPTIST CHURCH

*216 Leigh Street*
*(804) 643-3366 | richmondebenezer.com*

The need to look outside of Jackson Ward for employment led to the realization that only one-quarter of the city's employees were African American and few were clerical or white-collar jobs. In 1963, the Black

community decided to protest the city's employment practices with a march. The crowd gathered at Ebenezer Baptist Church, which had housed the first free school for Black children in 1866. The crowd peacefully marched from the church and to city hall. Once there, the crowd stayed briefly and then returned to the church.

The following year, the Civil Rights Act of 1964 was passed; it brought integration to public spaces, restaurants and movie theaters. The act had a profound effect on the Jackson Ward community. Integration shifted the African American economy from Jackson Ward to predominantly white-owned businesses, where the Black community was now allowed to shop. The residents were no longer producers and owners; they were laborers and employees. In 1950, 50 percent of the African American workforce in Richmond was either in the service industry or a laborer. Shoe shining was a popular job among twelve-to-sixteen-year-old African American males, and the city issued 154 legal shoe shining permits. There were over 500 bootleg shoe shiners. The busiest corner was Fourth and Broad Streets.

Jesse M. Tinsley, president of the Richmond Branch of NAACP, and Roscoe C. Jackson, a member of the Democratic Voters League, worked together to increase the number of African American registered voters. By 1940, due to their efforts, the number of African American voters had increased by 50 percent, and eight years later, Oliver Hill was elected to Richmond City Council.

Following in their footsteps was the Richmond Crusade of Voters created by William S. Thornton, John Mitchell Brooks and William Ferguson Reid in 1956. The mission was to increase African American voter participation. They named the crusade the "Miracle of Richmond" and created a motto: "Each one reach one." The rallying cry was modeled after the antebellum tradition of "each one teach one." The crusade was a success, yet the success unnerved the Virginia legislature and they enacted the "blank sheet" registration. The legislators' reasoning was it provided a way to test literacy. The *Richmond Afro-American* and the *Richmond Planet* newspapers fought back with a program titled "Boomerang for Bigots." The program taught African American voters how to fill out the blank form.

The Crusade also sponsored the "Registration Tap Month" in 1956. A Crusade employee tapped a pedestrian on the shoulder, usually in Jackson Ward. If the person produced a voter registration card, the person was awarded one dollar. If the person had the voter registration card and poll tax receipt, the award was two dollars.

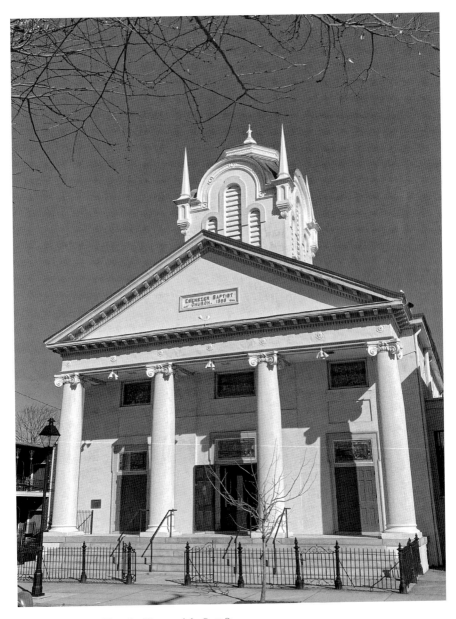

Ebenezer Baptist Church. *Photograph by Scott Stowe.*

# DOROTHY HEIGHTS HISTORICAL MARKER

*Hull Street Branch library, at the corner of Hull and Fourteenth Streets*

The interest in voting continued, and by 1962, seven of the nine candidates for city council the Crusade endorsed were elected. Richmond, fearful of losing the white political majority, started a long legal battle to annex surrounding areas. The borders between the city and the surrounding counties was a mixture of white working-class and moderate-income family homes. The city annexed Chesterfield County's land on the south side of the James River. The annexation battle combined with the inexpensive suburban homes created a white flight movement in Richmond. Pretty soon, the surrounding counties of Henrico and Chesterfield's population growth far surpassed Richmond's. The population of Chesterfield County increased by 76.2 percent in the 1950s and Henrico County increased by 104.6 percent, while the population of Richmond grew by 8 percent.

# L. DOUGLAS WILDER LIBRARY

*Virginia Union University*
*1500 North Lombardy Street*
*(804) 257-5600 | vuu.edu/library*

The annexation also changed the city government from a ward/district to an at-large system of voting. The new government system, along with the passing of the Voting Rights Act of 1965, which removed barriers to vote, provided African Americans the opportunity to regain their political voices. The result was the historic 1977 election of Henry L. Marsh as the city's first African American mayor. In 1990, Virginia became the first state to elect an African American governor since Reconstruction. The Honorable L. Douglas Wilder served as governor from 1990 to 1994.

L. Douglas Wilder was born in 1931 in the Church Hill neighborhood and graduated from Virginia Union University. After college, Wilder served in the army during the Korean War. Wilder considered returning to school to earn a master's degree in science before he became inspired by *Brown v. Board of Education* and decided to enroll in law school. In 1969, he entered state politics with a winning run for the Virginia Senate. In 1985, he ran and won the office of lieutenant governor, and four years later he ran for and was elected to the position of governor.

While the annexation battle raged, the city was battling for the destruction of a whole neighborhood. In the name of progress, the Fulton neighborhood was targeted for destruction with the intent to build an industrial park. This was the possible location of the Powhatan village where Christopher Newport and John Smith met with Chief Powhatan's son. James Alexander Fulton, an Irishman, purchased the land and built a home. The area grew popular for the Irish working class, and after the Civil War, African Americans moved into the area. By the 1960s, the Fulton neighborhood was predominantly African American of low to moderate income. Yet almost half of the residents owned their homes. The city moved forward and razed the area and left it empty for years before homes were rebuilt. Fulton has recently seen a rebirth with its proximity of the Virginia Capital Trail, the improvements along the riverfront and new residential condominiums.

The city of Richmond continues to change and adjust to the ways of the future. As of 2020, the city is no longer number one in cigarette manufacturing and continues the debate of renewal versus preservation, as exemplified by the current Navy Hill Development Project.

## RUMORS OF WAR STATUE

*Virginia Museum of Fine Arts*
*200 North Arthur Ashe Boulevard*

In December 2019, Kehinde Wiley's *Rumors of War* was permanently installed on the grounds of the Virginia Museum of Fine Arts. The statue was first unveiled in Times Square, New York City, before permanently moved to Richmond. The young African American man atop a horse is similar to the Confederate generals on Monument Avenue. Unknown to all, in the summer of 2020, all of the statues but General Lee would be removed (as of this writing). Wiley also painted the official presidential portrait of Barack Obama for the National Portrait Gallery.

*Rumors of War*, Kehinde Wiley. *Photograph by Dan Palese Photographs.*

# II.

# THE NEIGHBORHOODS OF RICHMOND IN MOSTLY CHRONOLOGICAL ORDER

Hollywood Cemetery. *Photograph by Dan Palese Photographs.*

# MANCHESTER

## FLOODWALL WALKWAYS

*101 Hull Street*
*Partly wheelchair accessible*

Manchester, or "Dog Town," is located directly across the river from Richmond. It was a separate city until it was annexed in 1910, although some residents say it was a merger, not annexation. When the English settlers returned to the area after the early problems of Captain Francis West and the hostile Native Americans on the north bank, they settled on the southern, more peaceful banks of the river. Although, the Anglo-Powhatan Wars of 1622 and 1647 almost wiped out the entire population of this and other settlements.

Manchester originally started out as Rocky Ridge and was owned by William Byrd II. He eventually owned over five thousand acres on the south bank of the James and was believed to have lived near Manchester prior to moving to Westover Plantation.

Coal was discovered in Midlothian (in present-day Chesterfield County) and brought to Manchester for trade. The colony's first railroad was a gravity-driven, horse-assisted line that connected the coal mines in Midlothian to the ships at the Manchester docks. In the late eighteenth century, the coal was shipped to states as far north as Massachuestts.

Flour Mills, Manchester. *Photograph by Dan Palese Photographs.*

The James River's ninety-foot drop created hydropower that was harnessed to turn machinery, and as early as 1732, grist and cloth mills were located in Manchester and the area grew. After William Byrd III's lottery in 1769, which included this area, the residents officially named their settlement Manchester, and the town added a hotel, tobacco factories and warehouses. The town was attacked again, but this time by Benedict Arnold in 1781 after he had switched to fight for the British.

## RICHMOND RAILROAD MUSEUM

*102 Hull Street*
*(804) 231-4324 | richmondrailroadmuseum.org | Admission fee*

This museum is a hidden gem in Old Town Manchester and is housed in the old Southern Railway Station. The station was built in 1915 and went through renovation in 2009. The model train exhibit is a treat for children and anyone who loves model trains. At the back of the museum are actual train cars that can be toured. The museum and walking tours are led by railroad enthusiasts with a wealth of knowledge about trains and Richmond. The Richmond Floodwall Tour is offered by the railroad museum and is a walking tour along the top of the floodwall (includes two sets of stairs).

The railroad industry was important to the economy of Manchester, the area long connected to Richmond by bridges. The Mayo Bridge, in 1788, was a welcome addition for the town of Manchester. Although the bridge charged a toll, it was a nice addition to the Patrick Coutts' Ferry. The area industries grew, adding three tobacco inspection stations and a few mills. The merchants and businesses soon moved across the river to Richmond following the decision to build a canal on the north bank. Manchester barely survived the loss of business, yet industry returned, and with hydropower, large flour mills were built. In 1853, Dunlop Mills was built and operated solely on water power. The mill produced the only flour capable of crossing the equator without spoiling. England and Scotland were also big markets for the Dunlop flour.

Other types of mills emerged in Manchester, such as cotton, paper and bone mills. The Old Southern Stove Works, founded in 1857, was still in operation almost one hundred years later as the Southern Steel and Stove Company. The pot-bellied stoves were still in demand by operators of boathouses.

# RICHMOND SLAVE TRAIL

*Manchester Docks Ancarrow's Landing to First African Baptist Church*
*rvariverfront.com/monuments/slavetrail.html | Free*

The modern traveler driving to Ancarrow's Landing, Manchester, can follow a road near the railroad museum that winds for approximately one mile to find a large parking lot with numerous spots available. This is the starting point of the Slave Trail. The Slave Trail is roughly a three-mile walking trail that starts in Ancarrow's Landing.

The Richmond Slave Trail follows the route enslaved people traveled from ships to slave auctions and holding jails. Ancarrow's Landing was the south bank offloading spot for slaves who arrived in Richmond for sale. The trail from Ancarrow's Landing to Mayo Bridge is lined by historical markers that tell these people's stories. At times, the trail narrows to the width of one person and there a few benches along the route. The Mayo Bridge, today as then, is busy and well worn. After crossing the bridge, slaves walked up Fifteenth Street and passed a couple of auction buildings. The current trail crosses the Mayo Bridge and then descends twenty-two steps to the Canal Walk. At this time, follow the Slave Trade markers in the sidewalks to the First African Baptist Church.

Manchester was incorporated in November 1769, and in 1871, the county courts were moved to Manchester, on the same site they are today. In 1910, the two cities, Richmond and Manchester, merged. The merger deal included allowing the courthouse to stay in Manchester. The city purchased the Mayo Bridge, removed the toll and provided free pedestrian access across the river. This free pedestrian access is now down the middle of the Manchester Bridge, also called the Ninth Street Bridge.

An unsung hero for the free pedestrian bridge hailed from Manchester, Ballard Edwards, an African American man born free in 1828. Edwards lived until 1881, and during his lifetime, he served the citizens as a politician and a protector. During Reconstruction, Edwards was elected to the Virginia House of Delegates in 1869, and he voted on the ratification of the Fourteenth and Fifteenth Amendments. He supported building a free pedestrian bridge in order to help the workers who traveled into Richmond for work. This free bridge, parallel to the modern Manchester Bridge, was constructed of iron and steel.

Manchester named its streets after War of 1812 military heroes: William Bainbridge, Stephen Decatur, Isaac Hull, William MacDonough, Hazard Perry, David Porter and Robert Stockton.

The Great Depression again brought hard times to this area, and the suburban sprawl after World War II did little to bring economic opportunities to Manchester. Recently, the area has seen a revitalization with new businesses, restaurants and residential buildings.

# SHOCKOE SLIP AND SHOCKOE BOTTOM

Trade began at Shockoe Slip, and settlement spread to Shockoe Bottom. The dividing line between the two neighborhoods is the I-95 overpass. The original town was located within the Shockoe Bottom area. The original boundaries are Dock Street heading north to Broad Street, Twenty-Fifth Street heading east to Fifteenth Street, the area under I-95.

## CHRISTOPHER NEWPORT CROSS

*261 South Twelfth Street*

Christopher Newport planted a cross at the Fall Line ten days after arriving in Jamestown; that original cross has since disappeared, and the exact spot where he planted it is unknown. A modern-day traveler can visit a replica of the cross at a spot close to the believed original location. The current location of the cross is on land once owned by the powerful Powhatan Federation and marks the most western spot of their territory. The land to the west was owned by the Monacan tribe.

A few hardy souls settled among the Natives and began trade, and by the 1670s, William Byrd I's trading post was quite profitable. The village grew, and businesses soon expanded to the other side of Shockoe Creek.

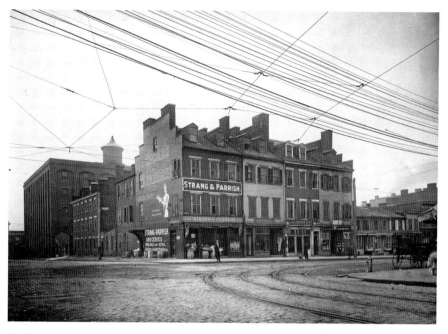

Southwest corner of Eighteenth and Main Streets, 1912. *The Valentine.*

## RICHMOND RIVERFRONT CANAL WALK

*Access points at nearly every block between Fifth and Seventeenth Streets*
*Handicapped-accessible entrances at Fifth, Tenth, Twelfth, Fourteenth and Sixteenth Streets*
*rvariverfront.com | venturerichmond.com*

Richmond quickly became a trade town and acquired a rough reputation, complete with a red-light district to entertain the sailors and dockhands. The riverfront was an active place with banks, homes, warehouses, taverns and such, very similar to the Main Street today between Seventeenth and Twenty-Fifth Streets. The area used to include one of the oldest continuously used farmers markets, which was established in 1780 by the same legislative act that created the Capitol Square. Today's citizens are hopeful that the city will build the promised vendor stalls and bring more vendors back to the market.

Canal on Byrd Street. *Photograph by Scott Stowe.*

## BETH AHABAH MUSEUM AND ARCHIVES

*1109 West Franklin Street*
*(804) 358-6757 | bethahabah.org*

Despite the coarse population, religious groups established themselves in Richmond in the eighteenth century. The Kahal Kadosh Beth Shalome, first Jewish synagogue in Richmond, located close to Fourteenth and East Franklin Streets, was organized in 1789. The Jewish Cemetery was between Twenty-First and Franklin and established in 1791.

The first Quaker meetinghouse, located at Nineteenth and Cary Streets, was organized in 1795.

## MASONS HALL

*1807 East Franklin Street*
*masonshall1785.org | Email to schedule a tour*

The oldest American Masonic hall still in use is located in Richmond. The hall was built in 1785 and was a meeting place for city leaders. The hall allowed religious groups to hold meetings there when they couldn't find anywhere else to hold services. During the War of 1812, the hall was utilized as a hospital. The Masons Hall survived the Evacuation Fire.

## JAMES CENTER

*Public Art Exhibit*
*901 East Cary Street*
*(804) 344-3232 | thejamescenter.com | Free*

The warehouses were vital to the economy of Richmond and the trade market. When Richmond became the capital, the population increased, businesses started and expanded and new industry and transportation systems emerged. The Bank of Virginia, on Bank Street, was chartered in 1804. The James River and Kanawha Canal's five locks connected the Great Basin and the Richmond docks. The Great Basin, now filled in, located under the current site of the James Center, provided vessels the

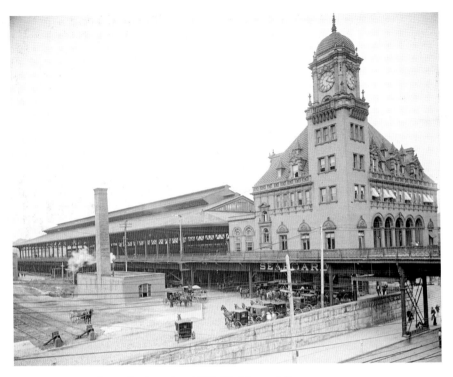

Richmond, Main Street Station, circa 1900–10. *Library of Congress.*

opportunity to come farther into the city to unload their cargo. In 1854, Tidewater Connection locks linked the canal basin to the east of the city's James River tidewater. The canal allowed seafaring boats to reach the city warehouses. The granite locks were fifteen by one hundred feet, and the ships were loaded and unloaded while inside the basin.

## OLD NEGRO BURIAL GROUND MARKER

*East Marshall Street 0.1 miles west of North Sixteenth Street*

The area adjacent to I-95 behind the Main Street Station and on both sides of Broad Street was the location of Lumpkin's Jail and the African Burial Ground; both are stops on the Richmond Slave Trail. The African burial ground may have started as early as 1799, and the site was also used as the city's gallows. Gabriel's Rebellion co-conspirators were hanged on

this spot. A historical marker on Broad Street for Gabriel is on the sidewalk overpass from Fifteenth to Sixteenth Streets.

## EMILY WINFREE'S SLAVE COTTAGE

*Behind Main Street Station*
*1500 East Main Street*

The small two-room cottage, currently stored on a trailer next to Lumpkin's Jail, was the home of ex-slave Emily Winfree. The home was paid for and provided by her owner and was originally located in Manchester. The home was slated for demolition, and the Alliance to Conserve Old Richmond Neighborhoods (ACORN) saved the building. Winfree lived in half of the house with her children and rented out the other side.

## PACE-KING MANSION

*205 North Nineteenth Street*
*Private residence*

A couple of blocks east is the Pace-King Mansion, located across from the Adam Craig House. The Pace-King house was built in 1860 by Charles Hill, who died shortly after completion. James B. Pace lived in the home in the 1870s, and Jane King resided in the home in the 1880s through 1890. King ran a successful wholesale and ice business from her home, which included a two-story slave quarters in the rear.

The riches of the slave and tobacco trade didn't trickle down to the residents. Main Street was still not paved between Sixth and Ninth Streets in the year prior to the Civil War. When the Confederate States of America was initially started by South Carolina, Virginia was not a willing participant. Virginia's economy had ties to both the North and the South. With the shots at Fort Sumter, Virginia seceded from the Union and joined the Confederacy. A short time later, in the early stages of the war, Richmond's location provided an ideal spot for the capital of the Confederacy. The Civil War altered the city landscape, as most of Shockoe Bottom and Slip burned in the Evacuation Fire.

# MAIN STREET STATION

*Virginia Welcome Center*
*1500 East Main Street*
*(804) 646-1862 | mainstreetstationrichmond.com*

The Evacuation Fire destroyed most of the buildings on Main Street between Ninth and Fourteenth. The city and residents had to rebuild the destroyed businesses and warehouses. In the 1890s, city leaders examined plans drawn by Wilson, Harrison and Richards of Philadelphia for a railroad station on Main Street. The site chosen was the location of Bell's Tavern, where Marquis de Lafayette dined in Richmond. On June 2, 1900, the first train departed the station, heading to Tampa. The station struggled financially and closed in 1975. In 2003, after a beautiful renovation, the station resumed operation as a passenger rail station.

The station is now home to a Virginia Welcome Center and staffed seven days a week. The building is worth dropping in to see the beautiful renovations.

Richmond Main Street Station. *Photograph by Scott Stowe.*

# SHOCKOE HILL CEMETERY

## SHOCKOE HILL CEMETERY

*Fourth and Hospital Streets*
*(804) 721-9675 | shockoehillcemetery.org | Free*

A visit to Shockoe Hill Cemetery on a scheduled tour would be the best way to explore and learn about its famous residents. Shockoe Hill was annexed by the city in 1786 and was initially part of the elite neighborhood that surrounded Virginia's new state capitol.

By 1820, St. John's Church cemetery had reached full capacity. The city created Shockoe Hill Cemetery, originally four acres that eventually grew to twelve acres, for the burial of white residents. Between 1820 and 1840, the elites of Richmond were buried here: Revolutionary War hero Peter Francisco, Chief Justice John Marshall, Edgar Allan Poe's adopted parents, first mayor Dr. William Foushee and Sarah Elmira Royster Shelton, Edgar Allan Poe's love interest. However, not all persons buried in the cemetery were celebrated citizens, some were more infamous than loved, such as Elizabeth Van Lew, Union spy and thorn in the Confederates' side. Shockoe Hill Cemetery remained active into the twentieth century and has approximately thirty-one thousand people buried here.

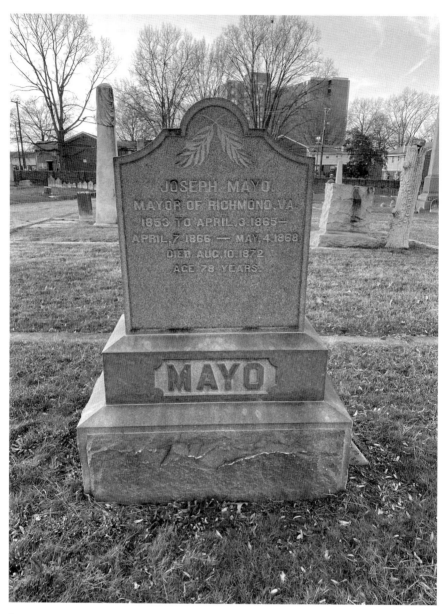

Joseph Mayo, Shockoe Hill Cemetery. *Photograph by Megan Thrower.*

# HEBREW CEMETERY

*Fourth and Hospital Streets*
*Contact Beth Ahabah Museum and Archives for cemetery tour information.*
*1109 West Franklin Street*
*(804) 353-2668 | bama@bethahabah.org | Donation*

The Beth Ahabah Museum provides wonderful exhibits and archives on Richmond's Jewish history and culture. In 1789, the Kahal Kadosh Beth Shalome was established, followed by the Hebrew Cemetery in 1816–17. By 1822, the first Virginia synagogue had been built on Mayo Street. Although Jews had lived and worked in Richmond since the 1760s, anti-Semitism persisted. During the Civil War, the northern Virginia Confederate military cemeteries refused to bury the Jewish Confederate soldiers, so their bodies were brought to the Hebrew Cemetery in Richmond and buried in side-by-side plots. The Hebrew Ladies Memorial Association raised funds for the grave markers and an iron fence that surrounded the graves. This section

Soldiers' Section of Hebrew Cemetery. *Photograph by Megan Thrower.*

of the cemetery is known as Hebrew Confederate Cemetery and is the only Jewish military cemetery outside of Israel.

The Second African Burial Ground was located directly east of the Hebrew Cemetery and next to the poorhouse. There was thought to be over twenty-one thousand unmarked graves from around 1835 until 1879. Some of the bodies were used by the students at the Medical College of Virginia, a common occurrence near medical schools. The cemetery grounds are now under an abandoned gas station.

The almshouse or poorhouse building on Hospital Street was located in proximity to all three cemeteries and built to assist the poor white residents of Richmond. The construction began in 1860 and was almost complete when the Civil War started. The Confederate government used the almshouse as General Hospital No. 1 and treated both Union and Confederate wounded. At times, the hospital had more than five hundred patients. During the last months of the war, students from Virginia Military Institute occupied the site since their campus had been burned by Union soldiers. After the war, the almshouse operated as a charity hospital and housed tubercular adult patients until 1955. The Department of Housing and Urban Development now runs the Shockoe Hill Apartments for low-income seniors.

# CHURCH HILL

When Richmonders and out-of-town guests mention Church Hill, most assume that this neighborhood was the earliest Richmond settlement, which is not quite true. Settlement first occurred on land with the best access to the river. Shockoe Bottom and Shockoe Slip had easier access than the cliffs of Church Hill. Main Street developed from the Slip and moved east until the upward slope of the rugged-terrain hill slowed the effort. A pedestrian walkway from Twenty-Ninth and East Grace to Thirty-First and East Grace provides the modern traveler with a glimpse of the steep, rugged terrain. Some parts of the city remained isolated until the gullies were filled in and the streets were graded and improved. Libby Hill and Shed Town are included in this section.

## HISTORIC SHOCKOE VALLEY HISTORICAL SIGN

*2112–98 East Grace Street*

At the Grace Street Park and Church Hill Overlook, a modern-day traveler could imagine William Byrd II as he stood on Richmond Hill, now Church Hill, taking in the view. The meandering James River reminded him of Richmond-on-the-Thames, hence the city, Richmond.

Broad Street, facing east toward Church Hill. *Photograph by Dan Palese Photographs.*

## ST. JOHN'S EPISOCOPAL CHURCH

*2401 East Broad Street*
*(804) 648-5015 | info@historicstjohnschurch.org | Admission fee, garden free*

A must-see experience in Richmond is the "Liberty or Death" reenactments at St. John's Episcopal Church. The performers, in historical costumes, debate the legalities and issues of conflict with England. The colonial delegates are committed to their ideas, and the audience can feel their passion.

The church structure was built on land donated by William Byrd II, and construction was completed in 1741. When St John's was erected, the hill was called Indian Town and the surrounding rugged terrain kept the church congregation small, with service days limited to three per year for communion on Christmas, Easter and Whitsunday. Although small, the graveyard quickly filled, so the city had to purchase additional land for plots.

The church was enlarged in 1772 and again about 1830. When the patriotic leaders chose to meet in Richmond to discuss the political feelings in 1775, the only building large enough to hold them was the church on the hill. That church has been referred to as "The Church," the "Upper Church," the "Richmond Hill Church" and the "Old Church" but is now known as St. John's Church.

# RICHMOND HILL HISTORICAL MARKER

*East Grace and North Twenty-Second Streets*

Some residents speculated that Church Hill property would appreciate in value. Richard Adams, a colonial land surveyor, built his house on Richmond Hill and purchased most of the twenty-five-acre parcel north of St. John's Church. Richard Adams and Thomas Jefferson were friends until a political falling out regarding the placement of the state capitol building. Richard Adams's plan proposed the new capitol's location on Richmond Hill. Adams wrongfully assumed his friend Governor Thomas Jefferson supported that location. The site chosen was ultimately Shockoe Hill (aka Court End, Academy Hill, Capital Hill). Adams never forgave his friend, and upon Adam's death, his children sold off the lots. The church's congregation naturally grew after 1818 as residential growth increased.

One of the earliest settlements on Church Hill was a small area named Shed Town or Shad Town. Shed Town or Shad Town was located on the plateau between Church Hill and Union Hill, Leigh Street (south) to Q Street, Twenty-Seventh east to Thirty-Third. The origin of the name has been lost to history. Both Samuel Mordecai and Mary Wingfield Scott stated it was either named after the shad fisheries or the sheds from numerous brick workers who lived in the area. Adams owned the land, which was filled with squatters, and the area grew slowly after 1820. The area was settled mostly by small tradesman with a few stores and almost no public buildings. The early settlers were skilled German immigrants and tended to be more accepting than other groups. Immigrant shops were most likely to transact business with slaves and free Black Richmonders.

# ADAMS DOUBLE HOUSE

*2501–2503 East Grace Street*
*Private residence*

The Adams Double House at 2501 East Grace Street was built circa 1809. The house is an interesting example of how residents adapted when the streets were graded and leveled out by adding small porches and basement storefronts. This was called "skied" by Mary Wingfield Scott.

## CARRINGTON ROW HOMES

*2307, 2309, 2311 East Broad Street*
*Private residences*

Carrington Row Homes along 2306 East Grace Street were built between 1810 and 1815 by Dr. John Adams for his sister, Ann Adams Carrington. They were the children of Richard Adams, who owned most of the Church Hill property. The homes are Richmond's earliest row houses still standing.

## ST. JOHN'S MEWS COMMUNITY GARDEN, CIRCA 1965

*Between East Broad and East Grace Streets,*
*bounded by Twenty-Third and Twenty-Fourth Streets*

St. John's Mews, located on Cobblestone Alley, is a hidden gem. The mews were restored by the Garden Club of Virginia, and they worked to use original materials such as cobblestones and ironworks designed to replicate nineteenth-century fences.

St. John's Mews. *Photograph by Megan Thrower.*

# CHIMBORAZO PARK

*3201 East Broad Street*
*richmondgov.com/parks/parkChimborazo.aspx*

Chimborazo Park, the former location of a Confederate hospital, is a vast open space covering thirty acres of hilltop overlooking the James River. The park no longer allows vehicles to drive through, but there is parking at the medical museum and along the street. The old park's roads are wide walkways to explore the park and find the miniature Statue of Liberty. The park also has two dog parks, separated by size of the dog.

The best-known Civil War hospital was Chimborazo in Church Hill, but Richmond had over fifty hospitals throughout the duration of the war. Some of these hospitals were temporary, such as private residences, and some existed only for the duration of the war, like Chimborazo. The Civil War hospitals currently standing were mostly tobacco warehouses or factories prior to becoming a hospital. Although the city had numerous hospitals, the number of wounded veterans and refugees quickly led to the streets sometimes serving as hospitals as well.

The city's residents and businesses moved westward following the Civil War, and both Shockoe Bottom and Main Street were rebuilt. Church Hill was saved from possible isolation and desertion by the nation's first electric trolley. In 1888, the first electric trolley left Twenty-Ninth and P Streets in Church Hill and traveled west until Hancock and Clay Streets, a one-and-a-half hour run. Two years later, the trolley traveled from Church Hill to Reservoir Park (Byrd Park).

Only one tobacco factory operated in Church Hill prior to the Civil War, Turpin and Yarbrough, at the corner of Franklin and Twenty-Fifth Streets. Built in 1853 and designed by John Freeman, the factory was one of five tobacco factories in Richmond. The Turpin and Yarbrough factory was converted to a hospital during the Civil War and housed well over three thousand sick and wounded Alabama soldiers. After the war, in 1909, the Pohlig Brothers Paper Box Factory owned and operated the space and stayed on the premises until 1992. Today the building is residential homes renovated by Stanley Shield.

# ETHEL BAILEY FURMAN HOME

*3025 Q Street*
*Private residence*

Church Hill was home to women who pushed the boundaries and were quite successful. Elizabeth Van Lew, who spied for the Union, is discussed earlier. The other is Ethel Bailey Furman (1893–1976), the first female African American architect in Virginia. She lived at 3025 Q Street, which was built by her father, who was a contractor. Most of her early training was following her father at his work sites, and then she had formal training with a tutor in New York. And she received her two-year degree from Chicago Technical Institute in 1946. She was active in the Richmond community, and the city named a park in her honor at 818 North Twenty-Eighth Street. She had over two hundred commissions, including both homes and churches.

# LIBBY HILL

## LIBBY PARK

*Located at Twenty-Eighth and East Franklin Streets*

Overlooking the James River, Libby Park is surrounded by two overlapping neighborhoods, known as both Libby Hill and St. John's Church Historical District. The park was first known as Eastern Square, Jefferson Park and Marshall Park. The park is currently known as Libby Hill Park.

Libby Hill is a small residential section of Church Hill, bounded by Main Street, East Franklin, Twenty-Ninth Street and Libby Terrace, that surrounds a park on three sides. Prior to the 1800s, the area was sparsely populated. During the American Revolutionary War, Baron von Steuben ordered the local militia to hold position on Libby Hill as Benedict Arnold and Colonel Simcoe advanced toward Richmond. The Americans possibly fired one volley toward British troops before disbanding, and the British successfully plundered the town. When Arnold returned four months later and burned Manchester, he saw Lafayette and his troops on Church Hill and left. Virginia governor George W Smith's home was located at the corner of Twenty-Seventh and East Franklin. He lived here up to his death in the theater fire of 1811.

The homes lining the border of Libby Hill Park represent the wealthy elite of antebellum Richmond. Most of the homes within this area were built

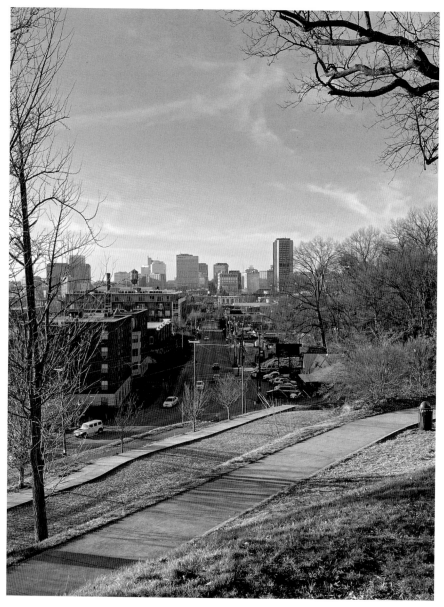

Libby Hill looking west. *Photograph by Megan Thrower.*

Libby Hill Park, 1908. *Library of Congress.*

between 1820 and the early 1900s and display various architectural styles. The blocks south of Broad Street, along East Grace and East Franklin, are especially elegant. These make up a vast number of homes in the area that have been restored in Church Hill.

## LIBBY HOUSE, CIRCA 1850

*1 North Twenty-Ninth Street*
*Private residence*

Libby Hill's name comes from Luther Libby's home, which was over five thousand square feet. Libby was a merchant and rented a warehouse on Cary Street. When the Confederates took over the warehouse, his name plate sign was still hanging, and the building became known as Libby Prison. Libby took his family to Henrico County to escape the war, but they were captured by the Union in 1864. Libby was placed in prison and released in bad health and died in 1871.

## CONFEDERATE SOLDIERS AND SAILORS STATUE*

*The statue has been removed and an empty pedestal remains.
Located at Twenty-Eighth and East Franklin Streets

# CAPITOL SQUARE AND COURT END

## "VOICES FROM THE GARDEN"

*Virginia Women's Monument*
*Capitol Square*
*womensmonumentcom.virginia.gov*

The Virginia State Capitol sits prominently on Capitol Hill, looking south over the city to the James River. The capitol grounds include a well-kept walkway that circles the building and leads visitors past the statue of George Washington, the Civil Rights Memorial, the Executive Mansion and the Virginia Women's Monument.

When Virginia's General Assembly moved the state capital from Williamsburg to Richmond, it radically altered the landscape of the city. Shockoe Hill was chosen for the site, and that included the twelve-acre Capitol Square.

Shockoe Hill, Academy Hill, Court End and Capitol Hill areas tend to overlap, and most locals refer to these areas as the Capitol and Virginia Commonwealth Medical Center. Most residential homes have been erased by demolition due to the growth of the city government and the hospital. The few remaining—the John Marshall House, Valentine Museum and Wickham Homes and White House of the Confederacy—represent a time of great wealth and a collection of highly intellectual minds.

When the General Assembly of Virginia decided to keep Richmond as the capital of the state, the legislators needed to move out of the temporary

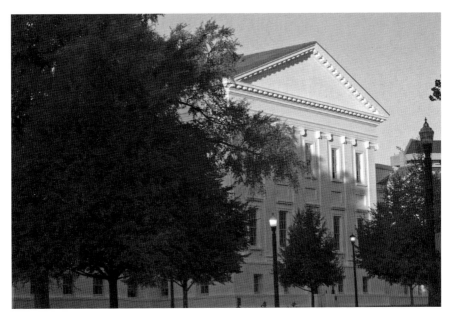

Virginia State Capitol. *Photograph by Dan Palese Photograph.*

buildings they had used into a more permanent building. The choice of architect was easy: Thomas Jefferson, along with Charles-Louis Clérisseau, designed the capitol building. The inspiration for the design was the Maison Carrée, a Roman temple in Nîmes, France. The construction began in 1785 and was completed in 1800; in 1903, wings were added for additional space for the legislatures.

The twelve acres were laid out as a public square, and the land surrounding the building was used by the public for a variety of tasks. Women often laid out their laundry to dry, and cows, pigs, chickens and other animals wandered over the grassy areas.

## EXECUTIVE MANSION

*Capitol Square*
*1111 East Broad Street*
*executivemansion.virginia.gov*

The governor's mansion was completed in 1813 on the eastern grounds of the Capitol Square. The Executive Mansion is the oldest governor's house

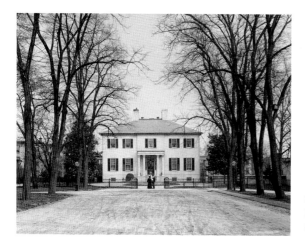

Governor's mansion, Richmond, 1905. *Library of Congress.*

in the nation still used as a home for the governor. The capitol is the longest established seat of government, making it the oldest continuous legislative body in the nation.

In 1816, the city leaders grew tired of the wandering animals and hired Maximilian Godefroy to design a formal landscape area; one result was an iron fence to keep out the animals. In 1850, the city contracted John Notman, the landscape designer of the Hollywood Cemetery, to revamp the capitol grounds, and eight years later, a statue of George Washington sitting on a horse, by Thomas Crawford, was installed on the outside grounds. Inside the capitol stands the only life-size statue of George Washington. He actually modeled for the sculptor Houdon, the only known time George Washington modeled.

In 1824, a brick bell tower was added to the capitol grounds to replace the earlier wooden tower. The bells were the prime mode of communication prior to the telegraph and the telephone. The bells continued their function of warning of approaching enemy (Union) forces, city fires and emergencies and announcing the call of the General Assembly to session. The bells were rung by hand until 1870, and then electricity was used. The bells still ring when the General Assembly goes into session.

Shortly after the decision of where to place the capitol, residents began to build homes north and west of the Capitol Square, in Court End. According to Samuel Mordecai, Court End and Capitol Square were filled with lawyers, professional gentleman and the wealthy.

# JOHN MARSHALL HOUSE

*818 East Marshall Street*
*(804) 648-7998*
*preservationvirginia.org | Admission fee*

In 1788, John Marshall began to build his Richmond home. The Marshalls purchased a whole city block and constructed a "plantation-in-town," a phrase coined by Mary Wingfield for the homes of the wealthy and elite in Richmond. The plantations-in-town occupied a whole city block and contained numerous outbuildings to support the main residence. The plantations-in-town had evolved from the typical Richmond eighteenth-century frame structure situated on a two-acre lot, with numerous outbuildings that included a well house and a necessary. John Marshall's block included his law office, a laundry, a kitchen, a carriage house and stable and a garden. As the area became a desired neighborhood, the lots diminished in size but still included outbuildings and a brick main residence. By the 1840s–50s, the lots were the width of the home and the kitchen and stable were stacked in the yard behind the house leading to the alley. The alleyways were conduits of information for the servants who worked and lived in the outbuildings and the delivery services.

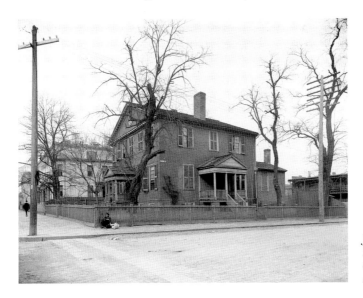

John Marshall's home, Richmond, circa 1900–1906. *Library of Congress.*

163

## WHITE HOUSE OF THE CONFEDERACY

*1201 East Clay Street*
*(804) 649-1861, ext. 100 | acwm.org | Free parking | Admission fee for museum*

Although it is hard to tell today with hospital campus surrounding the Confederate White House, the home was originally located in a prestigious residential area. The home's interior design and décor reflect the great wealth of the occupants.

## FIRST AFRICAN BAPTIST CHURCH

*301 East College Street*
*Owned by Virginia Commonwealth University*

The earliest place of worship in this area was the First Baptist Church on the northeast corner of Broad and College. The congregation was a mixture of white, free Black residents and slaves. When the white congregation moved to a new church in 1841, the Black congregation was allowed to have the church, albeit with a white preacher. In 1877, a new structure was built and the church renamed the First African Baptist Church.

## VCU MEDICAL CENTER EGYPTIAN BUILDING

*550 East Marshall Street*

The Egyptian building is located in Academy Square. The Egyptian architecture extends to the posts of the iron fence; the posts are shaped like mummy cases with protruding toes. The building was constructed in 1845 and was the first building erected for the Medical College of Virginia, which started as a medical department of Hampden-Sydney College in 1838. The initial location was in the Union Hotel at Nineteenth and Main Streets.

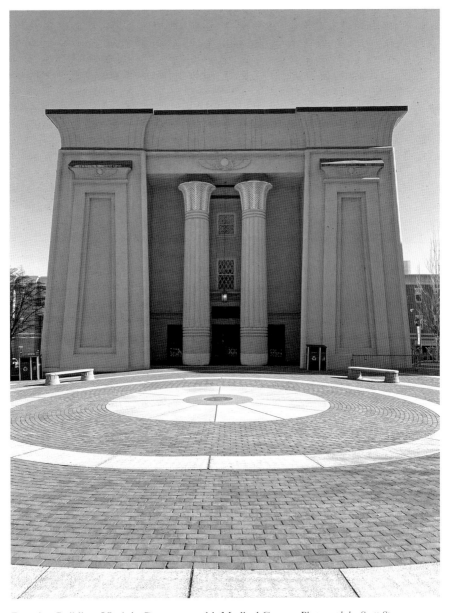

Egyptian Building, Virginia Commonwealth Medical Center. *Photograph by Scott Stowe.*

## CITY HALL OBSERVATION DECK

*Ninth and Broad Streets*
*Monday–Friday, 8:00 a.m.–5:00 p.m. | Free*

The city government, courts and Virginia Commonwealth University's medical facility expanded and now occupy most of this area. A new city hall was built in 1971 at 900 East Broad Street, and with twenty-one floors, it was the tallest building in Virginia for four years. A wonderful (free) treasure is hidden on the top floor of city hall. A free observation deck occupies the top floor, and a visitor can have a 360-degree walk-around view of Richmond. The view is well worth the parking challenge.

## LIBRARY OF VIRGINIA

*800 East Broad Street*
*(804) 692-3500 | lva.virginia.gov*

Across the street is the Library of Virginia, which was created in 1823 to preserve Virginia's manuscripts. In 1997, the library moved into a new building at 800 East Broad Street. The Library of Virginia houses the most comprehensive collection of materials related to the history of Virginia.

# UNION HILL

## JEFFERSON PARK

*Corner of North Twenty-First and East Marshall Streets*

Jefferson Park sits atop Union Hill and provides a wonderful westward view overlooking Shockoe Bottom toward downtown. The breezy park is a nice place to picnic or explore. The park is a flat lawn shaded by trees and has benches. The park has a horseshoe pit near the playground and the Jefferson Park Peace Fountain, inspired by Alicia Rasin, Richmond's ambassador of compassion. For the hearty, an exercise trail leads down the hill.

The neighborhood was part of the 831 acres Richard Adams purchased from William Byrd III around 1761. Upon Adams's death in 1820, his son inherited the estate, and in 1821, the son's estate was worth $1.2 million.

Union Hill was separated from Church Hill prior to 1882 due to the deep gully that ran along Jefferson Street. Venable and Twenty-Fifth Streets were the thoroughfares from the valley to the higher ground. In 1805, John Adams and his partner, Benjamin Mosby, laid off the western end of the Union Hill in lots. Some of the lots were along Venable Street. Venable Street was an early 1817 stage road to Williamsburg and named after Abraham B. Venable. Venable was a senator and the first president of the Bank of Virginia. In 1811, he was one of the audience members to perish in the Theater Fire.

Mr. Smedley, Jefferson Park. *Photograph by Megan Thrower.*

Due to the terrain, the street grid followed the contours and numerous switchbacks. In 1853, a traveler went a total distance of one mile to travel the three blocks from Leigh Street Baptist on Twenty-Fifth to Asbury Methodist on Twenty-Ninth Street. A modern traveler driving on Cedar Street has a glimpse of the rugged terrain as the road winds around Jefferson Park.

The isolation of the area didn't draw the wealthy and elite to the area. The residents lived mostly in rented homes. The neighborhood was isolated and inhabited by mostly Germans and free Black people and hired-out slaves. The mostly working-class neighborhood was a collection of cottages and two-story houses that haphazardly followed the terrain and lined the streets.

Around 1817, the name Union Hill first appeared; it possibly came from the joining of two hills, Doing's and Adams'. In 1813, Joshua Doing built a house on the overlook in Jefferson Park. His home included a two-story brick kitchen, a brick smokehouse and a stable. The house was demolished, and the city purchased the land in 1887 to create a park, first called Marshall Park and now known as Jefferson Park.

As the streets were leveled and graded to make them more passable, the homes' basements were exposed. Mary Wingfield Scott called this "skied" to describe the effect of the raised houses. Once the area leveled out and the ravines were filled in, the wealthy moved in and built homes along Princess Anne Boulevard. The homes on this road were built between 1890 and 1905.

# JACKSON WARD

## MAGGIE WALKER NATIONAL HISTORIC SITE

*600 North Second Street*
*nps.gov/mawa | Free*

The most famous resident of Jackson Ward is Maggie Walker, and her home is well worth the visit. The twenty-eight-room house is filled with mementoes of her full life.

In most cities, neighborhoods were created and quickly become routine and nondescript—not so with Jackson Ward. Jackson Ward, north of Broad Street and extending to I-95 and I-64 and from Third Street to Gilmer, was home to the "Black Wall Street" and the "Harlem of the South." Jim Crow laws created an enclave of African Americans who built a city within the city. Jackson Ward was left untouched by the Evacuation Fire of 1865, and the community has numerous buildings and residences that are well over a century old.

The name Jackson Addition first appeared on an 1835 Bates Map of Richmond that labeled it an area north of Clay (K) Street. The origin of the name has a few possibilities. In the 1820s, the popular James Jackson's (beer) garden was located at the corner of Second and Leigh Streets. The name also appeared when the area became a political ward, since Richmond already had wards named after presidents: Jefferson, Monroe and Madison. Maybe Jackson Ward was named for Andrew Jackson.

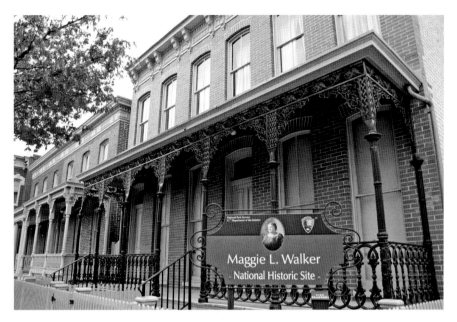

Maggie Walker National Park, Jackson Ward. *Photograph by Dan Palese Photographs.*

The area started out as a residential and business area for Jewish, Italian and German immigrants. Germans arrived in Richmond during the eighteenth century, but the largest wave of immigrants arrived in the 1840s–50s, when 150 Germans arrived in 1844. Most of the Germans were farmers and mechanics. Samuel Mordecai was excited about the arrival of Germans, since most came with skills: builders, stonemasons and bakers. The area continued to fill up with tradesmen, mechanics and small businessmen.

Prior to the Civil War, there was a small free Black population living in Jackson Ward; after the war, the neighborhood shifted to predominantly African American residents. The Germans were the most tolerant and welcoming of Black people, slave and free, who moved onto Third Street, but the Germans eventually followed the Italian and Jewish families and moved out of the area. By the late 1870s, Third Street from Shockoe Cemetery to Jackson Street was all Black residents. The African American population continued to move south toward Broad Street, and by the end of World War I, Clay Street residents were primarily African American. By the time of World War II, the northern side of Broad Street consisted of shops and businesses that catered to the African American community. The southern side of Broad Street, with Miller & Rhoads and Thalhimers, catered more to the white residents.

## JOHN JASPER MUSEUM TOUR

*Sixth Mount Zion*
*14 West Duval Street*
*(804) 648-7511 | smzbc.org | Donation*

This shift in population altered the congregation of a few churches. The Duval Street Chapel, a Presbyterian church built in 1846, became the Sixth Mount Zion in 1870 and had a mostly African American congregation. The Sixth Mount Zion Church is perched on a hill located at the edge of Jackson Ward looking over I-95/I-64. The highway is less than ten feet from the building, and looking across the divide, stands Maggie Walker's St. Luke's building.

Reverend John Jasper was an inspirational preacher and began delivering sermons while still a slave. After the Civil War, he moved the congregation from Belle Isle to Jackson Ward, and in 1887, the present building was erected. Reverend John Jasper preached his sermon "De Sun Do Move" first at Sixth Mount Zion and then repeated the sermon to over 250 churches, mostly in the southern states. The sermon was a combination of science and religion, and he used the Bible as his scientific evidence. Citing verses, Reverend John Jasper preached the sun moved around the earth. Audiences, both white and Black, flocked to hear his sermon. His legacy saved the church from destruction when the highway came through Jackson Ward. The church celebrates John Jasper Founders Day Celebration the third Sunday in February. The present building is in the National Register of Historic Places and the Virginia Landmarks Register. The tour is very informative and includes John Jasper exhibits and archives.

## GALLERY5, MUSEUM AND ART GALLERY

*Steamer Company Number Five Fire and Police State, circa 1884*
*200 West Marshall Street, the intersection of Brook Road and Marshall Street*
*(804) 678-8863 | galleryfive.org*

Reconstruction was a high point politically for the ward and its residents, particularly the years from 1871 to 1905. The city leaders gerrymandered a district with a predominantly Black population in order to sacrifice only one

city council seat to the African American population. Jackson Ward lost its city council seat when the political ward was dissolved and combined with surrounding ones.

# BOJANGLES STATUE

*Triangle of Chamberlayne Parkway, Adams and Leigh Streets*

The era of Jim Crow that followed Reconstruction provided a unique opportunity to the highly segregated African American population of Jackson Ward. Like most African Americans throughout the nation, the ward residents were excluded from white politics and business. This situation provided the catalyst for entrepreneurs to develop their own businesses and civic organizations. The historical context of the ward can't be underestimated: the neighborhood residents included Giles B. Jackson (1853–1924), the first African American admitted to practice law before the Supreme Court of Virginia (1877); Rosa D. Bowser (1855–1931), educator; Joseph E. Farrar (1830–1892), one of the founders of Virginia Home Building Fund and Loan Association; and of course, Bill "Bojangles" Robinson (1878–1949), the tap dancer and movie star.

Bill "Bojangles" Robinson.
*Photograph by Scott Stowe.*

Robinson was born in Jackson Ward and grew up shining shoes and tap dancing. He was discovered at an early age and spent time traveling with different vaudeville shows. He starred in over twelve movies and co-starred with Shirley Temple. The Robinson Theater built in 1937 in Church Hill was named in his honor. At the intersection of Chamberlayne Parkway, Adams Street and Leigh Street stands the Bojangles Statue. It was also at this intersection where Robinson paid over $1,000 have a stop light installed after he witnessed an accident between a child and an automobile.

The success of Jackson Ward's individuals and businesses was due in part to the assistance and encouragement from secret and benevolent societies. Nationwide, Americans joined societies for various reasons, provided funds

for the burial and for the sick, orphans, widows and the elderly. Benevolent societies in the African American communities became insurance agents as well as mutual aid societies.

## WILLIAM W. BROWNE HOME, CIRCA 1845

*105 West Jackson Street*
*Private residence*

An early group, the Burying Ground Society of the Free People of Color of the City of Richmond, was formed in 1815 to help with burial costs. The Virginia Branch of the Grand United Order of True Reformers invited William W. Browne to revive the order. His first order changed the name to the Grand Fountain of the United Order of True Reformers. He also opened a bank for African Americans in 1888, when the True Reformers were granted a charter by the State of Virginia. This was the first African American bank chartered in the United States. The bank officially opened on April 3, 1889, the anniversary of the day the Union army entered Richmond. Washington housed the bank in his front parlor until a new bank was built. The bank remained open until 1910. The Reformers also opened a grocery store at the corner of Sixth and Clay Street and the Hotel Reformer at Sixth and Baker Streets.

The Grand United Order of St. Luke, an African American fraternal and cooperative insurance society, was started by Mary Prout, an ex-slave in Baltimore, Maryland, in 1867. The purpose of St. Luke's was to assist the sick and help with the cost to bury the dead. Around the same time that St. Luke's was established, Maggie L. (Mitchell) Walker was born in the mansion of abolitionist Elizabeth Van Lew. Maggie's mother, Elizabeth Draper, worked in the home. At the age of fourteen, Maggie Walker joined St. Luke's.

## MAGGIE WALKER STATUE

*Intersection of Adams and Broad Streets*

In 1883, Maggie L. Walker graduated from Richmond Colored High and Normal School, now known as Armstrong High School. After graduation,

she taught until her marriage to Armstrong Walker Jr. in 1886. After marriage, she worked as an insurance agent and raised two sons; another son died within his first year of life. Walker also volunteered at St. Luke's, and eventually, in 1899, she was elected right worthy grand secretary of St. Luke's, its highest rank, and retained the title until 1934. She later became the executive secretary treasurer.

The headquarters was at 902 St. James Street in Postletown, an area known for the five streets named for apostles: St. Stephen, St. James, St. Peter, St. John and St. Paul. In her role as grand secretary, she was instrumental in developing three outreach branches of St. Luke's: a bank, a store and a newspaper. The bank was the most successful of the three.

Maggie Walker spoke of "making nickels into dollars." She believed a bank run by African Americans who supported the community led to economic success. The St. Luke's Penny Savings Bank was organized in 1903, and on opening day, November 2, 1903, the bank had over 280 deposits totaling over $8,000. St. Luke's continues today, although through mergers and buyouts, the bank is no longer a Black-run, independently owned bank. Until 2005, it was the oldest continuously Black-owned bank in the nation.

The *St. Luke Herald* newspaper began publication in 1902. Walker's mission for the newspaper was to increase the economic prosperity of the African American population. The *St. Luke Herald* kept the community connected and informed people of their rights. The highest weekly subscriptions rate occurred around 1929. The Great Depression slowed down subscriptions, and the newspaper ceased being a weekly and became more like a bulletin publication.

In 1905, the St. Luke Emporium Store opened at 112 East Broad Street. Walker continued with a goal to improve the financial station of women. When the store opened, Black female employees greeted customers without judgement and the store was stocked with items priced more affordably. The store struggled to compete amid the pressure from the white retail business owners and closed in 1912.

She continued to support women and African Americans through the various civic organizations. She served as the local vice president of the National Association for the Advancement of Colored People (NAACP) and worked with the National Association of Colored Women (NACW) and the Virginia Industrial School for Girls.

# QUALITY ROW

*100 Block of Leigh Street*
*Private residences and Maggie Walker Home*

Maggie L. Walker lived in the most desirable area of Jackson Ward, called Quality Row. The 100 block of Leigh Street features some of the finest homes in Jackson Ward and was sometimes referred to as the Park Avenue of the African American community. Walker's home even had electricity, which was rare then, and in 1928, an elevator was added. Some of her neighbors included Dr. J.J. Smallwood, a professor at Virginia Union University; James H. Johnson, president of Virginia State College; and Dr. David A. Ferguson, a dentist and founder of the National Dental Association.

Maggie L. Walker passed away on December 15, 1934, and was buried in Evergreen Cemetery. Shortly after her death, the city built the Maggie Walker High School for African American students. The school was built on the site of the Hartshorn Memorial College, which was a school for African American women and was incorporated into Virginia Union University. The high school closed for a while and reopened in 1998 as the Maggie L. Walker Governor's School for Government and International Studies.

# RICHMOND PLANET HISTORICAL MARKER

*Third Street entrance of the Greater Richmond Convention Center*

John Mitchell Jr. was another Jackson Ward resident who worked hard to improve life in the community. He was born a slave in 1863 at Laburnum. After the Civil War, Mitchell attended Richmond Colored High and Normal School, and he graduated in 1881 with the credentials to teach. He taught in Fredericksburg and Richmond and then wrote for the *New York Globe*. He became the editor of the *Richmond Planet* and an outspoken proponent for equality and civil rights. His editorials supported the 1904 streetcar boycott by African Americans and argued against the Confederate statues on Monument Avenue. In 1902, he founded the Mechanics Savings Bank, the third bank chartered by an African American in Richmond. The bank closed in 1922, and Mitchell passed away in 1929.

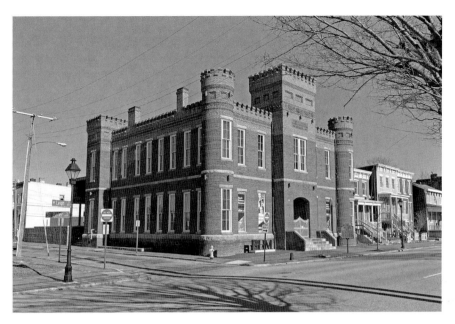

Black History Museum and Cultural Center of Virginia. *Photograph by Scott Stowe.*

## LEIGH STREET ARMORY

*Black History Museum*
*122 West Leigh Street*
*(804) 780-9093 | blackhistorymuseum.org | Admission fee*

As editor and community leader, Mitchell Jr. played an important role in convincing the Richmond government to build an armory in Jackson Ward. In 1895, the Leigh Street Armory was built and housed the African American First Battalion Virginia Volunteers Army. The African American soldiers and community were proud of their armory, and the First Battalion was called for service during the Spanish-American War. The racism felt by the African American volunteers led to difficulties, and in 1899, when the Virginia Volunteers were reorganized, there was not a Black regiment included.

The city decided to use the armory as a school for African Americans and housed the Monroe School there until 1940. During World War II, the armory housed and assisted African American soldiers. Recently, the Black History Museum of Richmond moved into the building.

Many American cities have areas called "Black Wall Street," and Richmond was no different. Due to the isolation and restrictive residential zones, the Jackson Ward community turned inward for their needs. This reliance on and support for the community fostered numerous businesses, home purchases and a successful, vibrant art and music scene.

The hub of Jackson Ward was Second Street, sometimes referred to as "The Deuce." Second Street was already an established main road, and prior to the Civil War, the area was settled by Germans and grocery stores lined the street. Second Street was the chief shopping center for both the free Black and slave population since the German stores accepted their business. The slave system of hiring out provided the enslaved opportunity to learn a skill or a trade, so after the war when the freedmen moved into the community, they brought their skills with them. These skills provided employment and money to spend. Residents were also able to open other types of businesses with the support of the six banks located in Jackson Ward.

## EGGLESTON HOTEL HISTORICAL MARKER

*Second and Leigh Streets*

A historical marker, at Second and Leigh, marks the spot of the famous Miller & Eggleston Hotel. William "Buck" Miller opened the hotel in 1904 and served African American guests, including Booker T. Washington. Neverett Eggleston purchased the hotel and renamed it the Eggleston. The hotel continued to house African Americans during a time there were few hotels available to them. Entertainers such as Louis Armstrong, Count Basie and Redd Fox performing at the Hippodrome Theater or visiting often stayed at the Eggleston.

## A.D. PRICE FUNERAL HOME

*Historical marker*
*Second and Leigh Streets*

Alfred Douglas Price was born a slave in Hanover County around 1860. After the war, Price settled in Jackson Ward and eventually opened a livery

stable and funeral business. He expanded his business to include a wholesaler of funeral supplies to African Americans in North Carolina, South Carolina and Georgia.

# HIPPODROME THEATER VENUES

*526 North Second Street*
*hippodromerichmond.com*

Second Street wasn't just for day-to-day business, it was also part of the idea that Jackson Ward was the Harlem of the South. As the Jazz Age swept Harlem in New York, the performers often stopped in Richmond and performed at the Hippodrome Theater. The Hippodrome, built in 1914, was the center of the African American entertainment world from 1920 to the 1940s. The theater had celebrated performers such as Ella Fitzgerald, Duke Ellington, Nat King Cole, James Brown and many more. The numerous clubs, theaters and restaurants made Jackson Ward a spot to see some big names.

Off of Second Street, community members created opportunities and offered assistance to the community. Dr. Sarah G. Jones, daughter of famed architect George W. Boyd, began her studies at Howard University, and in 1883, she became the first African American woman to pass the Virginia Medical Examining Board's examination. She and her husband, Miles Jones, opened a hospital on Baker Street for African Americans. They started a training school for nurses in 1902.

Churches in the African American community played a major role in the neighborhoods. The Third Street Bethel AME Church was built in 1857 and is located at 614 North Third Street. The church is the second-oldest African Methodist Church in Virginia and is listed in the Virginia Landmarks Register and the National Register of Historic Places. After the Civil War ended, the Freedom Bureau set up a school in this church. Some believed this was the location for the first African American Boy Scout troop.

Ebenezer Baptist Church began as Third African Baptist Church in 1857, and the congregation was a combination of enslaved and free people. The following year, the church was dedicated as Leigh Street Ebenezer Baptist Church and followed the law of having a white minister. The area surrounding the church and along the 200–400 block of Duval Street was

nicknamed "Little Africa," for the number of free Black homeowners in the area. After the Civil War, the church had the first public school for African Americans. Seventeen years later, Hartshorn Memorial College, a college for African American women, started in the basement of the church.

In one sense, the civil rights movement of the 1960s and desegregation broke up the tight-knit community of Jackson Ward. The African American population was no longer isolated and left on its own to develop its own economic system. The young had opportunities for education and occupations that older generations did not have, and they soon left the area and rarely returned. The community was reduced even more when the new interstate highway ripped Jackson Ward down the middle.

Mary Wingfield Scott wrote: "Should the proposed Express Highway… designed to follow Jackson Street, would destroy more than fifty houses built before 1865….This plan will have a more far reaching effect than any event in the history of Richmond except the Evacuation Fire."

Today, Jackson Ward is in the middle of recovery as new residential buildings are being built along First Street.

# MONROE WARD

The city and its residents began to move west just prior to the Civil War and relocated from Church Hill to areas closer to the courts and the new Broad Street shopping district. Monroe Ward occupied areas west of the Capitol Square to Belvidere Street and covered the area between Broad Street and the James River. This area became the Fifth Avenue of Richmond for residential homes.

## LINDEN ROW INN, CIRCA 1847–53

*100 East Franklin Street*
*(804) 783-7000 | lindenrowinn.com*

Linden Row was built between the years of 1847 and 1853 in a Greek Revival architectural style. The homes at 100–14 East Franklin Street were originally ten homes; the two east end homes were torn down. Mary Wingfield Scott saved the other eight from destruction. In 1988, the homes were renovated into the Linden Row Inn, and in the back gardens are the original slave dwellings and a beautiful garden patio. The row was home to prominent citizens from 1895 to 1906. Linden Row housed two prestigious girls' schools: the Southern Female Institute and Miss Jennie's School, run by Virginia Johnson Pegram and her daughter, Mary. Lady Astor (Nancy Langhorne) and the "Gibson Girl" (Irene Langhorne) were two of the

Jefferson Hotel. *Photograph by Dan Palese Photographs.*

many successful graduates of Miss Jennie's. The school is now named St. Catherine's and located in the Westhampton area of Richmond. Linden Row is a wonderful example of Greek Revival row homes, and although Poe's garden is gone, the original servant quarters behind the inn still stand.

## BOLLING HAXALL HOUSE, CIRCA 1858

*211 East Franklin Street*
*(804) 643-2847 | twcrichmond.org | Contact for tour information*

The Bolling Haxall House, built in 1858, was owned by Bolling W. Haxall, owner of the Haxall Mills, and is one of the few mansions left in the area. In 1869, the home was sold to Dr. Francis Willis. He added a walnut staircase, and tragically, his daughter, Elizabeth, fell down the staircase while sleepwalking. After her death, he sold the home to the Woman's Club.

# THE JEFFERSON HOTEL, CIRCA 1895

*101 West Franklin Street*
*(888) 918-1895 | jeffersonhotel.com*

The Jefferson Hotel, opened on October 31, 1895, treated guests to modern amenities of hot and cold running water, electricity and elevators. Lewis Ginter spared no expense to build his dream hotel. The Richmond location was perfect, the midway stop between New York and Florida. He hired Carrere and Hastings Architecture Firm from New York, the same firm that designed the Fifth Avenue New York Public Library and the Henry Frick House. Ginter spent $5 to $10 million to build and decorate the Jefferson Hotel, and construction took three years. The hotel was a success, and the citizens were proud of the elegant hotel. The first week of business included a rooftop party to celebrate the marriage of local Irene Langhorne to Charles Dana Gibson. Gibson was an illustrator and based his "Gibson Girl" illustrations on his wife. Irene's sister Nancy also attended the party. Nancy Langhorne became Lady Astor and was the first woman to take a seat in British Parliament. Both were students of Miss Jenny's.

Ginter spared no expense and offered various luxury amenities to guests. For the cost of a dollar, a guest could visit the Turkish baths and saunas. The baths were accessed by either the Jefferson Street or the Rotunda entrances. Upstairs in the Palm Court, live trees provided a warm, tropical atmosphere. A life-size marble statue of Thomas Jefferson stands in the middle of the Palm Court. Sculptor Edward V. Valentine used Jefferson's personal clothing

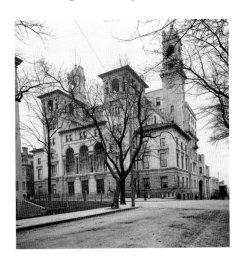

Hotel Jefferson, Richmond, Virginia, circa 1903. *Library of Congress.*

for the statue's measurements. The court included live alligators that lived in the shallow decorative pool. The origin of the alligators has been lost to history, although many different ideas float. A Ginter story: Ginter wanted to maintain authenticity of the Palm Court, and that included live alligators. A snowbird story: on a return trip from Florida and an overnight stay at the Jefferson Hotel, retirees decided the live baby alligator wasn't such a great pet, left the reptile in the pool and then continued the trip home. Both of these stories appeared plausible and both probably had a ring of truth in them. Either way, the hotel embraced the idea of alligators and kept at least one until 1948, when Old Pompey died. He reached the length of eight to nine feet. Pete was the meanest one, and another one liked to roam away from the pool and the court. For the most part, the alligators kept to themselves, although one female guest was quite startled when her "footrest" got up and walked away.

The Jefferson attempted to provide access to alcohol when Virginia's prohibition started. It was one of only five establishments to receive a liquor license. The hotel also bottled its own whiskey, Jefferson Whiskey and Jefferson Club Whiskey. When the Eighteenth Amendment went into effect, the Jefferson continued to fulfill the wants of its guests and was busted by the police. After Prohibition ended, hotels in Virginia were not allowed to sell mixed drinks, but the Jefferson quickly solved the problem by the creation of private clubs in the 1940s and 1950s. The private clubs stored patrons' liquor and sold guests the mixer.

The hotel has had its ups and downs. The first fire occurred on March 29, 1901. When the fire broke out, citizens rushed to the scene, rescued items from the hotel and assisted in putting out the fire. Edward and Henry Valentine hurried to the Jefferson in the hopes of helping, and once there, they organized citizens to carry out the Thomas Jefferson statue. The statue was placed on a mattress and safely carried out. Once outside, the statue fell, and the head detached. Edward Valentine reattached the head, and the statue was once again greeting visitors. Two-thirds of the hotel were destroyed, and only the Franklin Street front and the powerhouse were saved. No lives were lost, but recovery was slow, the hotel operated the rooms available and it took until May 1907 to fully reopen the burned areas.

A second fire in 1944 claimed six lives, including Senator Aubrey G. Weaver from Front Royal. The March 10, 1944 fire began in a second-floor linen closet, and the people who perished were on either the fifth or sixth floor. The upper floors were quite heavily damaged.

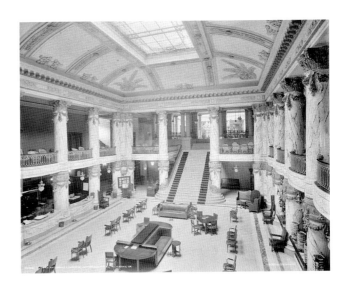

Lobby and grand staircase, Jefferson Hotel, circa 1908. *Library of Congress.*

The hotel limped along, housing soldiers during World War II and operating as residential housing until 1980. The hotel had numerous renovations, but the one constant was the marble staircase. The famous thirty-six steps descend from the balcony, rumored to have been the inspiration for the *Gone with the Wind* staircase.

## CHRISTMAS TREE LIGHTING SERVICE

*Jefferson Hotel*
*(804) 649-4750 | jeffersonhotel.com*

Lewis Ginter's dream hotel achieved the status of a Five Diamond (1983) and a Five Star Hotel (2001). A who's who list of people have stayed at the Jefferson: over thirteen U.S. presidents; world leaders, including Winston Churchill; celebrities Elvis, Frank Sinatra and Anthony Hopkins; and authors F. Scott Fitzgerald and Gertrude Stein. The Jefferson has once again risen to be one of the most elite hotels in America.

# ELLEN GLASGOW HOUSE

*1 West Main Street*
*Private residence*

Ellen Glasgow lived in the home from 1887 to 1945. Glasgow, a southern writer, was the sixth woman inducted into the American Academy of Arts and Letters, and in 1942, she received the Pulitzer Prize for her final novel, *In This Our Life*. On November 27, 1909, Ellen Glasgow, Lila Meade Valentine and other prominent women organized the Equal Suffrage League of Virginia.

# THE FAN

## THE FAN DISTRICT ASSOCIATION HOLIDAY HOUSE TOUR

*Second weekend in December*
*fandistrict.org | Admission fee*

The Fan District starts on the western side of Belvidere Street and divides the city into the pre– and post–Civil War eras. Belvidere Street is the section of Route 301 through Richmond from the Lee Bridge until the road crosses under I-64. Belvidere served as the western wilderness boundary until after the Civil War, when land speculators dreamed of a town named Sydney. Arthur Ashe Boulevard (just renamed in his honor, 2019) marks the western boundary of the Fan. The development's name was descriptive of the street pattern: they fanned westward from Laurel Street, the western boundary of the pentagon-shaped Monroe Park.

The area between Broad Street on the north and to the south, Main Street, was unorganized with sparsely scattered settlements. The few settlements were located along an old Native American trail renamed Westham Road. Westham Road connected Richmond's harbors to the western tribes. The trade goods were brought downriver and then loaded onto horses, carts or wagons and taken into the city. Today's Park Avenue follows the path of the Westham Road. Most city streets followed the grid system so the roads were straight and squared, but not Park Avenue. The road bends to follow the earlier Westham Road path that was dictated by the riverbank's terrain. A

Stonewall Jackson, Monument Avenue. *Photograph by Dan Palese Photographs.*

road close alongside the riverbank was near impossible due to the steep hills. A modern hiker can experience the hilly terrain on the North Bank Trails.

## SCUFFLETOWN PARK

*Alley off Strawberry Street between Park Avenue and Stuart Avenue*

Very little settlement west of Belvidere occurred in this area prior to the 1850s. The Scuffletown Park sits quietly nestled in a courtyard accessed by an alley from Strawberry Street. The well-groomed and hardscaped park offers visitors a grassy spot (no animals allowed on grass), picnic tables and shade. An explanation for the name came from a "scuffle" between the British (some say Benedict Arnold) and the colonial home guard during the American Revolutionary War. The few buildings along Westham Road belonged to Scuffletown Tavern, which existed from about 1782 to 1910. Smaller outbuildings, a kitchen, smoke and carriage houses, a barn and stable surrounded the tavern. The tavern owner, William Collins, hung his sign with the image of a globe as the center of a man's body, his head and shoulders top the North Pole and his feet at the South Pole. The phrase

"Help a Scuffler Through" was painted on the sign. The building remained a tavern until 1804, when the seven-bedroom tavern became a private home.

In 1817, the idea of a town named Sydney developed among three land speculators: Jacqueline B. Harvie, Benjamin J. Harris and George Winston. Jacqueline Burwell Harvie, married to Mary Marshall, the only daughter of John Marshall, managed his father's estate, which included 1,200 acres. Benjamin Harris was in the tobacco and cotton mill industries and purchased Belvidere and surrounding acreage. The third partner was George Winston, one of the top and well-known builders at this time, who operated a lumberyard and a brickyard. Their idea was to create a town between Belvidere Street traveling west to Belmont Avenue, and Cary Street (the new Westham Plank Road) heading north crossing Scuffletown Road and stopping at Broad Street.

The Panic of 1818–19 collapsed the idea of Sydney and two of the three men went bankrupt and sold all their belongings, including slaves. Harvie's income was diversified among many businesses and he survived the panic, yet he couldn't shake the debt. The land platted for Sydney was not developed until Richmond annexed the land. Prior to the annexation, Henrico County was not interested in paving streets given the likelihood the land would be annexed.

The Fan District's residential value was enhanced when transportation options became viable and it was easier to live farther away from the city core. The horse-drawn streetcar and then the electric streetcar fueled a housing boom between 1880 and 1920 that faded during the Great Depression and then homes fell into disrepair. A rebirth occurred after World War II, when returning soldiers married and started families; at that time, the Fan was known as Stork Alley.

The district has two areas: the Lower Fan and the Upper Fan. The Lower Fan was the area between Monroe Park and North Lombardy Street. The Upper Fan, including Monument Avenue and surrounding blocks, was annexed later and became the most prestigious address in town.

## MONROE PARK

*620 West Main Street*

The Lower Fan begins at Monroe Park. The park was conceived by the city leaders in the mid-1800s, when the growth of urban areas limited the

residents' access to green open spaces. The loss of fresh air was believed to be a problem, and the creation of city parks and cemeteries was a nationwide movement in cities such as New York, Chicago, Philadelphia and Richmond. Richmond financed five parks, and in 1851, the first was the ten-acre site of Western Square (now Monroe Park).

The original name, Western Park, was changed in 1853 to Monroe Park in honor of President James Monroe. Monroe Park was the location for the first annual fair for the Virginia Agricultural Society. The fair was held at Monroe Park until 1859, when it relocated to Broad Street. During the Civil War, Confederates used Monroe Park as a military training camp. After the war, the Union troops built a tent city on the park's grounds.

Once Union troops left the park and the fairgrounds were relocated, renovations occurred and the park was restored to earlier designs. The renovations and streetcar transportation access made this an ideal location for new residential homes. Just a few blocks west, on the 800–900 blocks of West Franklin Street and West Grace Street, the area developed into one of the most prestigious addresses in the late nineteenth and early twentieth century. Mary Wingfield Scott described the homes as "monstrosities" and "quite ugly."

Lewis Ginter built a home at 901 West Franklin Street in the 1890s. The home had front entrances on West Franklin and Shafer Streets, and the home was thought to be the most expensive home built in Richmond, built at a cost of $1.25 million. Ginter lived in the home for approximately five years before his death. After his death, his niece Grace Arents occupied the home until she moved to Bloemendaal House, now the site of Lewis Ginter Botanical Gardens. In 1924, the Franklin Street Ginter home was purchased by the city, and fifteen years later, the city sold the property to the Richmond Professional Institute, the forerunner of the Virginia Commonwealth University (VCU). VCU's Office of the Provost and Vice President of Academic Affairs are currently located in the Ginter home.

## PARK PLAZA (VCU)

*Statue by Richmond artist and former howitzer William L. Sheppard to honor the Civil War howitzers\**
*\*The statue has been removed and an empty pedestal remains.*
*Park and Grove Avenues and Harrison Street*

The city followed the new customs of parks in urban planning, and small parks were scattered throughout the city. The beginning of a nice walking tour of urban parks, Park Plaza, Triangle, Meadow and Scuffletown Parks, is a few blocks south of Ginter's home on Park Avenue, the old Westham Parkway. The homes along Park Avenue date from 1900 to the 1910s.

## LOMBARDY AND PARK AVENUE TRIANGLE PARK

*347 North Lombardy Street*

Heading west on Park Avenue, the next park is the Lombardy and Park Avenue Triangle Park. The park is an ideal place to take young children to play on the playground equipment and sand pit. A short brick wall with iron gates surrounds the park. No animals are allowed in the park.

## MEADOW PARK*

*\*The statue has been removed and an empty pedestal remains.*
*401 North Meadow Street*

Continuing West on Park Avenue, the next park is Meadow Park. This park is in the memory of Joanne Britton Norvell. The grassy arboretum is very nice and includes numerous benches and shade. There is a monument commemorating the First Regiment, organized in 1754 with Joshua Fry as colonel and George Washington as lieutenant colonel. The First Regiment fought in seven American wars, including Fort Necessity and the Spanish American War.

## PARADISE PARK

*1700 block of Grove Avenue*

Some Fan parks are pocket parks and were in style in the 1960s–70s. An urban movement similar to the nineteenth century open green spaces, the pocket parks were to provide urban residents with open spaces. Paradise Park, hidden in an alley between Grove and Floyd, has a horseshoe pit and

concrete climbing area for children. The park was designed by Carlton Abbott and nicknamed Geometry Park because of the playground. The park has a linear hardscape bordered by seating, mostly concrete artwork, and little grass. An interesting spot to visit.

## SYDNEY PARK

*Triangular park at Floyd, Brunswick and North Morris*

Sydney Park is the smallest park in the city, but it has a nice grass area with benches.

## MUSEUM OF CATHOLIC HISTORY

*800 South Cathedral Place*
*(804) 359-5661 ext. 218 | richmonddiocese.org/office/museum*

After Thomas Jefferson wrote the Virginia Bill for Religious Freedom, Catholics in Virginia felt safe to practice their religion. The museum's exhibits detail the history of the Catholic Church in Virginia.

## JOHN WHITWORTH HOME

*2221 Grove Avenue*
*Private residence*

The John Whitworth home, built circa 1857, is one of the oldest mid-nineteenth-century frame houses in the Fan neighborhood. In 1923, the new owner, Charles F. Gillette, transformed the backyard into his own laboratory. He was a well-known landscape architect who created and designed landscapes and gardens at Kenmore in Fredericksburg, Nelson House in Yorktown and both the Virginia House and Agecroft Hall in Richmond. The formal layout still exists behind the tall hedge.

# EASTER ON PARADE

*Monument Avenue*
*Davis Avenue to Allen Avenue*

On Easter Sunday, residents, guests and pets gather on Monument Avenue to parade around the blocks showing off their latest bonnets. The parade, or more likely a southern stroll, usually starts around 1:00 p.m. Thousands of spectators and participants gather to walk and witness the wide variety of Easter bonnets. People and pets compete in contests to win the best bonnet. The event includes music, children's activities and a booth to make bonnets.

Monument Avenue is the Upper Fan's most famous street and one of Virginia's best-known avenues. The avenue is fourteen blocks long and runs westward from Lombardy Street to Roseneath Road. The land was a three-block extension of West Franklin Street. In 1906, the city annexed and paved the extension. The avenue's traffic lanes were a 130-foot-wide right-of-way divided by a 40-foot median. Scarlet and sugar maple trees lined the median, and grass grew in the center. The park-like setting provided fresh air and picnic spots for the growing number of residents of the new townhomes.

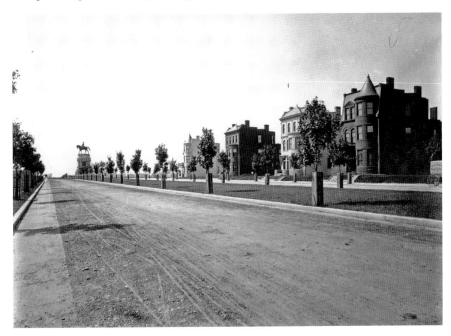

Monument Avenue, looking west toward Lee Monument. *Cook Collection, The Valentine.*

The Branch Museum of Architecture and Design. *Photograph by Scott Stowe.*

## THE BRANCH MUSEUM OF ARCHITECTURE AND DESIGN

*2501 Monument Avenue*
*branchmuseum.org | Admission fee*

The avenue mansions were inclined to be more horizontal than vertical.

One of the new-moneyed elite, John Kerr Branch, bank president, chose to live along the avenue. The Branch House, built in 1917 and designed by architect John Russell Pope, was a twenty-seven-thousand-square-foot house with eleven levels—it had one of the first elevators. The twenty-eight-room home is now the Branch Museum of Architecture and Design.

## ROBERT E. LEE STATUE*

*Monument and Allen Avenues*

The initial idea of the Monument Avenue was a place to honor General Robert E. Lee. Lee died in October 1870, and even before his death,

Richmond citizens debated the idea of a statue. The emergence of the Lost Cause theme in the late nineteenth and early twentieth centuries was a way to hold on to the past in Richmond. The white citizens decided to dedicate land to the greats of the Confederacy, and Otway Allen offered land for the General Lee statue. Not all Richmonders were pleased with the decision; some disagreed with the location outside of the city limits. And others, like John Mitchell Jr., editor of the *Richmond Planet*, argued the statue represented the Confederacy and that time had passed. Neither argument prevented the cornerstone being laid on October 27, 1887. Three years later, the statue was completed by Frenchman Jean Antonin Mercié and shipped from Paris, France, to Richmond. The city's citizens and visitors for the Confederate reunion joined together at the docks to haul the statue of Lee to its spot at the intersection of North Allen and Monument Avenues. Over 10,000 people helped move the statue by pulling the attached ropes; once the statue was in place, the rope was cut up and distributed for souvenirs. General Joseph E. Johnston unveiled the statue on May 29, 1890, while over 100,000 people were in town to attend the Confederate reunion.

*Social justice activism spread throughout the nation, and the eyes turned to the former home of the Confederacy. And in the summer of 2020, 130 years after John Mitchell's editorial was printed, Confederate statues throughout the city have been removed, except General Lee. As of this writing, the statue's future is unknown.

# J.E.B STUART STATUE*

*The statue has been removed and an empty pedestal remains.*
*Monument and Lombardy Avenues*

Confederates returned in 1907. Although fewer in number, they witnessed the unveiling of two Confederate statues, J.E.B. Stuart and Jefferson Davis. Stuart had been mortally wounded at Yellow Tavern and died in Richmond on May 11, 1864. He was buried in Hollywood Cemetery. Stuart's statue by sculptor Fred Moynihan marked the start of historic Monument Avenue at the intersection of West Franklin and Lombardy. The statue was unveiled on Thursday, May 30, 1907, and celebrated by a parade of ten thousand men and fifty thousand attendees.

## JEFFERSON DAVIS STATUE*

*The statue has been removed and an empty pedestal remains.*
*Monument Avenue and Davis Street*

Four days later, on Monday June 3, the Jefferson Davis Monument was unveiled following a procession of three thousand children who brought the monument up from the river. This was similar to the reception of the Lee statue. Davis's statue had a twenty-one-gun salute. Davis's statue included a semicircular classical colonnade of thirteen columns. Each column represented a Confederate state, along with Missouri and Kentucky. Jefferson Davis was also buried in Hollywood Cemetery.

## STONEWALL JACKSON*

*The statue has been removed and an empty pedestal remains.*
*Monument Avenue and Arthur Ashe Boulevard*

Two blocks west was the Stonewall Jackson statue. Thomas Jonathan "Stonewall" Jackson was mortally wounded at the Battle of Chancellorsville and died on May 10, 1863. His statue was sculpted by F. William Sievers. This statue was unveiled in June 1915 with roughly five thousand ex-Confederates in attendance. General Lee's grandson spoke at the event.

## COMMANDER MATTHEW FONTAINE MAURY*

*The statue has been removed and an empty pedestal remains.*
*Monument and Belmont Avenues*

The most western Confederate statue was Commander Matthew Fontaine Maury, often referred to as the "Pathfinder of the Seas." His statue was placed at the intersection of Belmont Avenue and Monument. He is believed to be the founder of the science of oceanography and was well known prior to the Civil War as the author of *The Physical Geography of the Sea*, published in 1855. His war work included an improvement to an electrical detonation and travel to England to procure supplies for the Confederacy. After the war, he was a professor at the Virginia Military Institute. His statue was unveiled

on November 11, 1929, and was different than the others. F. William Sievers once again was the sculptor, but this time, there was no horse. Instead of a horse, Maury sits below a world held up by sailors and farmers. The unique statue perspective honors a man of the world, not just of the Confederacy.

## ARTHUR ASHE

*Monument and Roseneath Avenues*

Arthur Ashe Monument. *Photograph by Scott Stowe.*

The last statue added to Monument Avenue honors another man of the world, Arthur Ashe. Ashe was a world-renowned tennis player, influential humanitarian, outspoken opponent of apartheid and author of a three-volume history of Black athletes. The sculpture was by Paul DiPasquale, and he was supplied photographs by Ashe. His statue stands with one hand holding a tennis racket and the other hand holding a book. At his feet are children, placed as an acknowledgement of his dedication to serving the community.

And while issues still arise, such as what to do about Monument Avenue, the city held a dedication ceremony on June 22, 2019, for the renaming of the boulevard to Arthur Ashe Boulevard. The celebration at the Virginia Museum of History and Culture was well attended.

## CIVIL WAR DEFENSE LINES

Richmond's western defense lines during the Civil War are marked with a cannon in the median of Monument Avenue. The inner defense line was near the 2300 block, and the intermediate was located at the 3400 block.

# OREGON HILL

## OREGON HILL HISTORIC OVERLOOK

*South Cherry and South Pine Streets*
*Excellent views of James River, Belle Isle and Lee Bridge*

Oregon Hill residents are quite proud of their community. The Oregon Hill neighborhood stretches south from Cary Street to the James River and west from Belvidere Street to Hollywood Cemetery. Similar to the Jackson Ward neighborhood, an expressway cuts through Oregon Hill, and some argue whether the northern boundary stops at the Downtown Expressway or Cary Street.

The neighborhood was a tight-knit community of industrial workers, and their families began with the early manufacturing on Belle Isle. The white employees sought the homes on the hill because the location was remote, and the far western area wasn't appealing to the middle and upper classes due to the proximity to the Virginia State Penitentiary, built in 1800 and demolished in 1991. The area was renamed from Belvidere to Oregon Hill, after the dispute with Great Britain over the Oregon Territory.

The "front-porch" neighborhood, as residents refer to it, is still a tight-knit and very loyal community. Although it started out as the country estate Belvidere of William Byrd III, this was not a fancy neighborhood.

Belvidere was part of the 1,800-acre estate his grandfather had inherited from his uncle Thomas Stegg. Byrd III designed Belvidere's front entrance to face the main western road into the city; this was different from other river

Front porches with St. Andrew's Church, Oregon Hill. *Photograph by Dan Palese Photographs.*

homes, which typically faced the river. The home was built between today's Belvidere and China Streets. The two-story frame home was 130 feet in length. The Belvidere estate was sold as part of the William Byrd III lottery.

Belvidere was destroyed by fire in February 1854. Local lore tells of residents removing the bricks to use in their own homes.

In the 1840s–50s, the growth of Tredegar sparked the expansion of the area, and residents crossed over Belvidere Street to settle on a 166-foot bluff overlooking the river. The workers who moved to this area were new to Richmond, arrived from the countryside or were recent immigrants: German, Irish, Italian, Welsh and others. All groups maintained their Old World customs and traditions.

Small cottages lined Maiden Lane, Holly, Belvidere and Church Streets and were filled with Tredegar employees and other industrial workers and families. The neighborhood was connected through employment rather than ethnicity, although very few African Americans lived in Oregon Hill.

The homes built west of Belvidere tended to be duplexes, semidetached and two-story row houses. The wood-frame homes were not built to last, yet they have. Many are still owned by the same families, and 80 percent of Oregon Hill homes are listed in the National Register of Historic Places.

Oregon Hill Mural. *Photograph by Dan Palese Photographs.*

C.A. Bustard wrote in a 1978 newspaper article that Oregon Hill was a "rural town in an urban setting." The star of the Oregon home was the front porch. The residences took (and still do) great pride in their porches, decorative iron railings and accents. The front porch was utilized by residents on a daily basis, as people visited across rails and kept up with neighbors and families.

The twenty-two-block neighborhood was filled with generations living next door to one other. The western isolation of Oregon Hill permitted the ideas of honest, industrious workers to flourish and be preserved and created new traditions. The neighborhood was filled with working-class white Richmonders who struggled financially yet lacked any sort of pretense. The community was impoverished but hardworking, run-down but proud and crumbling but striving at the same time.

As the areas north and west of Cary Street experienced residential growth, Oregon Hill residents actively protected their area and the neighborhood remained roughly a white working-class neighborhood. A small number of residents were African American, and they lived mostly on South Cherry Street. There was no overt racism; the Black families were not treated unkindly but were left mostly alone.

## SAMUEL PARSONS PLEASANT HOME, CIRCA 1817-18

*601 Spring Street*
*Private residence*

Oregon Hill was too far away to be affected by the flames of the Evacuation Fire. The home of Samuel Parsons was one of the earliest structures in Oregon Hill, completed in 1819. His home was part of the Harvie plan, the town of Sydney. Parsons's home was located directly across from his employer, the Virginia State Penitentiary. He was the superintendent for fourteen years. He was also a member of the Quaker church and an abolitionist. His fellow friend and co-worker purchased a home in the same area.

## JACOB HOUSE, CIRCA 1817

*619 West Cary Street*
*Private building*

John Jacob, an assistant superintendent at the penitentiary, purchased his home in 1832. The home had various owners, and during the Civil War, the Slott family lived in the home. William Slott was an iron "moulder," as were many of his neighbors. The number of iron workers in Oregon Hill gave the area the nickname "Disciples of Vulcan." It is easy to see the connection to the Roman god for fire, metalworking and forging in a neighborhood with such ornate ironwork decorating its front porches. The home is now owned by Virginia Commonwealth University.

## ST. ANDREW'S EPISCOPAL CHURCH

*240 South Laurel Street*
*(804) 648-7980 | standrewsoregonhill.org*

The "Patron Saint of Oregon Hill" was Grace Evelyn Arents (1848–1926), Lewis Ginter's niece. She was born in New York in 1848 and moved with her family to Richmond following her father's death. When Lewis Ginter died in 1897, he left most of his wealth to Grace, and she spent the rest of

her life helping residents, predominantly in the Oregon Hill neighborhood. She assisted in all aspects of the neighborhood's well-being: religious, educational, social and medical.

She started with a small donation for a pump organ and pumper for St. Andrew's Church in 1875. Twelve years later, she hired an architect to design a larger sanctuary and a new school.

## HOLLY STREET PLAYGROUND

*819 Holly Street*

Grace Arents was also concerned about education and opened a library in 1894. Her love for children led to the building of the first supervised playground in Richmond, Holly Street Playground. She also opened a kindergarten in 1895, and then in 1901 started the Grace Arents School. She was on hand every day and served as the principal. In 1972, the school became Open High School, one of two Richmond high schools to be ranked in the *U.S. News and World Report* as one of the best schools in the nation. The school prides itself on the students' dedication to service and community, a quality shared with Arents.

Her commitment extended past education to the support of the community. She financed two rows of homes for rent to low-income residents, 200–202 South Linden Street and 912–924 Cumberland Street (all demolished). The rents collected from the homes went to St. Andrews School to maintain the tuition-free institution. Similar to other early twentieth-century reformers, Arents was concerned about the health and living conditions of the poor. She paid for a public bathhouse for Oregon residents who lacked indoor plumbing and electricity. The bathhouse existed well into the 1930s and was a fond memory of many residents in the Oregon Hill Oral History Project, housed at the Valentine Museum. The use of the bathhouse cost five cents and included a shower, a towel and a sliver of soap. The facilities were quite popular on the weekends.

In 1954, over nine thousand Richmonders still had an outhouse, and many more were without electricity. A load of laundry was a whole day's chore that started in the morning filling the wash bucket with water and scrubbing the clothes clean using a washboard if no wringer machine was available. Two rinses later, the laundry was hung to dry, and the next few days were dedicated to ironing.

Grace Arents offered the building at 223 South Cherry Street to the Instructive Visiting Nurses Association (IVNA) rent free for three years. The nurses tended the working poor, and the St. Andrew's teacher dormitory became home to IVNA nurses until 1984, when the organization moved to Thompson Street. One resident recalled a housekeeper visiting her after the birth of her baby. The housekeeper cooked meals and washed clothes. The resident believed the nurses were the ones responsible for sending the help.

Many residents remember the effect these nurses had on the community but also have fond memories of the William Byrd Community House. The community center was the idea of the nurses and social workers who banded together to create a new recreational center. The center provided educational and recreational programming for the whole family, children to seniors. Shortly after Arents's death in 1926, it became a public library.

## HOLLYWOOD CEMETERY

*412 South Cherry Street*
*(804) 648-8501 | hollywoodcemetery.org | Free*

The modern-day traveler is sure to enjoy Hollywood Cemetery. The cemetery is filled with historical figures and anecdotal stories. Be aware, the cemetery was designed to follow the natural topography, and the roads are rather hilly. There are numerous ways to tour the cemetery; walking, Segway, guided and self-guided tours. Be sure to view the James River rapids. At the crematorium overlook, the North Bank Trail is visible between the railroad tracks and the base of the overlook hill. Hollywood was made a historical landmark by the state in 1967. With its two-thousand-plus trees, the cemetery was recognized as an arboretum in 2017.

Richmond's Hollywood Cemetery was founded in 1847, long before Hollywood, California, ever existed. The cemetery's land was originally part of the Belvidere estate, and the Harvie family purchased this area on a bluff overlooking the Falls. The tree-filled area became known as Harvie's Wood. The area was enjoyed by Richmonders for recreational and hunting activities and even the occasional duel.

In 1847, Joshua Fry and William Henry Haxall purchased the land for a cemetery; early on, the nation's cities combined private cemeteries and parks as open spaces. This mid-nineteenth century idea provided a

place for citizens to leave the hustle and bustle of everyday life and enjoy a quiet stroll or picnic. Fry and Haxall approached architect John Notman to design a private cemetery within the natural environment. He said yes and suggested the name Hollywood for the numerous holly trees. He planted indigenous species and incorporated nature's landscapes into the overall scheme of the area. The cemetery meanders up and down the hills and around, as the paths follow the natural way of the terrain of the 125-acre park.

## PRESIDENTS JAMES MONROE AND JOHN TYLER

*President's Circle*
*Hollywood Cemetery*

By 1856, Hollywood had approximately 1,240 burials, and two years later, James Monroe's body was moved from New York to Hollywood on July 5, 1858. His tomb resembles a birdcage and was designed by Albert Lybrock. The Gothic-style marker was made with cast iron.

President John Tyler was buried in the cemetery in 1862 with honors and a celebration hosted by Confederate president Jefferson Davis. Due to his allegiance with the Confederacy, Washington, D.C., treated him as an outsider.

One of the first Confederate soldiers to be buried here was Henry Lawson Wyatt, who was killed on June 10, 1861, at the Battle of Big Bethel. He was nineteen years old and buried with full honors. As the battles continued, the number of Confederate dead increased. The cemetery never charged the families for the plots and only charged the government half the cost of the burial. Over 18,000 Confederate soldiers were buried here, including the fallen Confederates at Gettysburg. Dr. Weaver exhumed a total of 2,935 from the battlefield in Gettysburg, and the bodies were shipped back to Richmond for burial.

General John Pegram was the last Confederate general killed in battle to be buried at Hollywood. At least sixteen Civil War generals who died after the war or reinterred after the war are buried here, including General Pickett, reinterred here in 1875. Catherine Hodges went to war as a vivandière for Company K, Fifth Regiment, Louisiana Volunteers. Once in Richmond, she attended to the sick as a nurse but unfortunately died. She was buried in Section B, Row 27, of the Soldiers' Section.

Scarlet fever took the lives of General James Longstreet's three children: Mary Anne, James and Augustus. The three were believed to be buried in Hollywood. When the Union forces occupied the city, 230 Federal soldiers were buried in Section A.

## MONUMENT TO THE CONFEDERATE WAR DEAD

*Hollywood Cemetery | Free*

As Southerners woke from the shock of the lost war, they yearned to remember the promise of the past. When Richmond emerged as a central component for the Lost Cause, Hollywood Cemetery was a connection to that past. The first Civil War memorial was erected in 1868 in Hollywood Cemetery, designed by engineer Charles H. Dimmock. He designed a ninety-foot pyramid made of James River granite. The statue stands over the Soldiers Section as a result of the fundraising efforts of the women in the Hollywood Memorial Association.

## JEFFERSON DAVIS

*Davis Circle, Hollywood Cemetery*

Jefferson Davis's body was moved to Hollywood in 1893 at the request of his wife. Their children were also reinterred in Hollywood.

## VIRGINIA WAR MEMORIAL

*621 South Belvidere Street*
*vawarmemorial.org | Free*

To the east of Belvidere Street is the Virginia War Memorial, built in 1955 to honor World War II and Korean War fallen soldiers. The memorial was designed by Samuel J. Collins and his nephew Richard E. Collins. The site has been expanded to include recent fallen soldiers. Standing guard is the statue *Memory*, a woman in grief, designed by Leo F. Friedlander. The Shrine of Memory includes almost twelve thousand names.

# MUSEUM DISTRICT

Arthur Ashe Boulevard separates the Fan and Museum Districts. The Museum District borders on the western side and continues west to the Downtown Expressway, 195. Broad Street marks the northern boundary, and the district runs south to Ellwood Avenue, just north of Carytown.

The museum district residential areas grew as a result of a new Byrd Park Pump House built to accommodate the reservoir's town supply. The Reservoir/Byrd Park was located on the south end of Clover Street, now Arthur Ashe Boulevard. The new pumphouse collected water from the river and its own canal and sent it uphill to the reservoir from 1883 to 1924. Wilfred Emory Cutshaw designed the Gothic-style building with a main floor for the pump machinery and the top floor for recreation. He stressed the public use of buildings, and during the years of operation, the pumphouse's top floor hosted numerous parties. The building has suffered in the last few years, although there is a push to renovate the pumphouse.

## ROBINSON HOUSE

*Richmond Region Tourism Center*
*200 North Arthur Ashe Boulevard*
*visitrichmondva.com*

In 1884, around the midway point of Arthur Ashe Boulevard between Cary Street and Monument Avenue, banker Anthony Robinson Jr. sold 36 acres

Virginia Museum of Fine Arts. *Photograph by Dan Palese Photographs.*

and his home to the R.E. Lee Camp No. 1 for veterans. The home was 7,600 square feet and housed veterans who were indigent and/or disabled. The men had to abide by the rules placed on them by the board. These were pretty straightforward: no gambling and no guns. One thing that the board was unable to prevent was consumption of alcohol. During Prohibition, the men had one pint a day.

The camp housed over three thousand residents before closing down when the last two residents, John Shaw (age 105) and Sergeant Jack Blizzard (age 97), passed away. The Robinson House and the Confederate Chapel were the only two buildings to survive demolition. The home now houses the Virginia Visitor Center on the first floor, and Virginia Museum of Fine Arts uses the other floors.

## CONFEDERATE WAR MEMORIAL CHAPEL

*2900 Grove Avenue*
*(804) 340-1170 | Free*

Architect M.J. Dimmock designed both the Confederate and Hollywood Chapels. The Confederate Chapel was dedicated in May 1887, and when it

closed in 1941, the chapel had held over 1,700 funerals. The chapel became a meeting home and is currently owned and operated by the Virginia Museum of Fine Arts.

## VIRGINIA MUSEUM OF FINE ARTS

*200 North Arthur Ashe Boulevard*
*(804) 340-1400 | vmfa.museum | Free, special exhibits admission fee*

The Museum District was named after the two prominent museums located on Arthur Ashe Boulevard, the Virginia Museum of Fine Arts (VMFA) and the Virginia Museum of History and Culture (previously known as the Virginia Historical Society). In 1936, the Virginia General Assembly approved and voted for the opening of the Virginia Museum of Fine Arts. The initial cost of the museum was shared with the Works Progress Administration. The museum is world-renowned for its collections, such as the Lillian Thomas Pratt Fabergé collection. In December 2019, the museum permanently installed artist Kehinde Wiley's most recent statue, *Rumors of War.*

## VIRGINIA MUSEUM OF HISTORY AND CULTURE

*428 North Arthur Ashe Boulevard*
*(800) 358-8701 | virginiahistory.org | Admission fee*

The museum was initially established as a historical and philosophical society of Richmond, and John Marshall served as the first president. The museum's first permanent home was the Lee House on Franklin Street. In 1959, the society merged with the Battle Abbey, the Confederate Memorial Institute, and moved to the current location. The museum includes traveling exhibits as well as Virginia history exhibits and artifacts.

## MAYMONT

*2201 Shields Lake Drive*
*(804) 358-7166 | maymont.org | Grounds free, museum admission fee*

Maymont was the estate of James and Sallie Dooley and encompasses one hundred acres of beautifully landscaped hills that overlook the James River. The estate grounds include the Dooley Mansion, the granite carriage house, a children's zoo and wildlife walks, a nature center with an aquarium and formal Italian and Japanese gardens. The park hosts over half a million visitors each year and numerous special events, such as the Jazz Festival, Herbs Galore and More and others. The *Follow-the-Leader* children playing on a fallen log sculpture near the entrance to the Maymont Farm and Wildlife Exhibits invite all visitors to enjoy the park.

The public park was a gift from James and Sallie Dooley to the city of Richmond. James Dooley was able to embrace and combine trade and transportation industries with great success. With success comes the opportunity to give back, and the Dooleys were more than generous. Even before their deaths, the Dooleys contributed money for a hospital, a children's hospital, a public library and St. Joseph's Female Academy and Orphan Asylum.

James Dooley was born in Richmond on January 17, 1841, and was a son of Irish immigrants. His parents emigrated from Ireland and settled

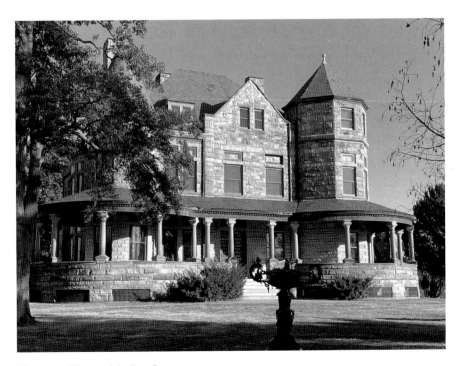

Maymont. *Photograph by Scott Stowe.*

in Richmond in 1836, and his father, John Dooley, owned and operated a hat manufacturing company on Main Street. The company was among the largest of its kind in the South.

At the start of the Civil War, his father enlisted in the Confederacy and James managed the hat company. Then James received his conscription card and enlisted in the army as a private in Company D. He was captured and held as a prisoner of war; luckily, he was exchanged before the war was over. His father's business was robbed and burned during the Evacuation Fire, so James returned to Georgetown College to complete his degree. After the war, he completed his degree and turned to the business of investing in railroads and manufacturing industries. Dooley was one of the founders of "The Terminal" or Richmond and West Point Terminal Railroad and Warehouse Company, the first railroad holding company in the United States. The holding company attempted to link smaller railroads together to bypass the restrictions of the Richmond & Danville Railroad.

James Dooley also invested in the Sloss Furnace Company after a visit to Birmingham, Alabama. His investments in railroads and industry provided enough income to build a wonderful estate just outside the city boundaries.

In 1890, ground was broken at the site of Maymont, the Dooleys' home on their one-hundred-acre estate. The land's downhill slope to the riverbank provided an opportunity to build cascading falls and winding trails, both paved and natural. Edgerton Rogers, the architect, called the home a suburban villa. The home was built at the start of the Gilded Age of the wonderful American mansions built by the captains of industry, such as the Biltmore by George Vanderbilt, grandson of Cornelius. The Richardson Romanesque design was also at the start of its popularity between the years of 1890 and 1900. Rogers, following the Richardson design, incorporated a lot of rock in the structure of the home.

The twelve-thousand-square-foot house is a wonderful example of Gilded Age homes with lavish furnishings collected from worldly travels. The Dooley Mansion was one of the first electric homes in the county and was equipped with an elevator, central heat and three full bathrooms. A Tiffany window was installed overlooking the grand staircase, and the home also included other works by Tiffany, such as the Tiffany Jack-in-the-Pulpit Vase. Mrs. Dooley's swan bed was a work of art. The swan bed was originally made for their summer estate, Swannanoa, located on Afton Mountain near Waynesboro, Virginia. Her will transferred the bed and other swan-themed items to Maymont for the public museum. The swan bed was made from wood and painted white with gilded touches.

Italian Gardens, Maymont. *Photograph by Scott Stowe.*

The home also included a crew of seven to eight employees who worked downstairs in the basement. The basement included a kitchen, laundry and servant quarters. Additional employees were needed to work in the carriage house and the three-story barn. Both the carriage house and the barn were

designed by Noland and Baskervill in the Normandy style with granite excavated from the property. They also designed the Italian parterre garden in three sections—one was the Secret Garden, which was a retreat for ladies. The Japanese gardens at the base of the hill are believed to be designed by Muto, a Japanese master gardener. The garden included waterways, paths and ornamental pieces.

Since the Dooleys willed the home and acreage to the city, it has grown to include a nature center, wildlife habitats and the Maymont Farm.

# WINDSOR FARMS

Two smaller neighborhoods line the southern stretch of West Cary Street. Windsor Farms neighborhood, just west of Byrd Park, was conceived by T.C. Williams in 1926. His company, T.C. Williams & Co., was labeled one of the "largest companies manufacturing tobacco for export in the country" by the *New York Times* in 1900. Windsor Farms had roughly 557 lots ranging from less than an acre to twenty-plus acres. John Nolen, the planner and landscape architect, laid out eleven miles of curving streets.

## AGECROFT HALL

*4305 Sulgrave Road*
*(804) 353-4241 | agecrofthall.org | Admission fee*

On the land closest to the river stands Agecroft Hall, the home of T.C. Williams Jr. The home was originally a fifteenth-century estate in Lancashire, England. The previous owners were the Langley and Dauntesey families, and the house had fallen into disrepair before Williams bought the estate. He purchased, dismantled and rebuilt the house in Richmond. The home is not a complete reproduction but includes elements from the Lancashire estate and other estates. Agecroft's English Gardens were designed by well-known landscape architect Charles Gillette.

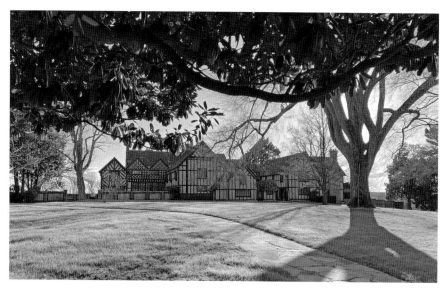

*Above*: Agecroft Hall and Gardens. *Photograph by Scott Stowe.*

*Left*: Virginia House, Richmond, Henrico County, 1929–30. *Library of Congress.*

# VIRGINIA HOUSE

*4301 Sulgrave Road*
*(804) 353-4251 | virginiahistory.org*

Around the corner from Agecroft is the Virginia House, another home built with and modeled from English estates. The architect Henry Grant Morse incorporated three English houses in the design of the home. Charles Gillette was the landscape architect on this project.

# AMPTHILL

*211 Ampthill Road*
*Private residence*

A third prominent home, Ampthill, was moved to just west of Windsor Farms. Similar to Agecroft and Virginia House, Ampthill was relocated from another location. Unlike the other two, Ampthill was constructed in America. Henry Clay built the home in 1730 on the south side of the river. The home eventually was owned by the Cary family, and they relocated the house across the river in 1929.

# NORTHSIDE

## LEWIS GINTER BOTANICAL GARDENS

*1800 Lakeside Avenue*
*(804) 262-9887 | lewisginter.org | Admission fee*

Richmond's Northside resembles a hodge-podge of neighborhoods, some with planned foresight and rich investors and some more like leftovers. The neighborhoods lined Brook Road, Richmond's old north–south turnpike. Brook Road, previously Brook Turnpike, is one of the oldest roads in Richmond. The road headed north and was the main thoroughfare for commodities carried in on horseback and wagons. In 1812, the Virginia General Assembly voted on a toll road. There were very few residential homes along this route prior to the Civil War. Colonial troops marched down this road, and Confederates built inner defense across it near Confederate Avenue.

One of the best-known Northside neighborhoods is Ginter Park. Ginter Park was the brainchild of Lewis Ginter, the same man who built the Jefferson and whose niece Grace Arents was the Patron Saint of Oregon Hill. Ginter and various partners continued to purchase land and plant communities. To entice people to move, he even built a zoo, golf course and the Lakeside Wheel Club for bicyclists. In his consideration for others, Lewis Ginter decided on an area north versus an area west of town for his

Lewis Ginter Arboretum. *Photograph by Dan Palese Photographs.*

neighborhood. The story said Ginter thought the residents would prefer not to travel into work facing a rising sun and departing for home in a setting sun. The first homes were built in 1895 on old Powhatan tribe hunting ground. These cottages were for the land company workers on Cottage Avenue, six of them still in use today along the 3600 block of Hawthorne Avenue. Just as William Levit would do in the late 1940s, Ginter laid out a neighborhood targeting an upper-middle class, unlike Levitt, who targeted the family just starting out. The roads were laid out with stones from the close-by Bryan Park; to keep costs down, Ginter had his own railroad move the stone. The residents began to move in during late 1898, and by the turn of the century, there were still no sidewalks, no streetlights and no gas or telephone services. The first homes were roughly three to five thousand square feet and built for large families and staff. An extension of the electric streetcar west and Ginter's Lakeside Line increased the population, and the area was incorporated into a town in 1912, although the residents had already taxed themselves to raise money for improvements. The twenty-one-block neighborhood raised money for fire protection, sidewalks, garbage collection and more. Shortly after the vote to tax, the town was annexed into the city.

# BARTON HEIGHTS CEMETERIES

*1600 Lamb Avenue*
*Pedestrian entrance on St. James Street*

Barton Heights Cemetery and neighborhood tell a different story than Ginter Park and Brookside. Barton Heights Cemetery was started around 1815 by African Americans wanting a place to bury their dead. The cemetery was actually six cemeteries whose boundaries disappeared over time. Each cemetery was owned by a burial society, an early type of insurance. Surrounding the cemetery, a neighborhood grew in 1890 named after land speculator James H. Barton. The neighborhood was believed to be the first electric streetcar suburb in the county and one of the earliest neighborhoods to offer rent-to-buy.

# SOUTH SIDE

Richmond city leaders had eyed the properties south of the James River, and after joining with Manchester, the growth of Richmond on the south side was expected, although not celebrated. The land fight ended with the 1970s annexation of Chesterfield County's land bordering the James. Annexation was nothing new to Richmonders; earlier, in 1914, Richmond annexed the area known as Forest Hill.

## PATTESON SCHUTTE HOUSE, CIRCA 1750

*5613 Kildare Avenue*
*Private residence*

Forest Hill was part of William Byrd II's Fall Plantation and currently is the oldest frame structure in the area, the Patteson Schutte House. James Patteson was a steward on Byrd's Falls Plantation, and in 1765, his nephew David Patteson joined him at the plantation. By 1768, David had purchased a total of 902 acres, including the Patteson Schutte House, and another home, Laurel Meadow. Patteson owned twenty-nine slaves in 1783. He served as a first lieutenant in the Revolutionary War and was a member of the House of Delegates and a representative from Chesterfield County at the Virginia Federal Constitution Convention of 1788. The home stayed in the Patteson family until 1862, when Ignatius Schutte purchased the property.

# SOUTH OF THE JAMES MARKET

*growrva.com/soj*
*Saturday morning*

When Forest Hill is mentioned, locals think of two things: the farmers' market and the snow sledding. In the 1890s, Richmond and Manchester Railway Company extended its electric streetcar from Manchester westward, along the route of Forest Hill Avenue, a road first mapped in 1804. At the end of the streetcar line, the company created an amusement park to boost passengers. For thirty-three years, the company ran the 105-acre amusement park and added attractions throughout the years. The crowds rode the merry-go-round and the Dip-the-Dip, danced in the pavilion and attended music shows at the bandstand. The young braved the fun house and played in the penny arcade. On hot summer days, the park offered a bathhouse for those who enjoyed the Benson quarry for swimming and boating.

# FOREST HILL PARK LOOP TRAIL

*4021 Forest Hill Avenue*
*3.25 miles*

Forest Hill Park offered something for all residents; if the man-made amusements were not to the liking, park guests wandered the numerous trails. The park still has a mixture of paths: for the casual walker the paved walkways offer a nice walk around the lake, for the more adventurous numerous single-track trails wind up and around the hills of the park. Forest Hill Park has free parking acres and ample street parking.

# REEDY CREEK PARK AND BUTTERMILK TRAILS

*4001 Riverside Drive*
*2.5 miles*

The Forest Hill Park paths join Reedy Creek and the Buttermilk Trail. A modern-day explorer can park at one of three current entrances and parking lots on the south bank: 4001 Riverside Drive and Forty-Third

Forest Hill Park. *Photograph by Scott Stowe.*

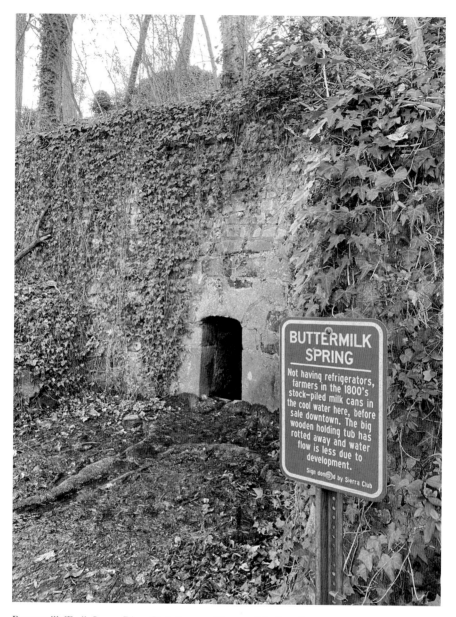

Buttermilk Trail, James River Park System. *Photograph by Scott Stowe.*

Street, 4401 Riverside Drive and Twenty-Second Street and 2101 Riverside Drive. The Buttermilk Trail is a roughly two-and-a-half-mile trail that follows the contours of the riverbank. Along the path and built into the granite wall is the Buttermilk Spring. In the 1800s, farmers stocked their milk in the cool waters before selling it downtown. The path is steep and challenging at times. The path's traffic includes pedestrians, dog walkers, runners and bicyclists.

## THE STONE HOUSE (BOSCOBEL)

*Holden Rhodes Home, circa 1843*
*4021 Forest Hill Avenue*

The Hull and Perry streetcar lines were full to capacity throughout the 1890s and turn of the century, but by 1932, the park had fewer visitors and the amusements were dismantled. In 1934, the same year as the last streetcar to Forest Hill Park, the city bought the park. With city funds and money from New Deal programs, the park was landscaped and hardscaped. The Stone House was renovated for community use. The park continues to undergo improvements, most recently the clearing away of invasive species. The removal of underbrush and vines revealed a rock pile mystery. The rock pyramid has no known explanation, but the stories range from slave burial site, to grave marker for a pet bear or part of a long-ago azalea garden.

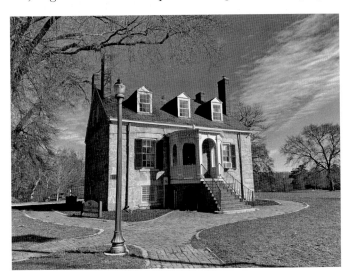

"Stone house" called Boscobel, Forest Hill Park. *Photograph by Scott Stowe.*

## RIVERSIDE DRIVE

*James River south bank*

Riverside Drive winds its way between Forest Hill Park and the James River. In February 2009, Riverside Drive was officially designated as the first scenic byway of the City of Richmond. Riverside is a popular road for all modes of transportation, from runners and walkers, bicycles, motorcycles and cars. Be very aware of traffic along the winding and hilly road. The road follows the riverbank terrain and includes two detours that briefly take the road away from the river.

## "NICKEL BRIDGE"

*Westover Hills Boulevard Bridge*

Westover Hills Boulevard is a main north–south thoroughfare that crosses the river. The Nickel Bridge connects Maymont to the Westover Hills neighborhood. The bridge was built in 1925 and renovated in 1992–93. The toll was originally ten cents, with half off for walkers and cyclists. The company changed the toll to five cents for everyone, and now the toll is thirty-five cents for cars—no toll for pedestrians or bicyclists. A parking lot on the north bank side provides easy access to the free bridge walkway and the entrance to the North Bank Trail.

# SITES CLOSE BY

ASHLAND MUSEUM | 105 Hanover Avenue | (804) 368-7314 | ashlandmuseum.org | Free

ASHLAND TRAIN STATION | 112 North Railroad Avenue | (804) 752-6766 | ashlandva.gov | Free

CHESTERFIELD COUNTY MUSEUM AND 1892 JAIL | 6831 Mimms Loop | (804) 768-7311 | chesterfieldhistory.com | Donation

COURTNEY ROAD SERVICE STATION, circa 1925 | 3401 Mountain Road | (804) 501-7275 | henricorecandparks.com | Free

DEEP RUN SCHOOLHOUSE, two-room school circa 1902, tours by appointment | 3401 Pump Road, Short Pump Park | (804) 501-7275 | henricorecandparks.com | Free

HALF-WAY HOUSE RESTAURANT | 10301 Jefferson Davis Highway North Chesterfield, VA 23237 | (804) 275-1760 | www.halfwayhouserestaurant.com

HANOVER COURTHOUSE, second-oldest continuously used courthouse in the United States circa 1735 stone jail | 13182 Hanover Courthouse Road | (804) 365-6000 | hanovercounty.gov | Free

HANOVER TAVERN, home of Patrick Henry | 13181 Hanover Courthouse Road | (804) 537-5050 | hanovertavern.org | Admission fee

HISTORIC POLEGREEN CHURCH | 6411 Heatherwood Drive | (804) 730-3837 | Historicpolegreen.org | Free

MAGNOLIA GRANGE | 10020 Iron Bridge Road | (804) 748-1498 | chesterfieldhistory.com | Admission fee

MEADOW FARM MUSEUM | 3400 Mountain Road | (804) 652-1455 | henricorecandparks.com | Free

MID-LOTHIAN MINES PARK | 13301 North Woolridge Road | (804) 796-7075 | midlomines.org | Free

PATRICK HENRY'S SCOTCHTOWN | 16120 Chiswell Lane | (804) 227-3500 | preservationvirginia.org/schotchtown | Admission fee

SHIRLEY PLANTATION | 501 Shirley Plantation | (804) 829-5121 | shirleyplantation.com

SLASH CHURCH | 11353 Mount Hermon | (804) 798-4520 | slashcc.org | Free

SYCAMORE TAVERN | 17193 Mountain Road | (804) 883-5355 | Free

WALKERTON TAVERN | 2892 Mountain Road | (804) 652-1485 | henricorecandparks.com | Free

# CIVIL WAR

BATTERY DANTZLER | 1820 Battery Dantzler Road | (804) 751-4946 | chesterfield.gov | Free

Confederate battery constructed in 1864 on the northern end of earthworks known as the Howlett Line

BEAVER DAM CREEK BATTLEFIELD | 7423 Cold Harbor Road | (804) 226-1981 | nps.gov/rich | Free

Seven Day Campaign began here on June 26, 1862

BERMUDA HUNDRED CAMPAIGN | chesterfieldhistory.com/military-history

COLD HARBOR BATTLEFIELD VISITOR CENTER | 5515 Anderson-Wright Drive | (804) 730-5025 | nps.gov/rich | Free

1862 Battle of Gaines' Mill and 1864 Battle of Cold Harbor

DABBS HOUSE MUSEUM | 3812 Nine Mile Road | (804) 652-3406 | henrico.us/rec/places/dabbs-house | Free

June 1862 military headquarters for the Confederacy

DREWRY'S BLUFF | 7600 Fort Darling Road | (804) 226-1981 | nps.gov/rich Trail to a Confederate fort

EPPINGTON PLANTATION | 14602 Eppes Falls Road | (804) 748-1623 | eppington.org | Admission Fee

Built circa 1768 by Francis Eppes VI, brother-in-law of Thomas Jefferson, tours by appointment

FORT HARRISON VISITOR CENTER | 8621 Battlefield Park Road | (804) 226-1981 | nps.gov.rich | Free

Self-guided walking trail, captured by three thousand Union soldiers on September 29, 1864

GAINES' MILL | 6283 Watt House Road | (804) 226-1981 | nps.gov/rich

Battlefield artillery exhibits, watt house and walking trail

GLENDALE/MALVERN HILL BATTLEFIELD VISITOR CENTER | 8301 Willis Church Road, inside the Glendale National Cemetery | (804) 226-1981 | nps.gov/rich | Free

PARKER'S BATTERY walking trail | 1801 Ware Bottom Spring Road | (804) 226-1981 | nps.gov/rich | Free

POINT OF ROCKS | Virginia.org

TOTOPOTOMOY CREEK BATTLEFIELD AT RURAL PLAINS | 7273 Studley Road | (804) 226-1981
May 1864 battles, The Shelton House, c. 1723 open April-November

# BIBLIOGRAPHY

## Periodicals

Beldini, Silvio A. "History Corner: William Mayo (1684–1744) Surveyor of the VA Piedmont. Part II." *Professional Surveyor Magazine*, March 2000.

Boyer, John. "Hurricane Agnes: Richmond's Record Flood Was 45 Years Ago." *Richmond (VA) Times-Dispatch*, June 22, 2017.

Cunningham, S.A. "The Battle Abbey of the South." *Confederate Magazine*, 1922.

King, Sarah. "The River." *Richmond Magazine*, May 2019.

Kollatz, Harry, Jr. "Lee in the Field." *Richmond Magazine*, June 2019.

"The Last Week of the Great War: A Chasm between Rhetoric and Reality in Richmond and Abroad." *Richmond Magazine*, November 2018.

"Monroe Park Timeline." *Style Magazine*, October 2018.

"New Shine for 'The Crown Jewel' Pump House at Byrd Park." *Discover Virginia*, February/March 2019.

"Where Ruins Mark a Deep History Midlothian Mines Park." *Discover Richmond*, February/March 2019.

Williams, Michael Paul. "At 97, Hill Recalls Triumph." *Richmond Times-Dispatch*, May 16, 2004.

———. "Getting to Know: Jackson Ward." *Richmond Times-Dispatch*, October 16, 2016.

Willis, Samantha. "Reflections of the Past: George O. Brown's Jackson Ward Studio Chronicled Black Life and Culture for 70 Years." *Richmond Magazine*, October 2018.

## Nonperiodicals

*Annual Report of the Health Department of the City of Richmond for Year Ending 1918.* Richmond, VA: Clyde E. Saunders City Printer, 1919.

Baker, Meredith Henne. *The Richmond Theater Fire: Early America's First Great Disaster*. Baton Rouge: Louisiana State University Press, 2012.

Bayliss, Mary Lynn. *The Dooleys of Richmond: An Irish Immigrant Family in the Old and New South*. Charlottesville: University of Virginia Press, 2017.

Belsches, Elvatrice Parker. *Richmond, Virginia*. Charleston, SC: Arcadia Publishing, 2002.

Bergman, Scott, and Sandi Bergman. *Haunted Richmond: The Shadows of Shockoe*. Charleston, SC: The History Press, 2007.

Boyer, John. *The James River in Richmond: Your Guide to Enjoying America's Best Urban Waterway*. Richmond, VA: Charles Creek Publishing, 1997.

Burns, Brian. *Lewis Ginter: Richmond's Gilded Age Icon*. Charleston, SC: The History Press, 2011.

Campbell, Benjamin P. *Richmond's Unhealed History*. Richmond, VA: Brandylane Publishers, 2012.

Case, Keshia A. *Richmond: A Historic Walking Tour*. Charleston, SC: Arcadia Publishing, 2010.

Chesnut, Mary Boykin. *Mary Chesnut's Diary*. London: Penguin, 2011.

Craven, Wesley Frank. *White, Red, and Black: The Seventeenth-Century Virginian*. New York: Norton, 1977.

Dabney, Virginius. *Richmond: The Story of a City*. Rev. and expanded ed. Charlottesville: University Press of Virginia, 1990.

———. *Virginia, the New Dominion*. Garden City, NY: Doubleday, 1971.

Daniel, Will. *James River Reflections*. Atglen, PA: Schiffer Publishing, 2011.

Deans, Bob. *The River Where America Began: A Journey along the James*. Lanham, MD: Rowman & Littlefield, 2007.

DuPriest, James E., Douglas O. Tice and Lisa Dawn. *Monument and Boulevard: Richmond's Grand Avenues*. Richmond, VA: Richmond Discoveries Publications, 1996.

Edwards, Kathy, Esme Howard and Toni Prawl. *Monument Avenue for Historic American Buildings Survey*. Washington, D.C.: U.S. Department of the Interior, 1992.

Fuller-Seeley, Kathryn, Elisabeth Dementi and Wayne Dementi. *Celebrate Richmond Theater*. Richmond, VA: Dietz Press, 2002.

Griggs, Walter S. *Hidden History of Richmond*. Charleston, SC: The History Press, 2012.

———. *Historic Disasters of Richmond*. Charleston, SC: The History Press, 2016.

Herbert, Paul H. *The Jefferson Hotel: The History of a Richmond Landmark*. Charleston, SC: The History Press, 2017.

Hitz, Mary Buford. *Never Ask Permission: Elisabeth Scott Bocock of Richmond, a Memoir*. Charlottesville: University Press of Virginia, 2000.

Hoffman, Steven J. *Race, Class and Power in the Building of Richmond, 1870–1920*. Jefferson, NC: McFarland, 2004.

Jewel, John, and John E. Booty. *An Apology of the Church of England*. Ithaca, NY: Published for the Folger Shakespeare Library by Cornell University Press, 1963.

Kensler, Stephanie. *Jackson Ward Neighborhood Plan*. Report prepared for Richmond Redevelopment & Housing Authority, 2014. https://wilder.vcu.edu/media/wilder/murp-studio-plans/ursp762/pdfs/s14/S14_SKensler_Jackson_Ward_Neighborhood_Plan.pdf.

Kimball, Gregg D. *American City, Southern Place: A Cultural History of Antebellum Richmond*. Athens: University of Georgia Press, 2000.

Kollatz, Harry. *Richmond in Ragtime: Socialists, Suffragists, Sex, and Murder*. Charleston, SC: The History Press, 2008.

Lankford, Nelson D. *Richmond Burning: The Last Days of the Confederate Capital*. New York: Penguin, 2003.

Layton, Robert C. *Discovering Richmond Monuments*. Charleston, SC: The History Press, 2013.

Lee, Richard M. *General Lee's City: An Illustrated Guide to the Historical Sites of Confederate Richmond*. McLean, VA: EPM Publications, 1987.

*Main Street Station Brochure*. Richmond, VA: City of Richmond Office of the Press Secretary, n.d.

Marambaud, Pierre. *William Byrd of Westover, 1674–1744*. Charlottesville: University Press of Virginia, 1971.

Marlowe, Gertrude Woodruff. *A Right Worthy Grand Mission: Maggie Lena Walker and the Quest for Black Economic Empowerment*. Washington, D.C.: Howard University Press, 2003.

Mitchell, Mary H. *Hollywood Cemetery: The History of a Southern Shrine*. Richmond: Virginia State Library, 1985.

Moore, Samuel J.T., Jr. *The Fan District Association of Richmond, Virginia Inc*. Richmond, VA, 1981. https://www.fandistrict.org/resources/Documents/FDA-History.pdf.

Mordecai, Samuel. *Richmond in By-gone Days*. Reprint ed. New York: Arno Press, 1975.

Neely, Paula Kripaitis, and David M. Clinger. *The Insiders' Guide to Greater Richmond*. 5th ed. Richmond, VA: Richmond Newspaper, 1996.

Nolan, Jeannette Covert. *Yankee Spy: Elizabeth Van Lew*. New York: Messner, 1970.

Richardson, Selden, and Maurice Duke. *Built by Blacks: African American Architecture and Neighborhoods in Richmond*. Charleston, SC: The History Press, 2008.

Rountree, Helen C. *Pocahontas's People: The Powhatan Indians of Virginia through Four Centuries*. Norman: University of Oklahoma Press, 1996.

Ryan, David, and Wayland Rennie. *Lewis Ginter's Richmond*. Richmond, VA: Dietz Press, 2005.

Sanford, James K. *Richmond: Her Triumphs, Tragedies & Growth*. Richmond, VA: Metropolitan Richmond Chamber of Commerce, 1975.

Scott, Mary Wingfield. *Houses of Richmond*. Prineville, OR: Bonanza Books, 1941.

———. *Old Richmond Neighborhoods*. Reprint ed. Richmond, VA: Valentine Museum, 1984.

*Shockoe Slip Walking Tour Pamphlet.* Richmond, n.d.

*Slave Trade Commission Brochure.* N.p.: Richmond City Council, n.d.

Smith, Brooks M., and Wayne Dementi. *Sports in Richmond.* Manakin-Sabot, VA: Dementi Milestone, 2010.

Snow, Kitty, and Harris Stilson. *From a Richmond Streetcar: Life through the Lens of Harris Stilson.* Petersburg, VA: Dietz Press, 2013.

Spears, Katarina M. *Richmond Landmarks.* Charleston, SC: Arcadia Publishing, 2012.

Stanard, Mary Newton. *Richmond; Its People and Its Story.* 2nd ed. Philadelphia: J.B. Lippincott Company, 1923.

St. J. Carneal, Drew. *Richmond's Fan District.* Richmond, VA: Council of Historic Richmond Foundation, 1996.

Thrower, Kristin Terbush. *Miller and Rhoads Legendary Santa Claus.* Richmond, VA: Dietz Press, 2002.

Totty, Dale. *Maritime Richmond.* Charleston, SC: Arcadia Publishing, 2004.

Trammell, Jack, and Guy Terrell. *A Short History of Richmond.* Charleston, SC: The History Press, 2017.

Tyler-McGraw, Marie. *At the Falls: Richmond, Virginia and Its People.* Chapel Hill: University of North Carolina Press, 1994.

Varon, Elizabeth R. *Southern Lady, Yankee Spy: The True Story of Elizabeth Van Lew, a Union Agent in the Heart of the Confederacy.* Oxford, UK: Oxford University Press, 2005.

Ward, Harry M. *Children of the Streets of Richmond, 1865–1920.* Jefferson, NC: McFarland & Company, Inc., Publishers, 2015.

Ward, Harry M., and Milton J. Elliott. *Richmond: An Illustrated History.* Northridge, CA: Windsor Publications, 1988.

Ward, Harry M., and Harold E. Greer. *Richmond during the Revolution, 1775-83.* Charlottesville: Published for the Richmond Independence Bicentennial Commission by the University Press of Virginia, 1977.

Warder, Ginger. *Linden Row Inn.* Charleston, South Carolina: Arcadia Publishing, 2014.

*Westover Autumn Pilgrimage House Tour.* Charles City, VA: Westover Episcopal Church, 2018.

## *Websites, Online Resources*

American White Water. "James River." https://www.americanwhitewater.org/content/River/detail/id/1952.

Church Hill People's News. "The Union Hill Historic District." http://chpn.net/2009/11/22/the-union-hill-historic-district/.

Fall, Joey. "Meat Juice Love: A Story of Portraits Series." The Valentine. https://thevalentine.org/valentines-meat-juice-love/.

Friends of the James River Park. "Fishing the Falls of the James." https://jamesriverpark.org/wp-content/uploads/2019/07/fishing.pdf.

———. "Manchester Climbing Wall." https://jamesriverpark.org/project/manchester-climbing-wall/.

Google Arts and Culture. 'Disciples of Vulcan, Examining the Oregon Hill Community." https://artsandculture.google.com/exhibit/disciples-of-vulcan-examining-the-oregon-hill-community/QQsijApu.

Influenza Encyclopedia. "Richmond, Virginia." https://www.influenzaarchive.org/cities/city-richmond.html#.

Jewish Virtual Library. "The Hebrew Confederate Cemetery." https://www.jewishvirtuallibrary.org/the-hebrew-confederate-cemetery.

Library of Virginia. "Grace Arents." www.lva.virginia.gov.

National Park Service. "The Trumpet of Progress." https://www.nps.gov/mawa/learn/historyculture/st-luke-herald.htm.

Noel, Tricia. "When Benedict Arnold Came to Town." Church Hill People News. https://chpn.net/2014/12/24/when-benedict-arnold-came-to-town-2/.

Richardson, Selden. "The Virginia Penitentiary in Richmond." Shockoe Examiner. https://theshockoeexaminer.blogspot.com/2013/07/the-virginia-penitentiary-in-Richmond.html.

Rose, Rebecca. "Richmond's Part in the Early Automobile and Racing Industries." Virginia Museum of History and Culture. https://vahistorical.wordpress.com/2012/08/27/Richmonds-part-in-the-early-automobile-and-racing-industries/.

Valentine, the. "Valentines Meat Juice Love." https://thevalentine.org/valentines-meat-juice-love/.

Virginia African American Cultural Resources. "Ethel Bailey Furman House." http://afrovirginia.org.

Virginia Department of Historic Resources. "Fan Area Historic District Nomination Form National Register of Historic Places." https://www.dhr.virginia.gov.

———. "Jackson Ward Historical District Additional Documentation for National Register for Historical Places." https://www.dhr.virginia.gov/wp-content/uploads/2018/04/127-0237_Jackson_Ward_HD_2002_AdditionalDocumentation_Final_Nomination.pdf.

Virginia Museum of History and Culture. "A Guide to the Richmond Light Infantry Blues Records, 1871–1980 (Call Number Mss3R4157cFA2)." https://www.virginiahistory.org/collections-and-resources/how-we-can-help-your-research/researcher-resources/finding-aids/richmond-1.

## *Unpublished & Other Sources*

"African American Education." 1960. Valentine Vertical File. The Valentine Museum, Richmond, VA.

"Almshouse Nomination Form." Unpublished manuscript, 1981. https://www.dhr.virginia.gov/VLR_to_transfer/PDFNoms/127-0353_Almshouse,The_1981_Final_Nomination.pd.

"Americans Lumpkins Jail." Valentine Vertical Collection. The Valentine Museum, Richmond, VA.

Bannister, Joseph. Interview by Sandy Davis. Richmond, VA. May 31, 1991. Oregon Hill Community History Association: Oral History Project, Valentine Collection.

C., Bustard A. "Oregon Hill, a Rural Town in Disguise." January 29, 1978. Oregon Hill Vertical Files. Valentine Museum, Richmond, VA.

"Church Hill Historic District A Self-Guided Walking Tour." Valentine tour books vertical file. Valentine Museum, Richmond, VA.

"Colonel John Mayo Papers, 1790–1801." Colonel John Mayo Papers, 1790–1801 1 Box (.5 Linear Feet). The Valentine Museum, Richmond, VA.

"Memorial Services Are in Crowded Churches Business and Industry." Valentine Vertical Files: WWII. Valentine Museum, Richmond, VA.

"National Register of Historic Inventory Nomination Form Fan Final Nomination." Unpublished manuscript, 1985. https://www.dhr.virginia.gov/wp-content/uploads/2018/04/127-0248_Fan_HD_1985_Final_Nomination.pdf .

"National Register of Historic Places Nomination Form Shockoe Slip." 1982. https://www.dhr.virginia.gov/wp-content/uploads/2018/04/127-0219_Shockoe_Slip_HD_1972_Final_Nomination.pdf.

"National Register of Historic Places Registration Form, Union Hill." Unpublished manuscript, n.d. https://www.dhr.virginia.gov/registers/Cities/Richmond/UnionHillHD_textlist.htm.

"Richmond Walking Tour Pamphlet." Tour vertical file. Valentine Museum, Richmond, VA.

"Shockoe Bottom Historic Sites." Richmond Tours Valentine vertical files. Valentine Museum, Richmond, VA.

"Shockoe_Hill_Cemetery Nomination Form." Unpublished manuscript, 1995. https://www.dhr.virginia.gov/wp-content/uploads/2018/04/127-0389_Shockoe_Hill_Cemetery_1995_FINAL_Nomination.pdf.

"VA Women and the Second World War; Record and Resources at the Library of Va." Valentine Vertical Files: WWII. The Valentine, Richmond, VA.

"Wharves in Shockoe Digging: Relics of First Settlement Found Buried Thirty Feet of Ground in Valley." April 7, 1925. Valentine Shockoe File. Valentine Museum, Richmond, VA.

# INDEX

# ABOUT THE AUTHOR

Kristin T. Thrower Stowe lives in the Richmond area. She has a master's degree in history and in teaching from Virginia Commonwealth University and a school librarian postgraduate certificate from Longwood University. Her first book, *Miller & Rhoads Legendary Santa Claus* (2001), tells the history of the real Santa that visited Richmond every Christmas. Kristin enjoys traveling; she has visited thirty-nine states and traveled overseas.

*Visit us at*
www.historypress.com